Urban Potters

Makers in the City

Katie Treggiden

Edited by
Micha Pycke &
Ruth Ruyffelaere

Keen to tell a diverse and inclusive story of the ceramics heritage of the six cities featured, the author and publisher are aware that we cover some culturally sensitive topics in this book. Every care has been taken to ensure that we use the most appropriate language to avoid causing offence and approval has been sought from cultural bodies within the relevant countries. However, we are also aware that language and sensitivities change over time and so we wish to offer our sincerest apologies in case any of the currently acceptable terms become offensive in the future. Aboriginal and Torres Strait Islander readers are advised that the Sydney chapter contains images of and quotations from deceased persons.

London

São Paulo

New York

Copenhagen

Tokyo

Sydney

Introduction

The archetypical studio potter is distinctly rural – Bernard Leach's defining tome, *A Potter's Book,* depicted the 'father of British studio pottery' throwing on a wheel in his countryside workshop and forever imprinted an image in our minds. The metropolitan focus of this book then, featuring 28 studio potters working in London, Tokyo, Copenhagen, New York, Sydney and São Paulo, might come as a surprise. And yet both the contemporary ceramics revival, and indeed the birth and growth of ceramics, are in fact inextricably tied to urbanisation.

Early man discovered the power of fire to harden earth into a durable material as long as 25,000 years ago – probably while placing clay figures into fires as part of ritual practices or lining hearths with clay to keep them watertight – but it wasn't until our nomadic ancestors started to settle into towns and villages 13,000 years later that ceramics started to be used as functional vessels.

A complete linear history of ceramics is almost impossible to write, so convoluted is the story of discovery, rediscovery, invention and reinvention of kilns, glazes, recipes, wheels and myriad techniques at different times, by different people in different places. Suffice to say that the hunter-gatherers of Jōmon-period Japan made the earliest examples of functional pottery over 12,000 years ago, and ceramic vessels – at first rounded for putting into fires and onto earthen floors and eventually flat bottomed with the advent of furniture – were used by the first settlers along the Middle Nile Valley and other early societies such as the European Beaker People, Predynastic Egyptians and Native American Indians. The earliest kilns date from the Hassuna period (6,000 BC) in Mesopotamia, and the advent of the kick wheel some 5,000 years ago redefined pottery from a part-time seasonal activity largely carried out by women to skilled and therefore predominantly male labour. New technology sped up production: records from the third Ur dynasty (22nd to 21st centuries BC) show pottery workshops employing up to 10 people outside agricultural

seasons – and pottery remained a small-scale urban activity for the best part of 4,000 years – at the beginning of the 18th century, most workshops in Stoke-on-Trent employed men in similar numbers.

The Industrial Revolution transformed ceramics and divided production in two – the large scale mass-manufacture of ceramic ware in response to the demands of population growth, the new popularity of tea, and the expansion of the British Empire; and the small-scale studio pottery that is the focus of this book, defined for our purposes as functional ware made by a single person.

In *The Invention of Craft,* Glenn Adamson argues that craft is in fact a modern construct – that it 'emerged as a coherent idea, a defined terrain, only as industry's opposite number, or "other".' The same could be said of studio pottery. The Industrial Revolution began in Britain, where Josiah Wedgwood, the youngest of an unexceptional potter's 13 children, turned his father's Staffordshire workshop into a global phenomenon and a purveyor to the Queen. Prevented from becoming a master potter by smallpox, he set about designing wares for other potters to make, eventually applying new technologies, new ideas about the division of labour and discipline of workers and, crucially, new marketing techniques to lead Britain's potteries into the industrial age – 'I will make machines out of men,' he wrote. But, as Adamson explains,

> craft was not a static backdrop against which industry emerged like a figure from the ground. Rather the two were created alongside one another, each defined against the other through constant juxtaposition.

And so while the well-documented rise of industrial pottery was taking place in Stoke-on-Trent, studio pottery was quietly asserting itself in opposition. Denmark's mid-century studio pottery movement similarly developed in parallel to Royal Copenhagen's factory-made porcelain.

Born in Hong Kong into a wealthy family, educated in London and Japan and influenced by the Arts and Crafts Movement, Bernard Leach (1887–1979) championed an anti-industrial approach to ceramics that influences makers all over the world to this day. 'Factories have practically driven folk-art out of England,' he wrote in *A Potter's Book*. 'The artist-craftsman, since the day of William Morris, has been the chief means of defence against the materialism of industry and its insensibility to beauty.' Conceding that 'perfection' was more than possible at the hands of machines, Leach

maintained that there was a 'higher, more personal, order of beauty,' only achievable when craftsmen made pots by hand.

Philosopher Yanagi Sōetsu (1889–1961) pioneered a related movement in Japan – the Mingei or folk art movement, defined by hand-crafted objects made by ordinary people – having been influenced by a visit to Korea, early pots used by common people in the Edo and Meiji periods in Japan, and the Arts and Crafts ideals Leach espoused when the two met at the turn of the 20th century.

Meanwhile American, Australian and Brazilian potters adopted approaches from Europe and Japan, and combined them with their own cultures and experiences to create new forms of expression.

These movements were a rejection, not only of industrialisation, but also of the cities where industrialisation took place. Writing in *20th Century Ceramics*, Edmund de Waal asserts,

> ... the growth of the Mingei movement in Japan and the rise of the studio potter in Britain, were [...] based on the apprehension that an increasingly urban and industrial society was losing a powerful value system. These were values found in the crafts, values that were projected as being based around community and closeness to the natural order.

Or, as Tanya Harrod puts it, 'Making technically imperfect pots was an anti-modern response to new processes and materials, to what DH Lawrence called "the tragedy of ugliness" that appeared to characterise the industrialised world.' In contrast, *A Potter's Book* offered a reassuring image of a potter happily apart from contemporary society, and it's no coincidence that Leach chose the Cornish village of St Ives to establish his pottery.

So if the original studio pottery movement was a reaction against industrialisation and urbanisation, what is driving the contemporary revival – and why is it happening in cities? The obvious answer to the former is that artists are reacting to the digital revolution in the same way that they reacted to the Industrial Revolution and Adamson's work bears this out: 'Our own era is just as potentially traumatic and disruptive as the time of the industrial revolution.' Indeed, he describes craft as 'an understandable response to the crises of modernity.'

And there's certainly something in what de Waal calls 'returning to earth' that makes clay very appealing in times of endless innovation and

uncertainty. 'Returning to earth carries with it the almost visceral feeling of having been separated, alienated or disconnected from the earth, or land, or culture,' he says. Combine this with the increasingly sanitised nature of city living and it seems that people just want to get their hands dirty. London potter Matthew Raw runs Raw Ceramic Workshops as part of his practice, and sees this first hand. 'My students always seem to Instagram their clay-covered shoes on their way home from a class,' he laughs. For the millennial generation that comprises much of Raw's client base, such haptic experiences are an important part of their (carefully curated online) identities. Contrast that with a professional caster who has worked in one of Stoke-on-Trent's potteries since he left school at 16 and is now nearing retirement: 'I don't get any joy from this job anymore,' he says. 'I'm just sick of having dirty hands all the time.' – and there is an uneasy awareness of the privilege in coveting dirty hands. In fact, in an essay entitled 'Why Don't We Hate Etsy?', Tanya Harrod takes this dichotomy further and suggests that Etsy, and, one could argue, the current craft phenomenon as a whole, 'exploits a dream, that of giving up a day job to pursue an autonomous life of craft,' adding that 'It is all a delusion of course, a perfect example of what Marxists call "false consciousness".'

Editor of *Crafts Magazine* Grant Gibson cites more expansive reasons for the current resurgence of craft, including increasingly risk-adverse manufacturers driving new designers to find their own routes to market, a recession-driven 'make do and mend' culture and conversely the rise of 'an uber-rich class' in cities such as London providing a market for expensive one-off pieces, together with the 'intellectual boost' provided by publications such as *The Craftsman* by Richard Sennet, Matthew Crawford's *The Case for Working With Your Hands*, and *The Hare With The Amber Eyes* by Edmund de Waal, alongside exhibitions such as *The Power of Making* at London's Victoria and Albert Museum (V&A) in 2011.

But not all crafts were created equal and, while all those things may all be true, the biggest pressure on creative people working in cities is space, and pottery is a particularly space-hungry pursuit. Be that as it may, the proximity to clients, culture and collaboration makes it worth the expense for many. It takes a special type of person with a great deal of humility and patience to deal with the unique challenges of working with clay. At every stage, there are a multitude of things that can go wrong – often remaining undetected until a pot explodes in the kiln, taking everything else with it. As Benedict Fludd says, 'failure with clay is more complete and more spectacular than with other forms of art.' Perhaps it just takes a very special type of person to work with clay in the city – urban potters might just have to add grit and determination to their humility and patience.

And that patience may be starting to pay off. Tanya Harrod argues that fired, glazed clay, long neglected by art critics and historians, is finally starting to get the recognition it deserves: 'In this brave new world, Grayson Perry's 2003 Turner Prize, bestowed upon a room full of pots, signifies a change of heart, an abandonment of the fustian hierarchies that have marginalised ceramics.' Although she does point out, quite rightly, that this attention all-too-often seems to be focused on male artists, rather then the usually female craftspeople who make their work, or indeed the studio potters who are the focus of this book.

The book comprises six chapters – London, Tokyo, Copenhagen, New York, Sydney and São Paulo – cities chosen for their vibrant ceramics scenes. For each one, I have written an introductory essay telling just one of the many stories of pottery in that city and then profiled some of the most exciting contemporary studio potters working in each city today. My hope in doing so is to tell a more inclusive story of clay, recognising the diversity of its craftsmen – and women.

Katie Treggiden

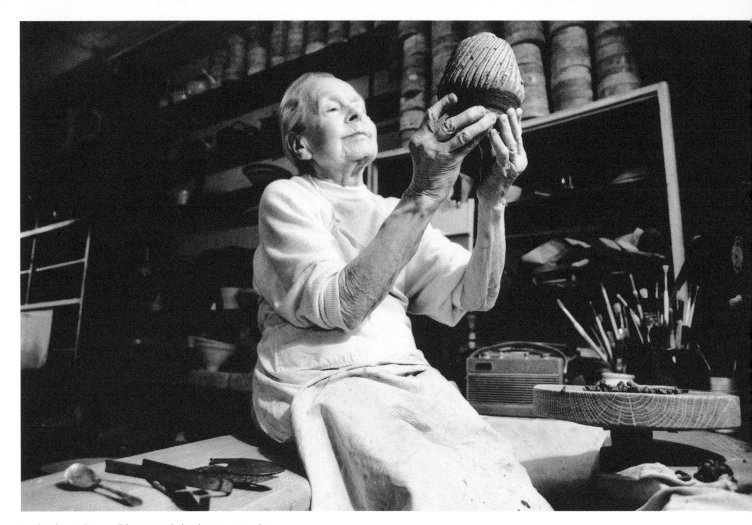

Lucie Rie potting at Albion Mews in her later years, 1980s

London

'There are limits to the amount of praise that can be heaped upon a coffee cup,' says craft historian Tanya Harrod in *The Real Thing*, 'But Lucie Rie's domestic wares are an unusually perfect marriage of form and function.' She is talking about one of Britain's most influential ceramicists, who lived and worked in London from 1936 until her death in 1995. But in the British capital, it's not just the pots that have to combine form and function, so too do the studios themselves – to survive in such a bustling metropolis, they must perfectly balance creativity with business acumen.

Ask anyone about the history of British pottery and they're likely to mention the Staffordshire Potteries or St Ives in Cornwall, where Bernard Leach set up shop in 1920. But London's ceramics heritage predates either, and at low tide, you can still find the remains of the potteries that lined the banks of the Thames in Roman times. It shouldn't come as a surprise – pottery is inextricably linked to urbanisation and London is one of the UK's oldest cities, having been established as 'Londinium,' by the Romans in around 43 AD.

Historically, London's ware was largely functional and innovations in technology, migrations of people and ideas, changing tastes, and inspiration and competition from overseas all played a part in the developing industry. From Dutchman Jacob Jansen's tin-glazed earthenware pottery established at London's Aldgate in 1571 to the 'soft-paste' porcelain works in Bow and Chelsea from 1740, London was the centre of industrial pottery. After the Second World War, Staffordshire-based Wedgwood and Allied English Potteries acquired smaller firms, effectively ending London's role in mass-produced ceramics.

However the increasingly industrialised nature of ceramics prompted an equal and opposite reaction in the revival of craft and led to the development of small studio potteries, both in London and beyond. An influx of émigrés fleeing the Nazis in Europe gave this new movement a boost – two of the most

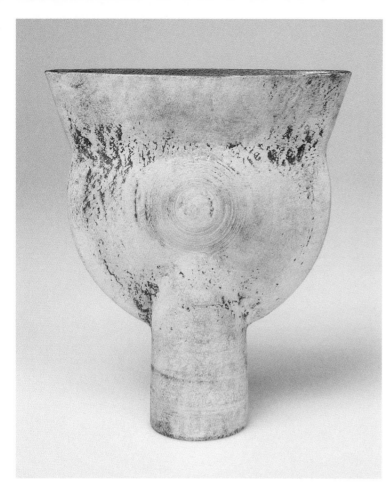

Vase by **Hans Coper**, 1960s

influential were Austrian Lucie Rie, who arrived in London in 1936 as a refugee, and German-born Hans Coper, who became her assistant in 1946 and eventually became a well-known potter in his own right. Even in the face of criticism from the leading lights of an increasingly fine art focused English ceramics community, both believed in the vessel form – and encouraged each other to remain true to their own ways of working. The pair sparked an intense interest in functional contemporary ceramics, and had a lasting effect on those who followed – there is scarcely a potter in this chapter, or indeed in London today, who doesn't cite their influence.

Before Rie arrived in London, she had trained at the prestigious Kunstgewerbeschule (School of Art and Design) in Vienna, and had made a name for herself, winning prizes for ceramics at several design fairs, including a gold medal at the Brussels International Exhibition of 1935. But she was unknown in Britain

and needed to be pragmatic about making an income. She established a business on the ground floor of her rented flat in London's Albion Mews custom-making ceramic buttons, jewellery, buckles and other fashion accessories for the couture market – items that were hard to find under wartime shortages. She often employed fellow refugees and when Coper came to her in 1946 looking for work and entertaining aspirations to become a sculptor, she took him on, despite his lack of experience. She too had ambitions beyond buttons – and wanted to return to making pots, the craft on which she had built her reputation in the 1920s. Buoyed by one another, the pair slowly began to make elegant stoneware and porcelain tableware under the name Lucie Rie Pottery, including tea and coffee services, cruet sets, vases and bowls, which were stocked by the likes of Heal's. Rie and Coper became partners in both design and manufacture, using two kick wheels and an electric kiln to make their distinctive angular, thin-walled wares, glazed in dark brown, white or both, and often featuring sgraffito – a linear decorative finish scratched into the surface. 'By the 1950s Coper and Rie were recognised as having evolved a ceramics style that looked urban and deceptively simple,' says Harrod. Their pared-down abstract geometric shapes reflected Modernist ideals and stood in stark contrast to Far-Eastern-inspired British studio pots championed by Bernard Leach, who wrote Rie's work off as 'feminine', saying it was too thin and would benefit from throwing rings revealing more of the making process. Muriel Rose of The Little Gallery said the feet of her vessels were 'weak' and William Honey of the Victoria and Albert Museum's ceramics department advised her not to use stoneware glazes on earthenware pots.

But after the war, perceptions started to shift. 'Rie provided a different axis for British studio potters from that of Leach,' explains Edmund de Waal in *20th Century Ceramics*:

Her centre of gravity was "metropolitan" as a critic at the time put it, she embodied interests in design and architecture, she lived in the city, used an electric kiln and was unbothered about

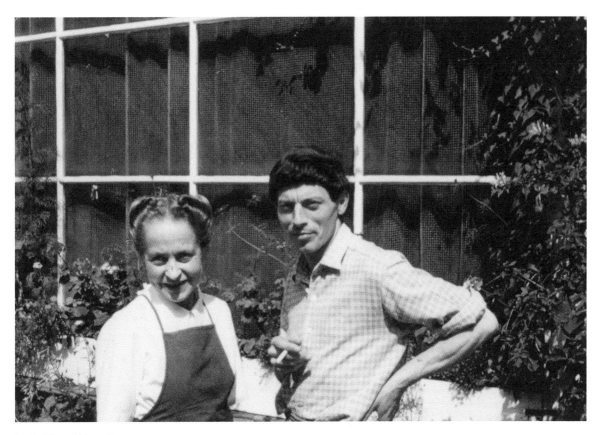

Lucie Rie and **Hans Coper**, 1950s

anxieties about 'truth to materials.' Her work, undemonstrative and focused, provided a bridge to pre-war European modernism. It had no aspirations to sculpture, it mediated its own place as a decorative art in the Viennese sense: it was neither cheap nor demotic but attracted collectors. In this way, Rie was a crucial model as ceramics became increasingly seen as part of the counter-culture movement.

Remaining in her Albion Mews studio until her death in 1995 and resolutely committed to the vessel form, despite increasingly making one-off pieces, Rie was a pioneer of urban studio pottery, and paved the way for the craftsmen and women featured in this chapter to follow.

Today, pottery plays a significant role in the wider craft resurgence happening in the capital and particularly in East London, where previously industrial buildings

are converted into shared workspaces and open studios. Just as pragmatic as Rie with her buttons, contemporary ceramicists are more likely to supplement their income by teaching, as open studios like Turning Earth and the Kiln Rooms fill the vacuum left by closing university courses. It's a model that not only enables potters to survive in London, but, due to more flexible and democratic access models, is also encouraging more city-dwellers than ever before to experiment with clay. You could say it's an unusually perfect marriage of form and function.

Florian Gadsby

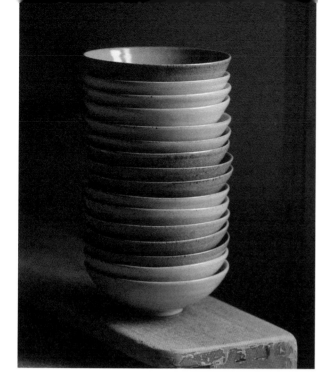

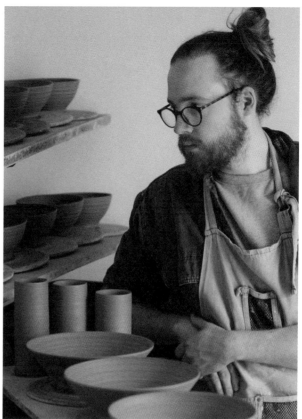

Florian Gadsby (b. 1992) can still remember the old brick bread oven outside the Rudolf Steiner school he attended as a boy. The school, where arts and crafts were considered as important as maths and English, had a clay deposit in the garden and pupils would dig up clay and create small figures to be fired alongside the bread.

After that early education, Gadsby trained as a potter on the Design and Craft Council of Ireland's ceramics course in Thomastown. 'The course was totally skill-based. They didn't even ask us about our aesthetic interests,' he says. 'They only cared about whether a piece was made to their standards. This meant we all got very good, very quickly.' After graduating, he spent two years as an apprentice for Lisa Hammond, whose studio, in an old railway ticket office in Greenwich, is the only one in London with soda kilns, enabling Gadsby to experiment with thickly thrown soda-fired ware for the first time.

His work is characterised by a soft, almost monochromatic palette dominated by gentle whites, blues, greens, greys and blacks. He cites the ceramics gallery at the Victoria and Albert Museum, the work of Lucie Rie and Hans Coper, Chinese pottery from the Song Dynasty and the almost infinite array of images available online among his inspirations. 'The presence of the online world has catapulted me somewhere I didn't even know existed,' he says. 'There are vast quantities of photographs and stories to be found involving ceramics. All I have to do is sift through the countless pages and innumerable enriching images will appear.' He's also aware of the impact of sharing his own world online. 'Knowing the effect I have on people by producing work, both physically and digitally, is humbling and encourages me to continue.'

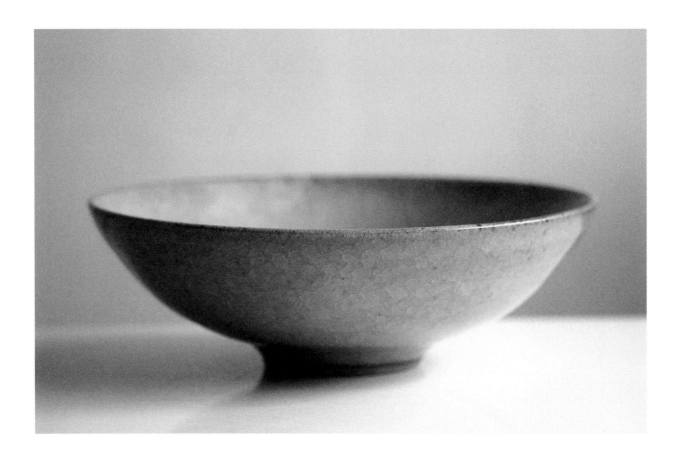

My work often has quite a complex surface so I try
to keep my colours simple so as not to distract from
the form beneath. The form is more important to me
than the glaze. Of course they must work together
but a poorly made pot will show beneath whichever
glaze you cover it with.

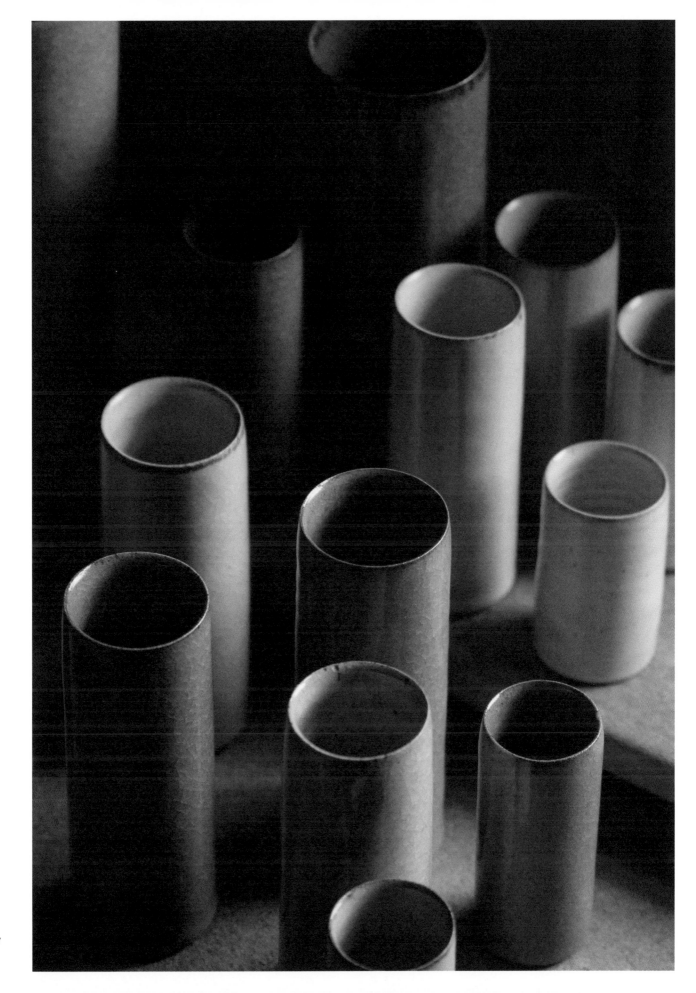

Nothing compares to that moment of pulling the clay up and shaping it. It's a fluid, skilful and highly unforgiving practice that takes decades to truly master. It places your mind into a state of pure concentration, even if you aren't directly thinking about what you're doing. Your hands do the work, muscle memory kicks in and your whole body has to be engaged.

Florian Gadsby

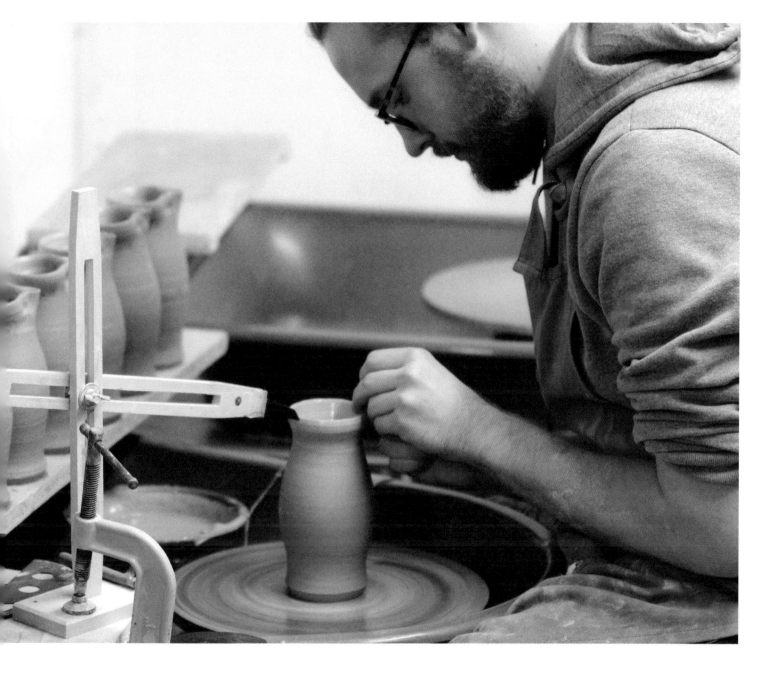

London

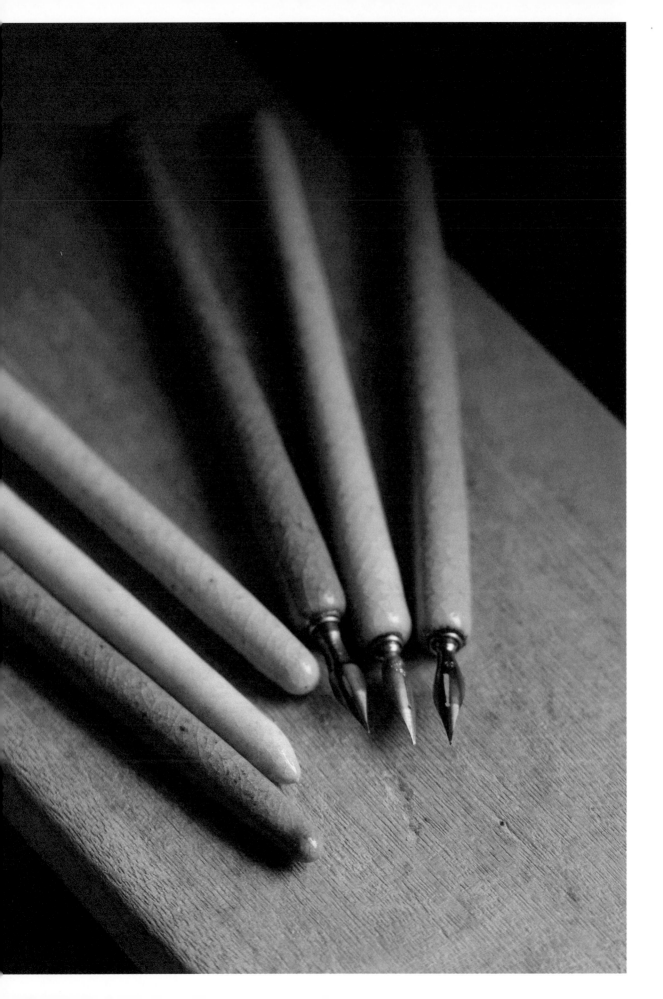

Functional ceramics will always be similar to others'
work. There have been thousands of years of pottery,
so finding your own unique voice in a sea of ceramics
can be excruciatingly difficult. The hand-thrown
ceramic dip pens I make are something a little out
of the ordinary. Using handsome and exquisitely
handmade objects to aid the creation of other
handmade objects is a beautiful idea.

Barry Stedman

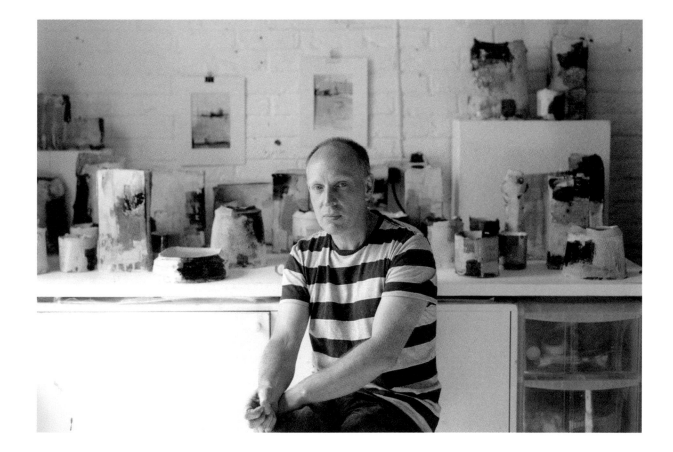

Barry Stedman (b. 1965) uses the red colour of iron-infused earthenware clay as a background, adding a white or cream slip as a base from which he builds up his colour palette, from light to dark, as if he were using oil paints or watercolours. He builds his vessels in slabs or on the wheel, and then alters, marks, scratches and rips them, using sticks or pieces of wood, while they are still moist. 'I take a raw, immediate approach to making that reflects the things I respond to around me,' he says. 'My work is about the environments that I find myself in; the structures, colours, sounds and atmosphere all contribute to what I make.'

Stedman does take inspiration from nature, but is also strongly influenced by the urban landscape he travels through every day. 'I travel across London by train several times every week and the passing views from the train window really inspire me,' he says. He takes photographs on his mobile phone and creates contact sheets of images he thinks might be a useful resource. 'The railway bridge at Blackfriars station that looks down on the River Thames in the early morning, with light reflecting on the water and bouncing around the glass panels, reflecting colours and shadows with details fading in and out. Strong silhouettes of the tall buildings and construction cranes. In South London the train runs up high, looking down over gardens and rooftops; brick walls covered in graffiti blurred as the train speeds past; compositions created in the rectangle of the windows cut through with striking verticals of scaffolding poles or railway masts.'

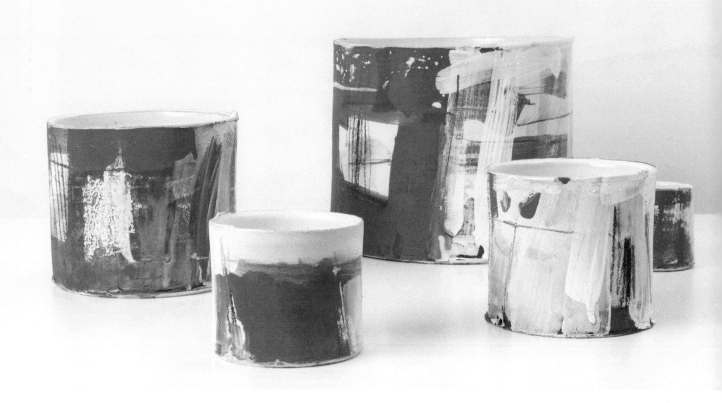

My work has moved on from an interest in traditional
English slipware, with its rich glazes and soft slips,
to a focus on abstract painting using bright
and vibrant colour.

Barry Stedman

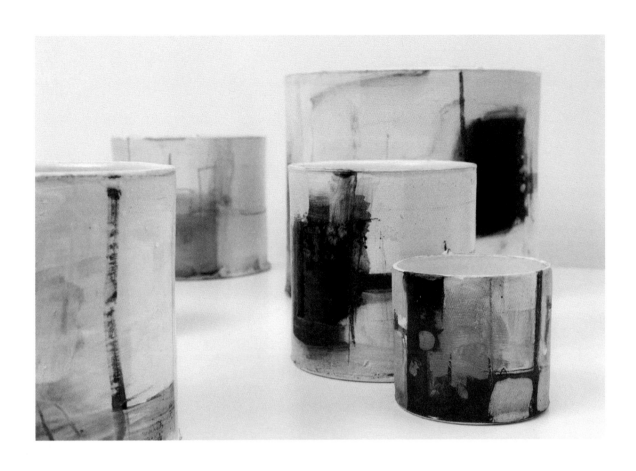

London

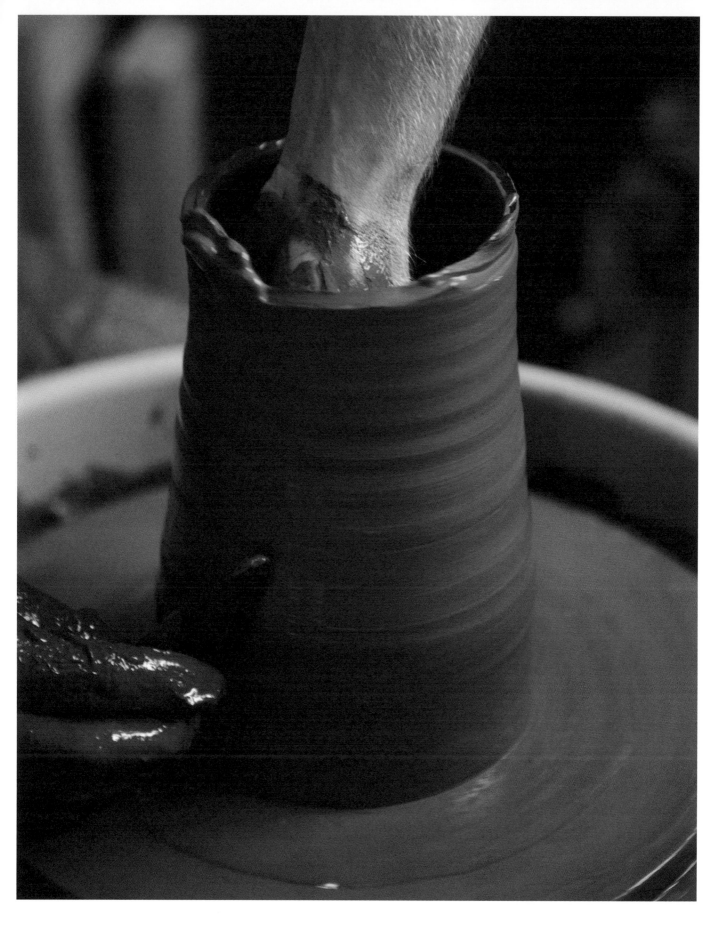

Barry Stedman

As someone working with a material such as clay, that is so responsive to the touch, I feel I will always be inspired by individual handmade things: the subtleties of rims and edges; the meeting points between surfaces and textures; and the sheer physicality of materials put together by hand.

I enjoy lots of aspects of ceramics, using soft clay to throw on the wheel or make slabs, but I also love mark making and working in layers on a surface, firing and reworking to build texture and depth of colour and tone.

Barry Stedman

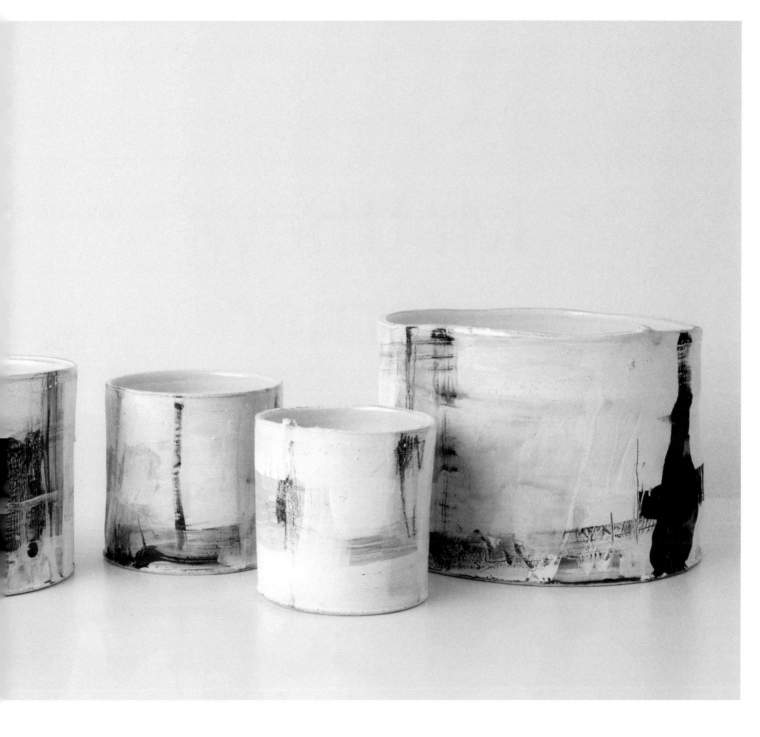

London

Matthew Warner

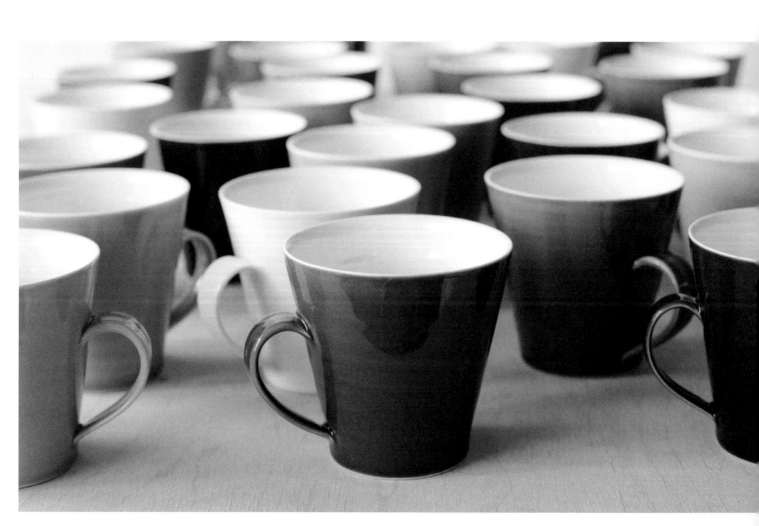

Matthew Warner (b. 1989) makes functional tableware using a combination of porcelain and stoneware clays coated in white or transparent coloured glazes. Despite the appearance of perfection, no two pieces are the same. 'When the pieces are used, the variations become apparent and each carefully considered detail reveals itself,' Warner explains. Every piece is thrown on the wheel. 'Throwing is a means to an end that I don't have any romantic associations with. I enjoy the freedom and spontaneity one has when working on the wheel, but it is simply a tool I use to make my work. I am much more interested in the end result than I am in the process of making.'

After graduating with a ceramics degree from Camberwell College of Art (Warner was one of the last students before the course closed), he became apprenticed to renowned potter and writer Julian Stair. 'My apprenticeship with Julian Stair helped me develop my understanding of my goals and interests as a potter,' he says. 'Working with Julian showed me that making pots isn't just a way to manufacture a

product – it can be a way to address ideas and concepts relevant to contemporary practice.' When the three-year apprenticeship came to an end in January 2016, Warner opened his own studio in South London.

Today, he is driven by his fascination with pots and their social connotations, 'in particular how they have been used to promote ideas of empire, power and moral enlightenment,' he explains. 'Pots fascinate me because they are relics or signs of social behaviour and cultural history. Pots and pottery, in one form or another, are everyday objects that span social divides. Pottery is approachable and democratic; it is familiar to everyone and does not require expert knowledge to interpret.'

Opening the kiln and seeing the final result is the best part of pottery. That moment of reflection, and debating in your own mind if your idea was as good as you hoped, or if you've got to have another attempt. I'm not overly romantic about the making process. I do enjoy it, but at times it can be very stressful.

Matthew Warner

The forms I use are archetypal: simplicity
and clarity of form have been my goals
and I think I have achieved that.

Matthew Warner

London

Matthew Warner

London

Nicola Tassie

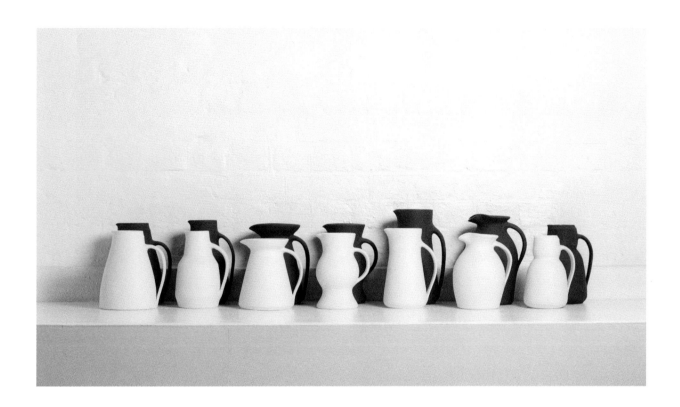

Nicola Tassie (b. 1960, Bangladesh) set up in a derelict building in East London's Shoreditch in 1986 when rents in the area were still affordable. She lived and painted upstairs and established a pottery studio in the basement, splitting her time between painting, pottery and a part-time job. The 1980s trend for art collectors to visit East London's studios drove interest in Tassie's work. 'We put on exhibitions in the studios and I started to sell – ceramics more than the paintings – which meant I could spend more time potting. With painting there was always the dilemma of content, but that was not a problem in pottery – it is heavy on process, and meaning is integrated in function and form. It's taken a long time, but I am now fully dedicated to the material.'

Tassie makes functional ware such as jugs, plates, cups, bowls in small batches, but the domestic object is also the starting point for more sculptural and artistic work, which often comprises still-life compositions and installations. She still relates to her former role as a fine artist and investigates the relationship between painting and ceramics: 'I don't find ceramics so far removed from the physical experience of painting and drawing – wet clay, slips, mark making, gesture, inlay lines, surface,' she says. 'In my early ceramics work, I was drawing and painting the surface with figurative imagery as a way of extending my life-drawing practice.' She has recently started a project exploring the jug form through cultures and time: Five Jugs after Vermeer refers to Vermeer's painting *The Milk Maid* and Seven Whites (see illustration above) is a homage to Morandi's iconic enamel jug, as seen in his etchings and still life paintings – in this way, Tassie returns to her favourite painters again and again for inspiration.

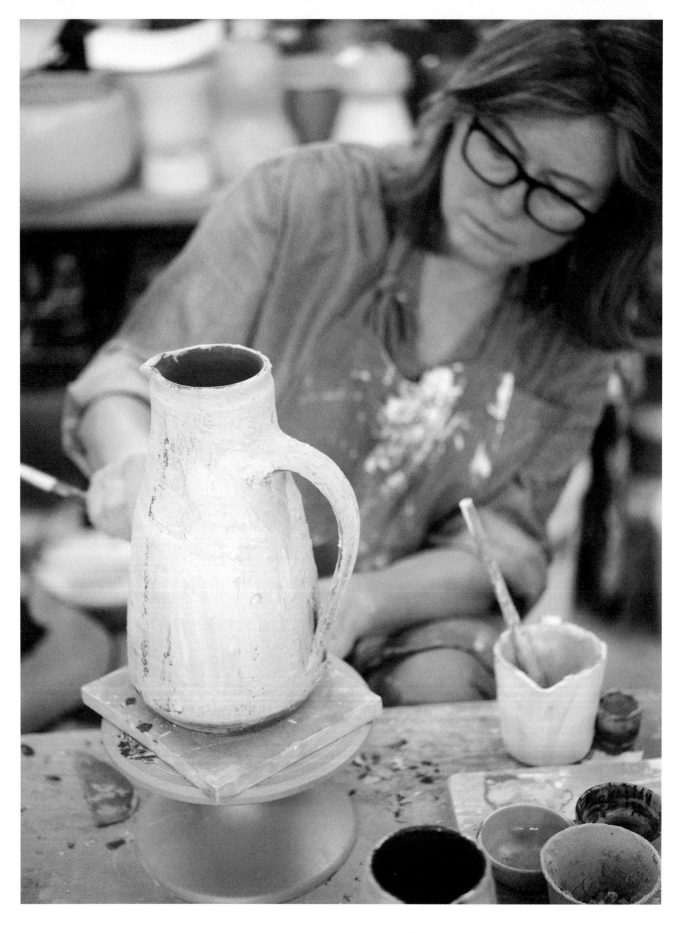

Nicola Tassie

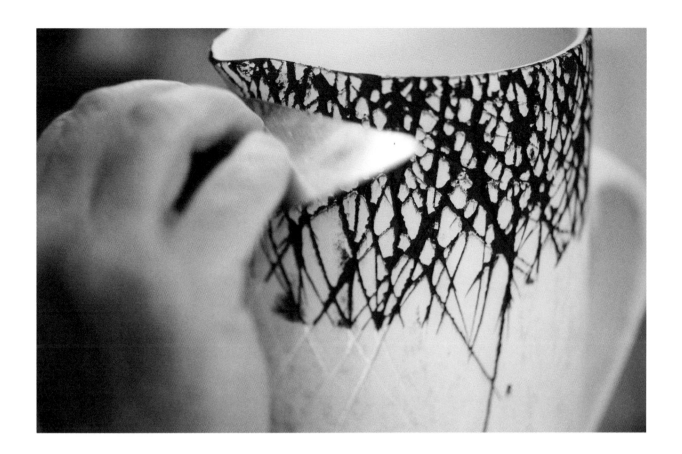

I began by working with slip-painted earthenware, then explored on-glaze lustres, combining sturdy jugs and bowls with excessive amounts of lustre to comment on the hierarchy of ceramic domestic ware. I now work in stoneware and porcelain – the decoration has evolved into mark making and become more minimal.

London

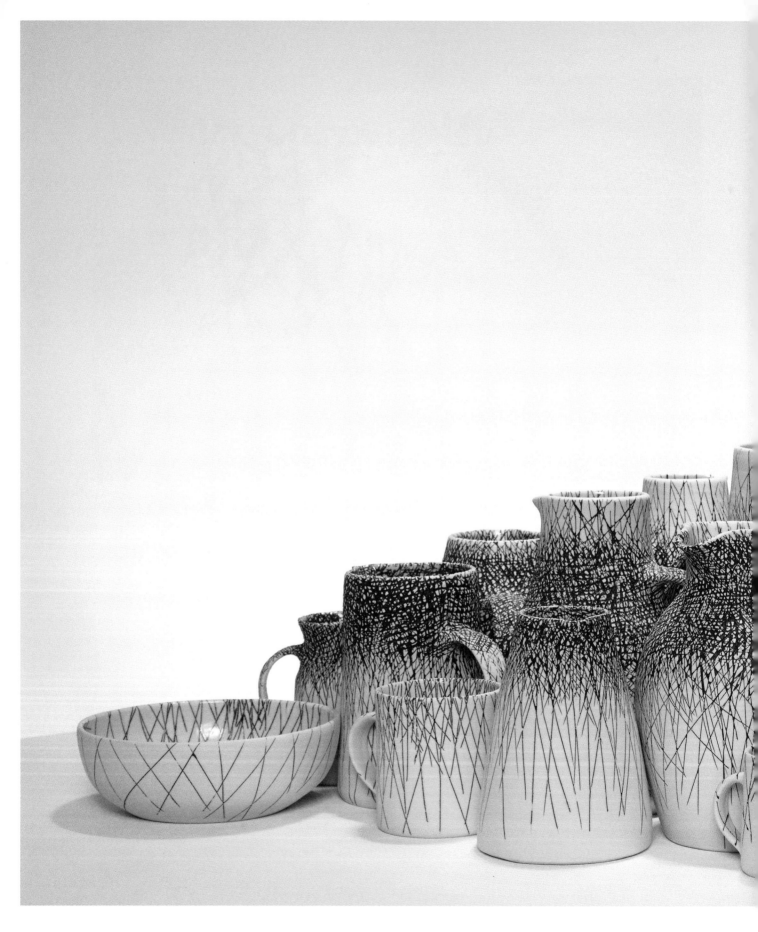

Nicola Tassie

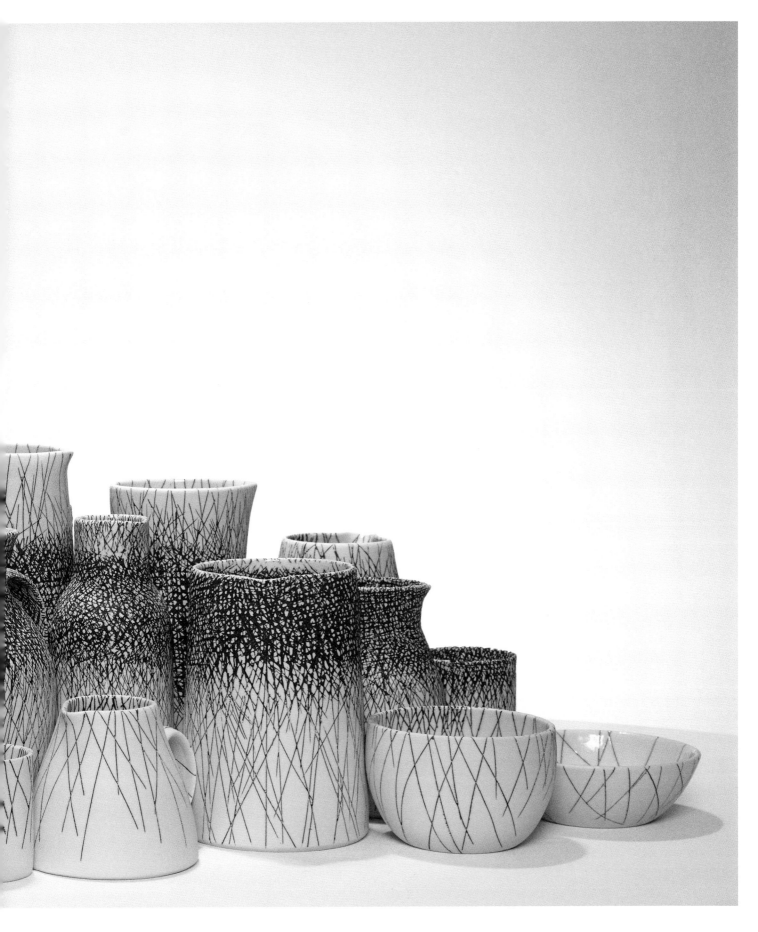

London

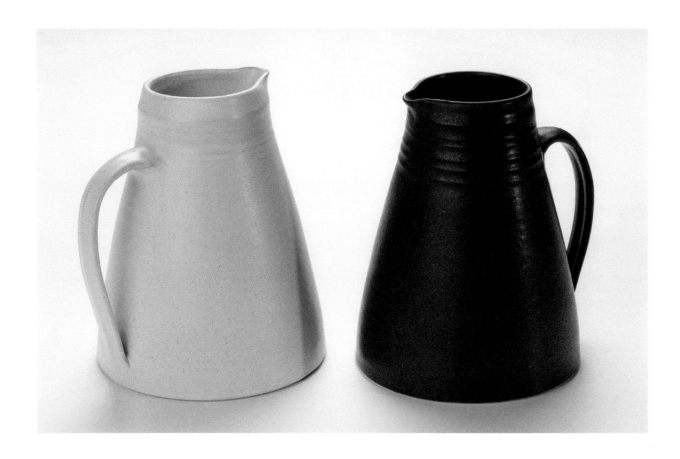

I make by hand because it's difficult to find the
shapes and textures I like in mass-produced ware, so
hand-making is a necessity. I do it because
I want the finished object it enables. However,
I do feel very fortunate to be able to work at 'making'
everyday. Making ceramics is a slow process – it
takes a long time to make something – and that
generates a particular affinity with the object
and an opportunity to examine our relationship
with the material world.

Nicola Tassie

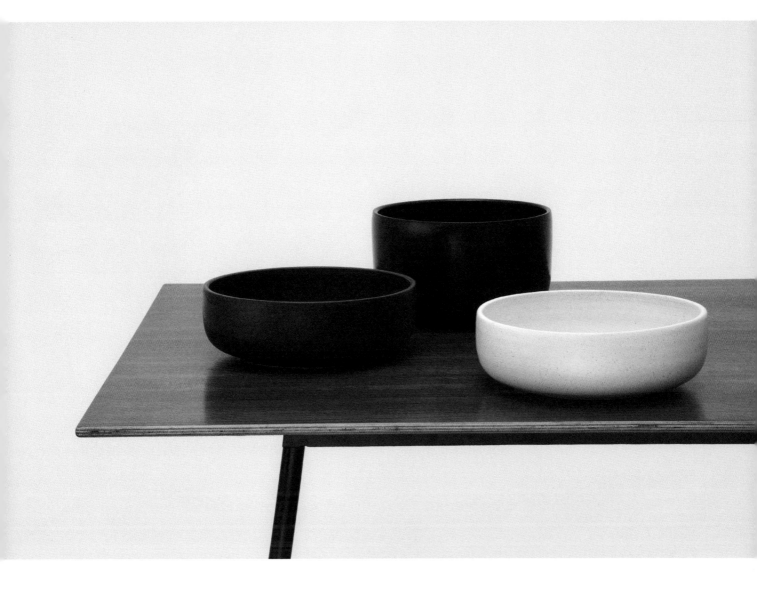

London

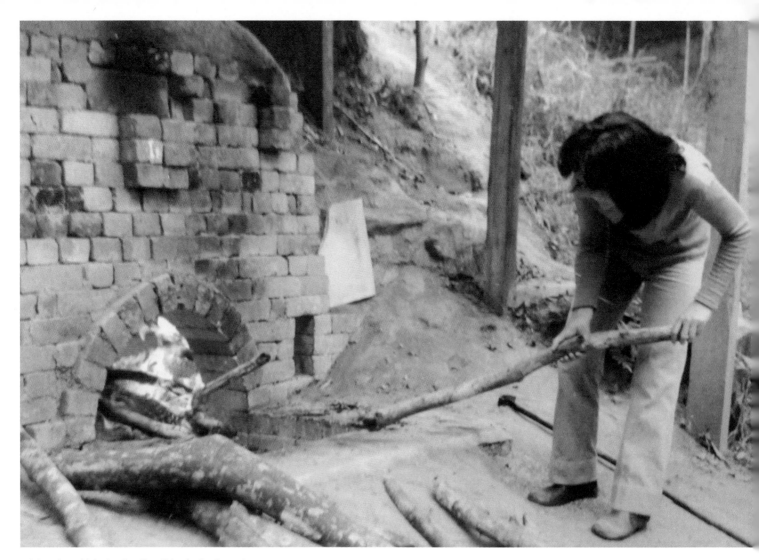

Mieko Ukeseki during her first firing in Cunha, 1983

São Paulo

São Paulo may not have a long history of ceramics, but its inhabitants do. Described by resident potter Sofia Oliveira as 'a city full of immigrants,' the city is home to most of the 1.6million people of Japanese descent who live in Brazil – the largest such population outside Japan. Each incoming community has added another layer to the vibrant palimpsest of culture that is São Paulo, but none has contributed more to the ceramics of the city than the Nikkei Burajiru-jin community – Brazilians of Japanese descent. And Brazil contributed just as much in return – it is as a result of this cultural fusion, especially the freedom that Brazil afforded Japanese women, that a unique approach to ceramics has developed in São Paulo.

The first Japanese migrants – 593 men, 188 women and eight children under 12 – arrived in São Paulo on a boat called the Kasato Maru in 1908, fleeing rural poverty brought about by the collapse of feudalism and adoption of Western systems, new land taxes and plummeting rice prices at the beginning of the Meiji period. The United States and Australia limited

or banned non-white immigration, but an agreement between the Brazilian and Japanese governments enabled farmers to come to São Paulo's coffee plantations. The abolition of slavery in 1888 and the fast-growing coffee trade – at one point the interior of São Paulo supplied half the world's coffee – led to an insatiable demand for labour. As a result 190,000 Japanese men, women and children came to Brazil between 1908 and 1940, on the promise of free accommodation, a pleasant climate, a rice-based diet, and, crucially, salaries of up to 10 times those in Japan. Most had intended to make their fortune and return home 'clad in brocade' as the saying of the time went, but when reality hit, their hopes became attached to life in Brazil. In common with many expatriate communities, food with its (often ceramic) accoutrements and traditional crafts including pottery were two of the ways they kept their culture alive, albeit in small numbers and increasingly expressed through the prism of their new diasporic identity. 'They hoped to maintain among themselves the best of Japanese traditions, language and customs, but they were also

interested in Brazil, its society, economy and culture,' says Stewart Lone in his book *The Japanese Community in Brazil, 1908–1940 – Between Samurai and Carnival.* São Paulo's policy of family recruitment in preference to single male workers, enabled women to play a significant role in establishing civil, cultural and social connections and Brazil was certainly a more welcoming host country than the United States or Peru, where many Japanese émigrés experienced racism and violence. The population of São Paulo city soared from 65,000 to 1.07 million between 1890 and 1934. 'Urban São Paulo moved from its earlier character of a two-tier society of white merchants and black slaves to a multi-coloured, multi-cultural metropolis,' explains Stewart Lone. As Japan became a powerful world economy and Japanese Brazilians started to achieve cultural, academic and economic status, they became respected as contributors to Brazil's success.

After the Second World War, immigration was no longer restricted to coffee plantation labour. Skilled artisans came to work in Brazil's recently founded porcelain factories, alongside independent artists seeking freedom of expression outside the confines of Japanese tradition and culture. The first generation of Japanese Brazilians also started to have children, who were free from what Lone calls the 'iron cage of nationalism.' Not bound by traditional identities, they valued 'moving and evolving, learning and adapting'. By the 1950s, São Paulo's multicultural creative community was thriving and, alongside the cultural exchange happening in music, dance, baseball and martial arts, important art exhibitions started to include work by Japanese artists and ceramicists.

In the 1960s and 1970s, a wave of creative people left Japan to establish practices in São Paulo. Anthropologist Harumi Befu explains that instead of being driven out of Japan by poverty, they were motivated by discrimination, especially the women; by the confines of Japan's 'rigid societal norms'; and by an adventurous spirit informed by global counterculture movements that encouraged alternative experiences. The first reason touches on an important point – one explored by Liliana Granja Pereira de Morais

in her essay 'Two Japanese Women Ceramists in Brazil: Identity, Culture and Representation' – almost half of the expatriate population was female, and this had particular importance in the development of ceramics.

The first ceramic objects in Japan, known as Jōmonware, were made by hand, usually by women. Pottery production was a part-time activity that slotted in between women's other domestic chores due to its sporadic nature – pots need time to harden between processes. Women worked in this way for 10s of thousands of years until the introduction of the potter's wheel in the Kofun period (300–593 AD), when ceramic production came to be seen as a skilled, and therefore male, activity. Apprenticeships passed from father to son, and women became excluded. This change was by no means limited to Japan, but a society that cast women in the traditional role of ryōsai kenbo ('good wife, wise mother') resulted in fewer female artists than in Western Europe well into the 20th century. Despite the emergence of the avant-garde movement after the Second World War, which ushered in new and experimental approaches to ceramics in opposition to patriarchal traditions – opening the door for female participation – many women left Japan in search of more artistic freedom. Brazil's blurred boundaries between art and craft and between functional and non-functional 'objet d'art' promised a refreshing change.

The influx of female Japanese ceramicists to Brazil in the 1960s and 1970s led to pottery and sculpture becoming a key part of São Paulo's flourishing contemporary art scene. Showcases such as the Kōgei Art Exhibition, curated by the Brazilian Society of Japanese Culture, contributed to the success of Japanese ceramicists already in Brazil and gave newly arrived artists an opportunity to show their work where both ceramic art and art by women was celebrated. This growing community contributed to an increasingly distinct Japanese-Brazilian identity.

The women brought with them Japanese techniques, still common in Brazil today, such as the use of local clay, traditional Japanese wheels, natural materials

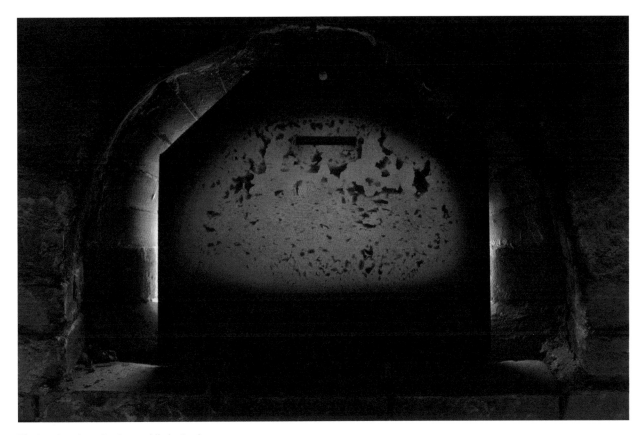

The interior of a **noborigama kiln** in Cunha

in ash glazes and high temperature wood-firing kilns such as the noborigama or 'climbing dragon,' which is built up a hillside to take advantage of the rising hot air. Despite the urbanisation and industrialisation of its eponymous city, São Paulo state was still sparsely populated and many took advantage of the space and proximity to nature. In 1975, a group of Portuguese and Japanese potters and painters, including influential female potter Mieko Ukeseki, turned a former slaughterhouse in the small town of Cunha into a collective studio for ceramic artists. The project grew and eventually 20 studios and seven 'climbing dragon' kilns were established, more than anywhere else in South America.

Today, potters in the increasingly vertical São Paulo city use electric kilns to reach the high temperatures once only obtainable in a noborigama kiln and come from all over the world, but like the female Japanese pioneers who went before them, in Brazil they find the freedom to create. 'Brazil seems to appear ... as a kind of empty space, a magic mirror that allows them to infinitely recreate their own culture and identity,' says Morais, and that's as true for today's ceramicists as it was for the early Nikkei Burajiru-jin.

Fernanda
Giaccio

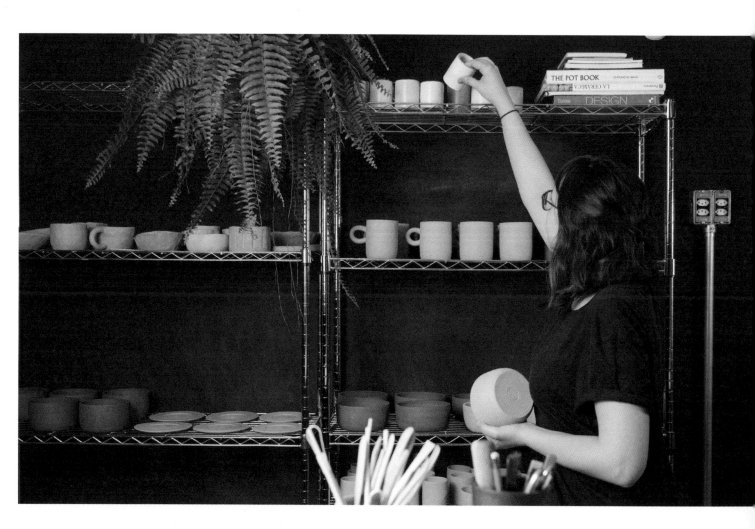

Industrial designer Fernanda Giaccio (b. 1988) is the founder of ceramics studio Noni. Ceramics was one of the industrial processes covered on her course. 'I learned that you can mould-cast all by yourself. You can be a tiny industry – how great is that?' But as impressed as she was by the approachability of the medium, she felt that it lacked professionalism and was too artistic. She established Noni out of a desire to approach ceramics not as an artist or a craftsperson, but as a product designer, developing a range of works with a strong visual identity. 'The pieces I make are part of a graphic diagram,' she says. 'I'm talking about the proportion and the shape of a handle on a cup, which will be combined with a glaze, which will complement a bowl of another colour, which will make sense only if combined with another particular vase. It's all in the shape. Every piece complements another.'

The demanding city of São Paulo and big orders from clients obliged Giaccio to grow and professionalise quickly. As a product designer, she understands that industry creates accessible objects for a broad audience, but she's proud to be part of a different generation, one that wants to build something honest and meaningful: 'Our generation is working with the leftovers from the past century of industry and organically breaking the cycle of an economy based on illusion,' she says. 'All my friends are running away from corporations and agencies. We are trying to discover our talents in order to be independent. In many artistic spheres you can see new things going on and ceramics is just one of these.'

São Paulo

Noni is about creating, developing and making.
The craftsman and the designer are the same person.
We are part of a new generation that wants to do
something meaningful, true and honest.

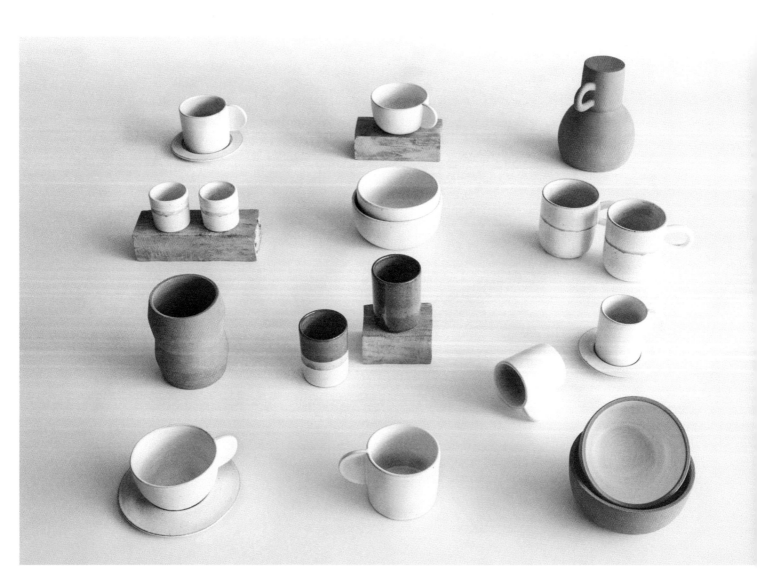

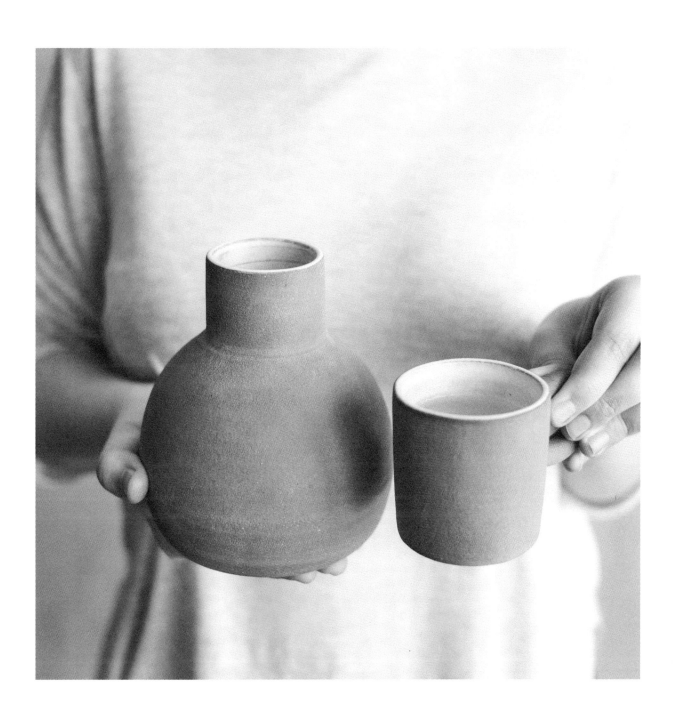

São Paulo

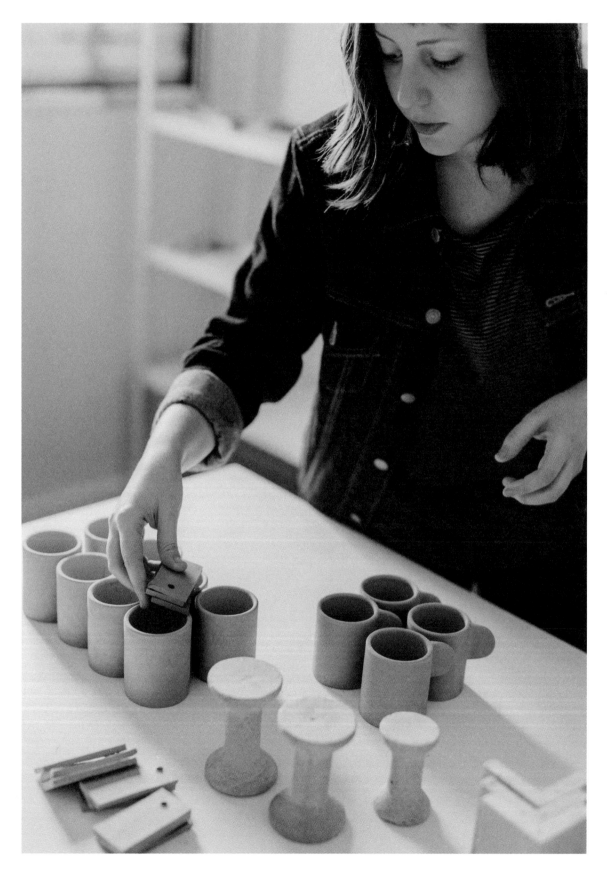

Fernanda Giaccio

In São Paulo, creative people know that they are throwing away their talents on exhausting nonsense jobs. They say that the culture here is "not to be bold, but to be sold".

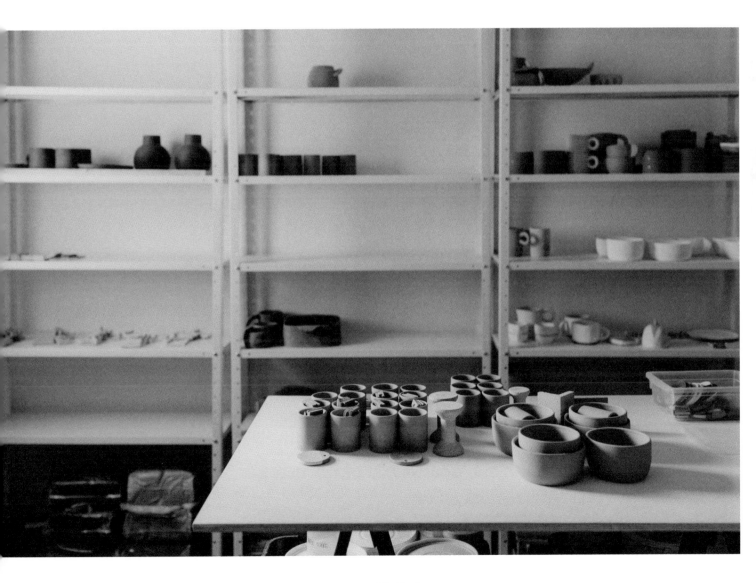

São Paulo

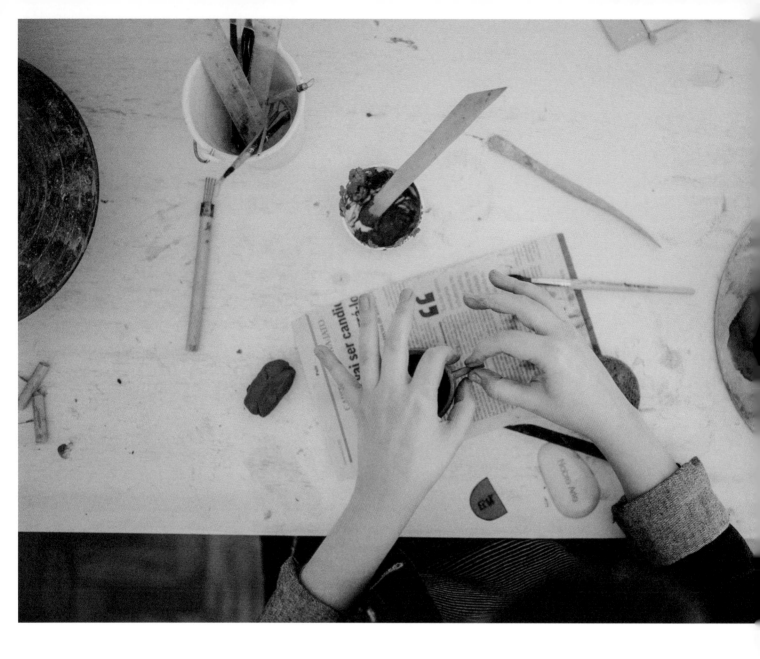

I love drawing and thinking about new pieces and
collections as much as I like to finish pieces, attach
the handles and smooth the surface with a sponge
so that it looks perfect, and finally I breath with relief
when I open the kiln and find everything as expected.

Fernanda Giaccio

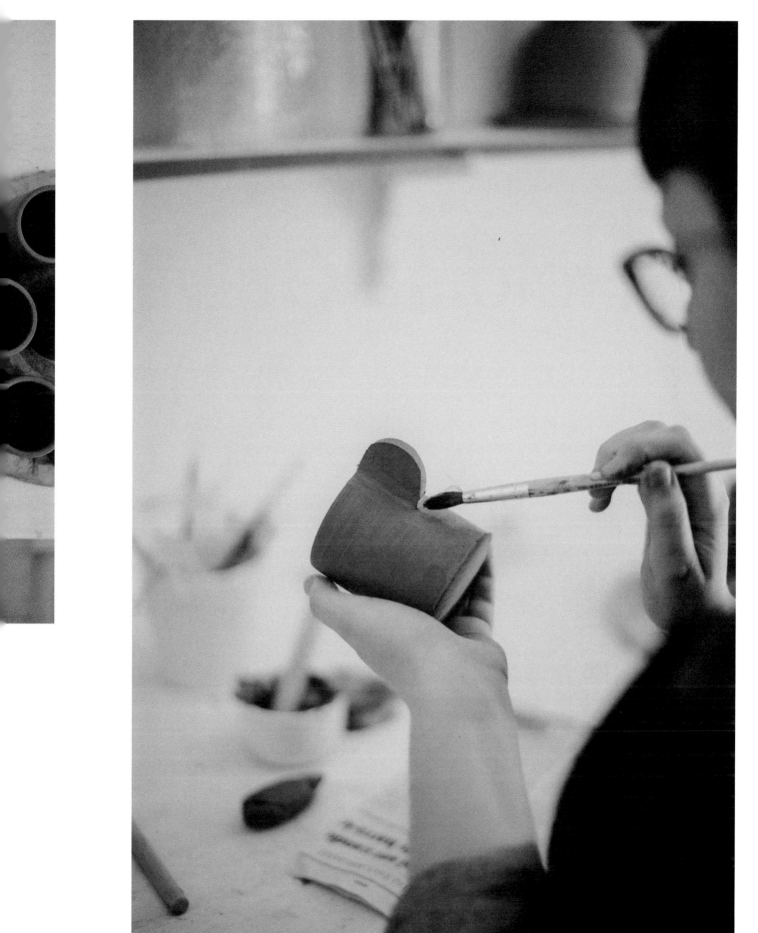

Heloisa Galvão

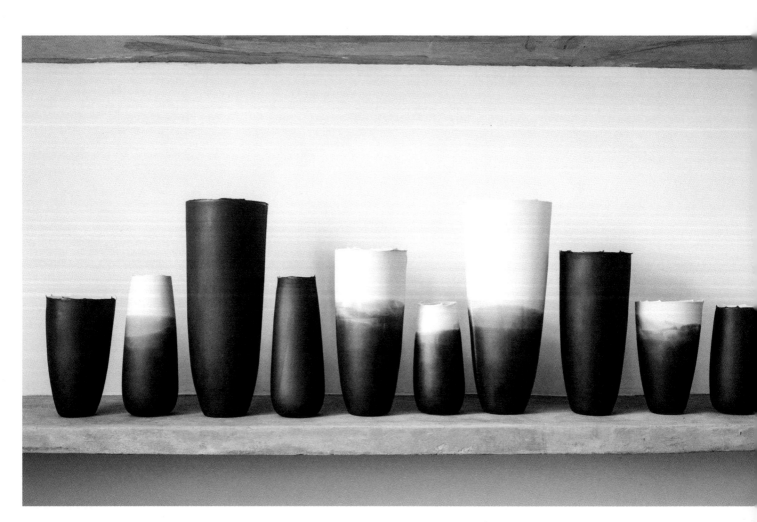

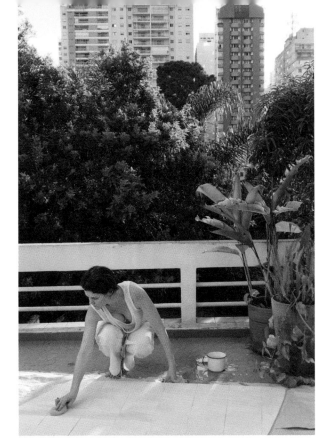

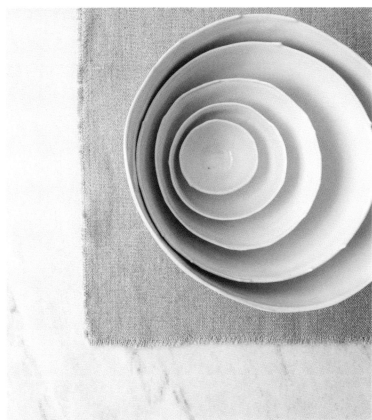

Heloisa Galvão (b. 1975) grew up on a small farm in the state of Espírito Santo, climbing trees, eating freshly picked fruit and digging clay from local ravines to make small sculptures. It's hardly surprising that her creative inspiration comes from nature: 'Even living in a great metropolis like São Paulo it is possible to be inspired by nature,' she says. 'The passing clouds, the small plants that grow on concrete walls, the shadows of trees projected onto sidewalks – nature is everywhere and it is very strong.'

Galvão learned the technique of transposing photography onto clay at university while investigating historical processes such as albumin and cyanotype, and applying them to different types of paper and fabric. The results were poor, and longing to get her hands dirty and find a truly malleable material, she decided to apply the same techniques to clay, and made a breakthrough.

She started working with porcelain in 2005, pushing the boundaries of its translucence. She developed extremely fine and light 'paper clay' objects, wanting to 'communicate the possibility of transforming a dense material into a light material, which could then occupy another place in space.' Her work with moulds began in 2011 when she was looking for a way to create clean, simple porcelain forms to act as a blank canvas for her photographic impressions. Instead, she discovered something quite different: 'When I made the first plaster cast, I filled it with porcelain and turned it upside down,' she says. 'The drops that formed in that process were so revealing that they became one of the main characteristics of my work. This fluidity is what interests me today.'

São Paulo

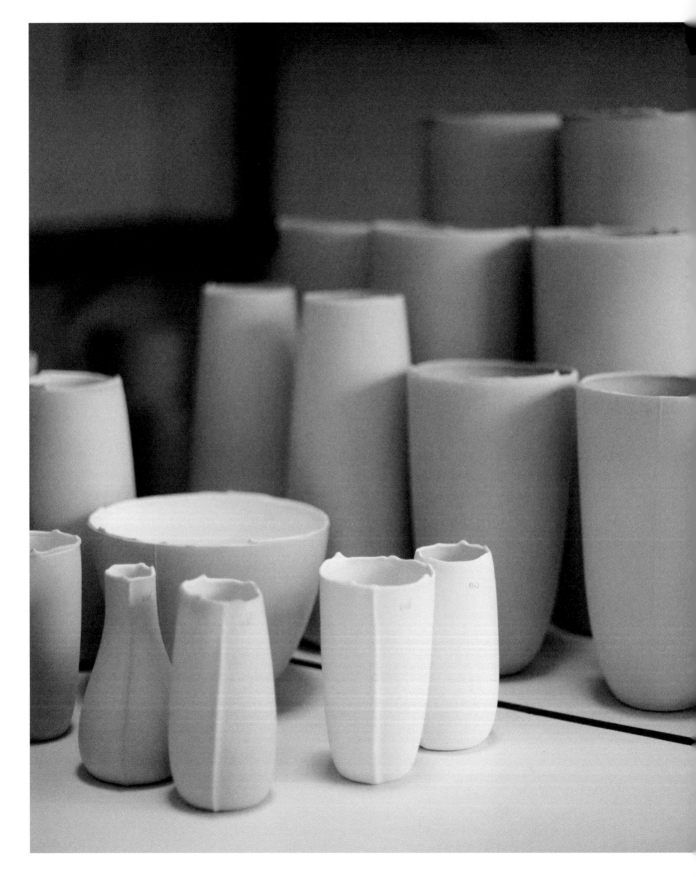

Heloisa Galvão

I work with clay – an inherently dense, heavy and strong material – seeking its limits, to achieve lightness and, almost, immateriality.

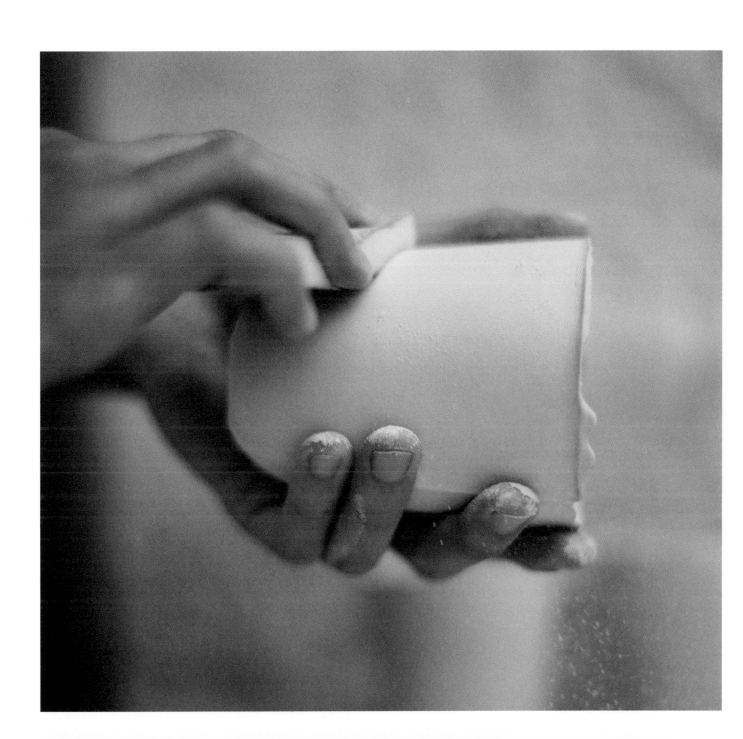

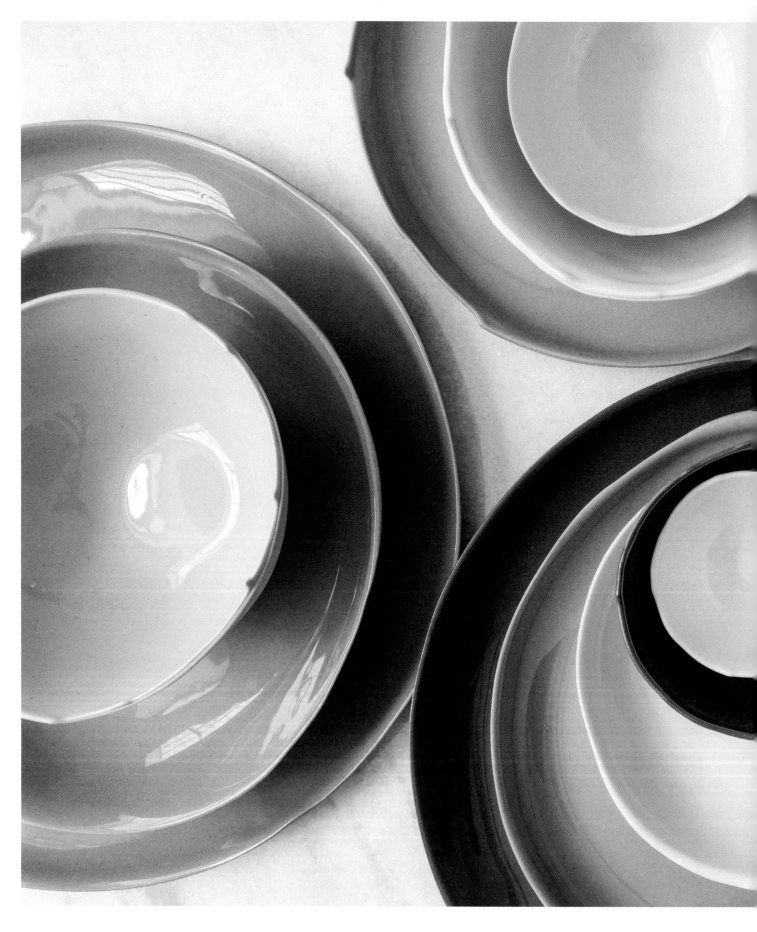

Heloisa Galvão

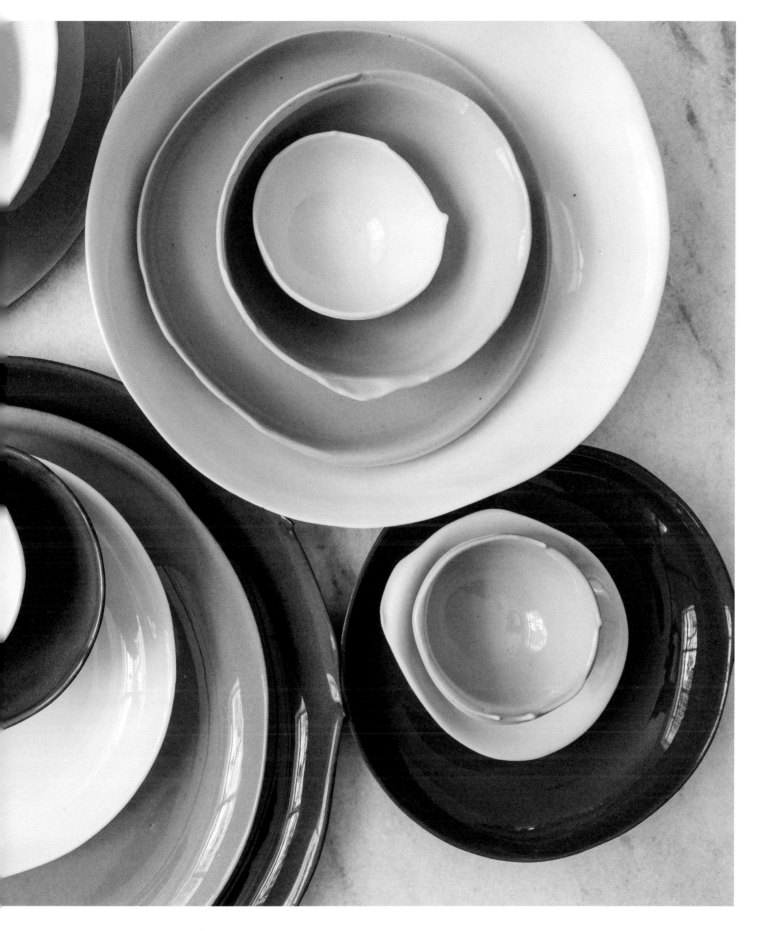

São Paulo

I develop colours in my studio, pigmenting directly into the liquid porcelain clay. I like to work by interfering with the pieces with different densities of underglaze, sometimes adding more watercolour and sometimes using a thicker consistency for serigraphs.

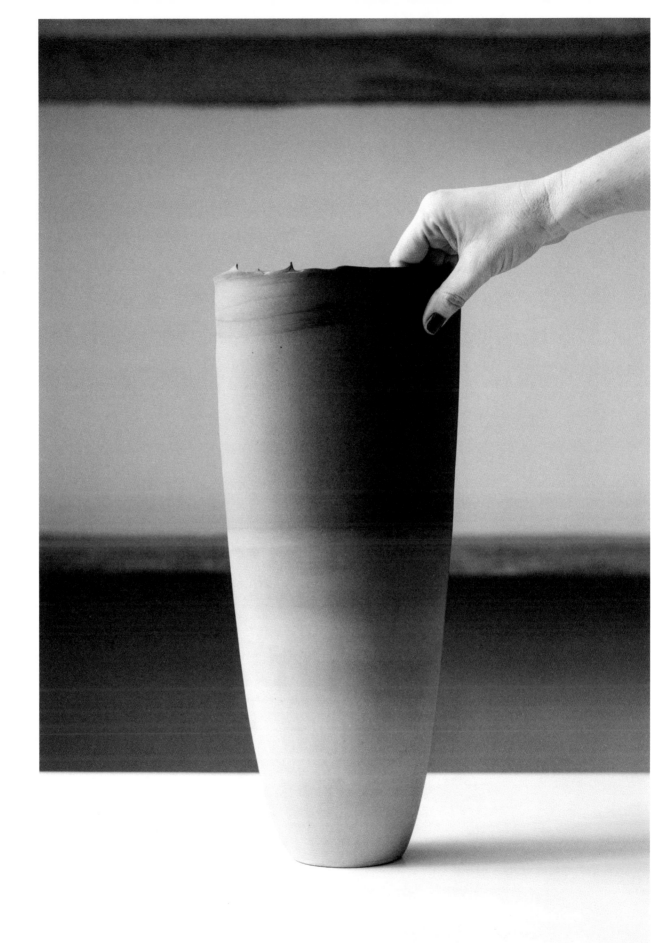

Sofia Oliveira

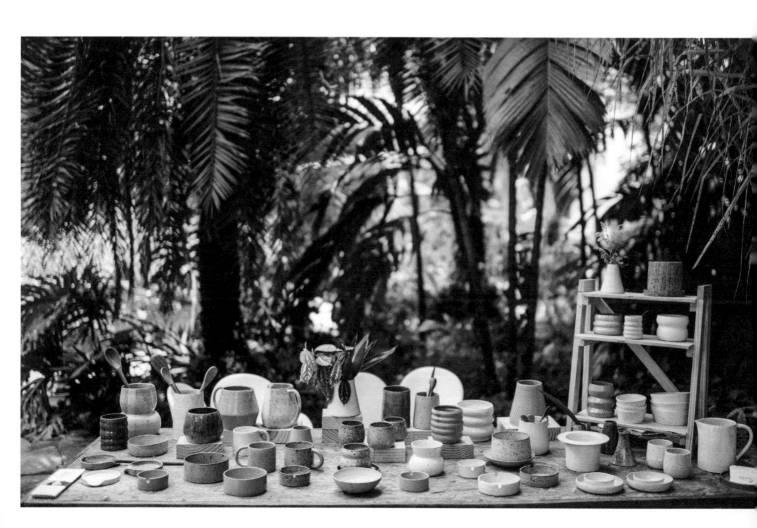

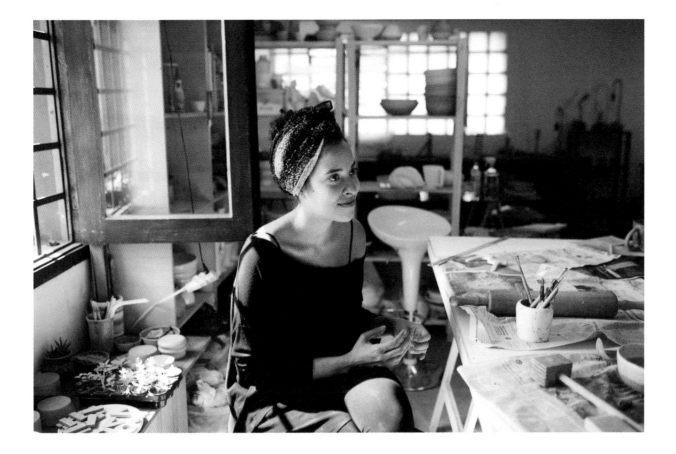

Sofia Oliveira (b. 1988) is part of a generation of young and creative people in São Paulo, and the world over, who are leaving corporate jobs in order to find contentment and meaning as artists and makers. Oliveira started her professional career in advertising but, feeling unfulfilled, left in order to find her true calling. Inspired by New York's Helen Levi (pp. 82–91), another second-career potter, she began by taking classes with renowned ceramicist Sara Carone. 'My time there was very important,' she says. 'Sara helps her students find their own style, rather than passing her aesthetic on – which happens a lot. It was more like a laboratory of experiments.'

After working with Carone, she trained in Paris: first at the École de Tournage Augusto Tozzola, then at ATC – Arts et Techniques Céramiques. 'In France, with Monsieur Tozzola, I learned the technique in depth,' she says. 'The schedule was heavier – we worked from 9am to 5pm every day. It really was an immersion in the study.'

Returning to Brazil in 2015, Oliveira started making her own functional ware under the name Olive Ceramics. Since then, she has seen the maker movement in her city grow exponentially and, in response, she created an online group for young potters, a place where they could exchange ideas and advice. 'We substituted competition for cooperation, and the group is growing like crazy,' she says. 'This is just a part of it, but I can definitely see people from other cities starting to get interested; the movement is growing and more and more people are quitting their other jobs to become professional potters.'

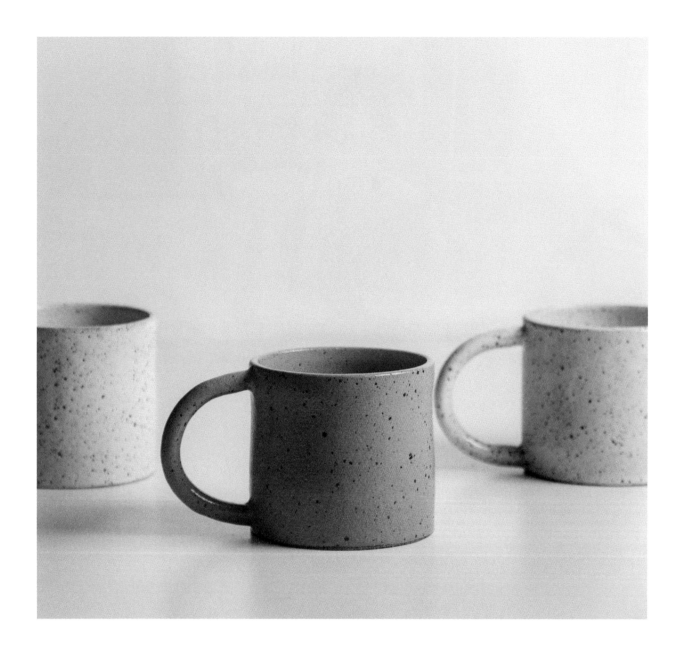

Since I started working in ceramics, everything
inspires me: the colour of a tree, the shape
of a building. I see the world differently now
and things I just didn't notice before are
suddenly an inspiration to me.

Sofia Oliveira

São Paulo

Sofia Oliveira

São Paulo

Yara Fukimoto

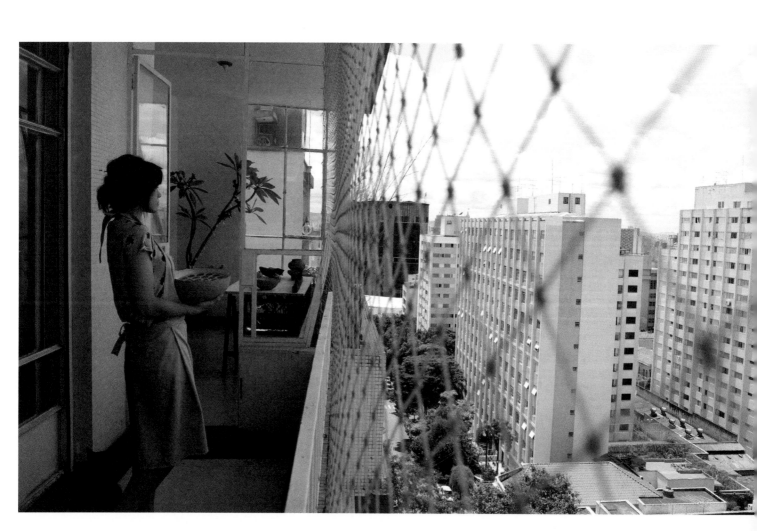

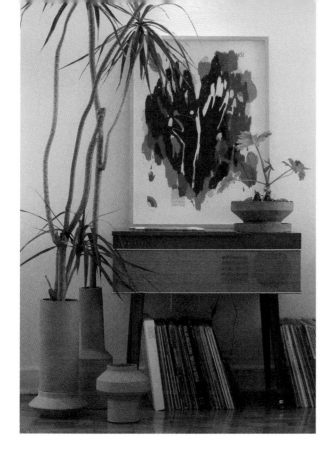

Yara Fukimoto (b. 1983) draws her inspiration from anything she finds on the beaches outside São Paulo or in what fragments of nature the frenetic city has to offer. Her work combines organic forms – shells, rocks, plants – with contemporary geometric shapes. 'I've realised that lightness touches me, especially when it's combined with strength: when strength is expressed through lightness,' she explains. She works only with local clays: a black clay and a white one, and barely uses glazes – when she does, it's only on the inside of her pieces as she wants to maintain the raw and natural look of the clay.

She studied industrial design at Mackenzie Presbyterian University. 'I grew up in a peripheral neighbourhood of São Paulo, where the streets and houses are built without much planning or aesthetic concern,' she says. 'Everything I miss around me, I try to find inside me and, somehow, I have found I can do that through creation. Perhaps that is why I decided to study design.' Ceramics was Fukimoto's favourite class, but it had a very industrial focus, with

an emphasis on slipcasting and moulds, so after graduation, she attended a masterclass by Kimi Nii, a renowned Japanese ceramicist based in São Paulo. 'That was when I truly fell in love with the medium and now I can say that Kimi is my eternal teacher and mentor.'

Fukimoto opened her own studio MY.S in 2007 with two friends working in diverse design disciplines. Fukimoto works from home, but in a city where tower blocks define the skyline, she finishes and fires her work in a ground level space outside the apartment blocks.

São Paulo

I travelled to a beach in Alagoas, northeast of Brazil. There was so much natural richness that it seemed like I was in a dream. My head was burning, thinking about all the possibilities I could create with clay. When an idea comes to my mind, I need to make it real.

Yara Fukimoto

São Paulo

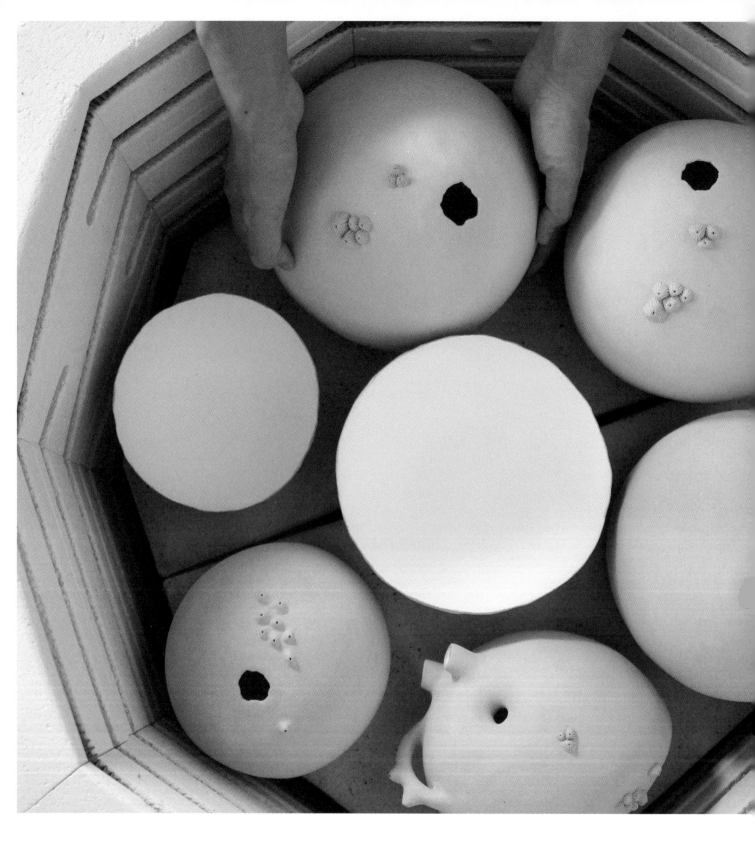

Yara Fukimoto

I like to challenge the limits of the clay, shaping very thin and delicate threads. They often end up breaking, but I still insist on making them.

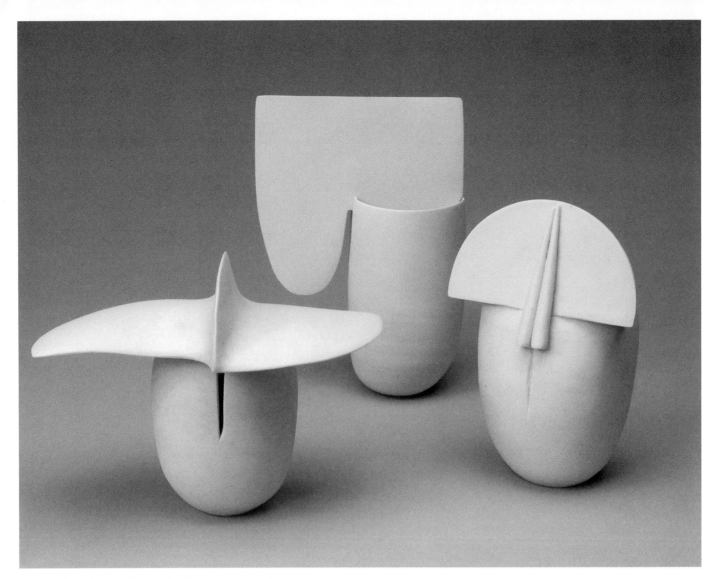

Three sculptural vessels by **Ruth Duckworth,** 2003–2006

New York

Free from a long tradition in ceramics, America's contribution to the discipline is defined by wild experimentation often inspired by creative innovators who came to the United States fleeing the persecution of the Second World War, or American veterans who turned to pottery to escape traumatic memories. Both brought new perspectives and techniques to the discipline, and in the immediate aftermath of the war, numbered more than 100,000.

The modernist movement, which started in Germany and Austria in the early 20th century, was supressed by the Nazis in the 1930s. Many of its protagonists escaped to the United States to carry on their work – so many in fact that the heart of movement can be described as having followed them. In terms of their influence on ceramics, three of the most important were Eva Zeisel, Ruth Duckworth and Marguerite Wildenhain.

Apprenticed to the last pottery master in the medieval guild system and falsely imprisoned in Soviet Russia for 16 months (12 of which were spent in solitary confinement), Eva Zeisel escaped Nazi-occupied Austria on the last train out of Vienna – on the day that Hitler's troops arrived – eventually making her way to America with just $67 to her name. She brought with her an organic, curvilinear take on modernism – inspired by modern architecture, Hungarian folk art, the curves of the human body, and a geometry that she said was 'in the air as a trickle-down from Cubism.' She went on to become the subject of MOMA's first one-woman show, recipient of a Lifetime Achievement award by the Cooper-Hewett National Design Museum, and one of the most influential ceramicists of the 20th century.

German-born Ruth Duckworth was the youngest child of a Lutheran mother and a Jewish father who left Hitler's Germany to study in England before making her way to the University of Chicago in 1964. Initially spurned by opinion-formers such as British-born Bernard Leach, her abstract work fell between useable wheel-thrown vessels and fine art

sculptures, which were then typically made from wood, metal or stone. A retrospective of her work at New York City's Museum of Arts & Design 2005 confirmed her status as a leading figure in large-scale expressive clay sculpture, paving the way for those who followed.

Described by American sculptor Robert Arneson as 'the grande dame of potters', Marguerite Wildenhain was one of the first students to enrol at the Bauhaus and graduate as a 'Master Potter.' She worked for several German and Dutch factories before fleeing the Nazis and coming to New York in 1940. She taught at various institutions before settling at Pond Farm, an artists' colony in California, eventually setting up a summer school there and writing two significant books—*Pottery: Form and Expression* and *The Invisible Core: A Potter's Life and Thoughts*. She famously defended American ceramics against a scathing attack from Leach. His analysis of American pottery, originally published in the American magazine *Craft Horizons*, was based on a

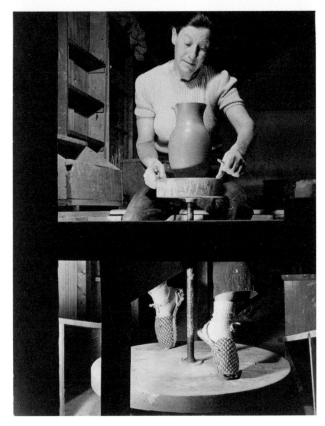

↑ **Marguerite Wildenhain** throwing a pot in her studio, *c.* 1940
→ **Eva Zeisel**, *c.* 1930

thankfulness that I had been born in an old culture. For the first time I realised how much unconscious support it still gives to the modern craftsman. The sap still flows from a tap-root deep in the soil of the past, giving the sense of form, pattern and colour below the level of intellectualisation. Americans have the disadvantage of having many roots but no tap-root, which is the equivalent of almost no root at all.

Wildenhain's articulate and blunt response was published as an open letter entitled, 'Potters Dissent':

Roots are, of course, useful to have, but who has the one, single "tap-root" you talked of? That single tap-root no longer exists in our day. It is probable that it never existed.

The fact that an independent magazine for 'makers, dreamers and doers' called *Taproot* is published in America today is testament to the influence of that exchange. America was asserting its right to experiment beyond the confines of traditions set forth by

Europe and South East Asia – and soon this boldness would extend not just to its immigrants, but also to American-born citizens whose experiences of war had shaken their faith in all they held to be true. In 1944, the Servicemen's Readjustment Act provided education benefits for returning veterans, many of whom were looking for new ways to explore ideas and express themselves. Art schools and universities responded with new and expanded ceramics departments, judging that clay was an immediate material for creative expression. By 1956, 7.8 million veterans had used the provision to attend colleges, universities or other training.

Potters started to make abstract expressionist ceramics with a defiantly contemporary approach, creating sensuous curvilinear forms that really exploited the physicality of their material. By the end of the 1950s, avant-garde studio pottery schools across America, inspired by the Japanese, saw throwing on a wheel as merely the starting point for other more experimental techniques. 'This was pottery, and crucially

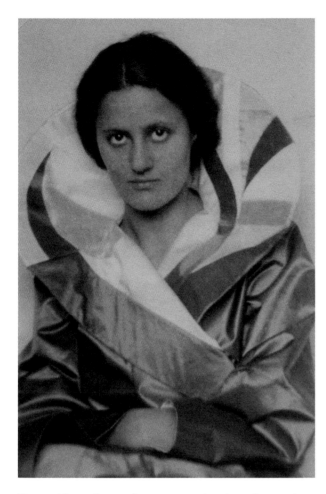

the making of vessels, as an exploratory, improvisational art', explains Edmund de Waal in *20th Century Ceramics*.

It was against this backdrop that a young artist from Montana was asked to chair the newly formed department of ceramics at the Los Angeles County Art Institute, which would eventually become the Otis Art Institute. When Peter Voulkos, already a potter of note, arrived in 1954 he was given a blank canvas, and quickly established an unorthodox and experimental approach to teaching that saw his ceramics studio play host to parties, music and firings 24 hours a day, seven days a week. Critic Rose Slivka compared the atmosphere to improvisational jazz and explained it as a release from 'anxiety over craftsmanship.' Despite criticising the 'atmosphere of iconoclasm [that] was predominantly male with a strong emphasis on scale and prowess,' de Waal acknowledges Voulkos' influence, saying,

It was in Peter Voulkos that these vigorous and iconoclastic modes of thinking and acting would come together, and produce a ceramic movement of great importance... Voulkos was fiercely and passionately eclectic, rapidly absorbing ideas and translating them into his own work.

A radical school of ceramics grew up around him. Inspired by so-called 'action painters' such as Jackson Pollock and Franz Kline, and associated with the abstract expressionist movement, his students started to break down traditional barriers, focussing on spontaneous gesture and the making process, and extending the possibilities of pottery beyond what was achievable on the wheel.

Standing on the shoulders of Zeisel, Duckworth and Wildenhain, Voulkos has had a profound influence on contemporary ceramics, not just in America, but all over the world. In deconstructing the vessel form and putting clay in the realm of sculpture alongside stone, metal and wood, he set American ceramic artists free from the traditions of both East and West, enabling them to experiment – or not – as they chose. In 1976, writing for *Art in America*, Sandy Ballatore summed up his influence: 'The lineage of a master and a few followers that begun in the 1950s has become a family tree.'

The branches of that tree now include ceramicists all over America, not least the studio potters of New York featured in this chapter. Just like their peers all over the world, they look to both history and their contemporaries for inspiration and feed off the vibrancy of their own metropolis, but what is different about the ceramics movement in New York is that it stubbornly refuses to be classified as either art or craft. 'I don't see a meaningful difference between artist and craftsperson,' says Jennifore Fiore, one of the potters in this chapter, while Romy Northover adds, 'Compartmentalising can feel restrictive.' Despite living and working in one of the most pressured cities in the world, thanks to that family tree, they are free to continue the bold experiments started by three women fleeing for their lives.

Helen Levi

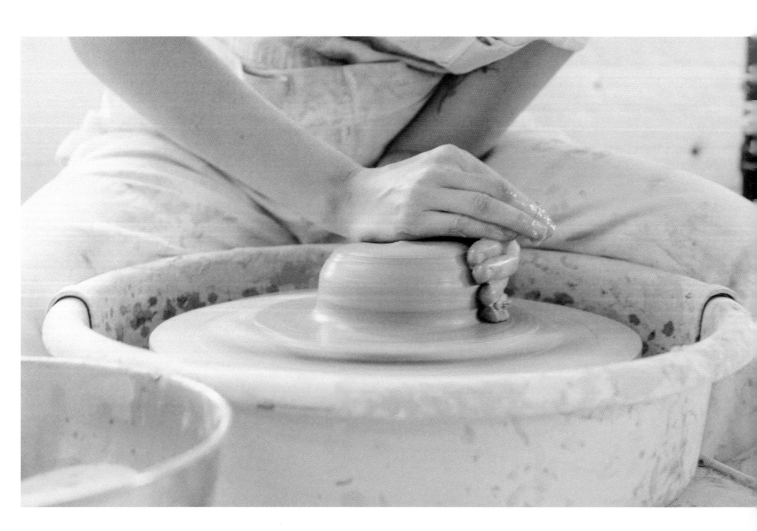

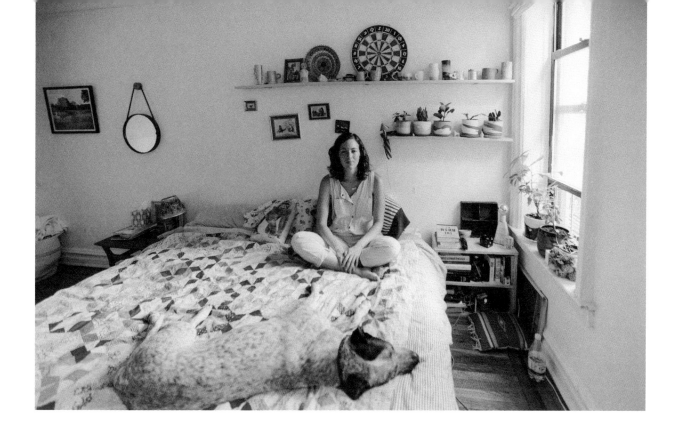

Helen Levi (b. 1987) dedicated herself to ceramics by chance: the woman who taught her when she was a child went on maternity leave and asked her to cover her classes while she was gone. 'For a few months, I was doing pottery almost full-time, running the studio and teaching – and it felt really good,' she says. It was at this time that she met fashion designer and boutique owner Steven Alan and got the chance to sell her work for the first time. 'I had never sold a piece before then. But after that order, I decided to run with it and see how far I could take it.' Now, she's operating from a huge studio space in Brooklyn, and spends her days throwing, glazing, trimming and attaching handles. 'This job is more fulfilling than anything else I had ever done.'

Born and raised in New York's East Village, Levi has been taking ceramics classes since she was a child and continued to practise through secondary school. 'But I have very little formal education, so my skills have grown in leaps and bounds in the last few years just by having to learn on the job,' she says. Levi has

recently moved into a new studio on the industrial waterfront neighbourhood of Red Hook. 'This studio is six times the size of my old studio, which had a mousetrap manufacturer below us so there was constant noise.'

Like many New Yorkers, Levi thrives on the energy that comes from living and working in a vibrant, non-stop city. But it's not only the city that inspires her. 'I think the mixture of city and country influences me a lot – I experience both by being in close proximity to lots of people and also by being at the end of a dead-end road with no one else around.' Her collections vary in colour and form but all are inspired by the landscapes that surround her. 'I often make collections named after different aspects of landscape that I love such as the Ocean Series and the Desert Series,' she says. 'Or sometimes when my work is finished and out of the kiln, I will notice a shape or a colour combination that reminds me of a place I've been, and only realise after the fact that it has found its way into my work.'

I want my ceramics to be everyday functional objects.
Only very occasionally do I make an object that's
too precious to use; I tend to prefer my pieces
to be approachable.

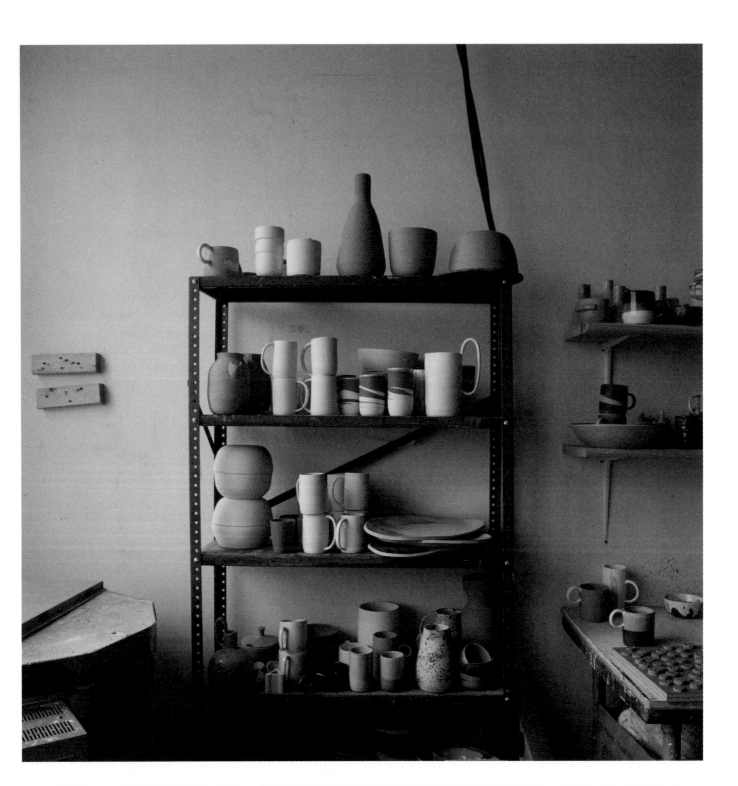

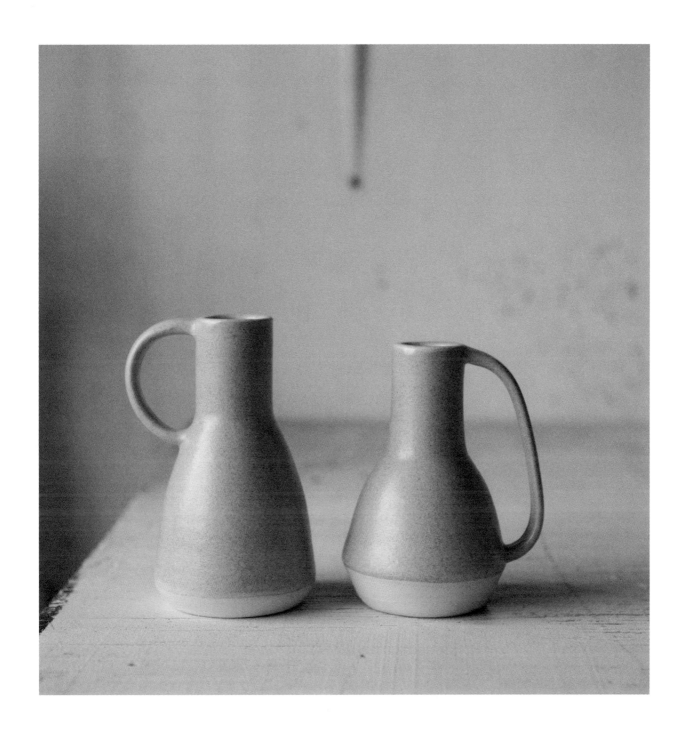

New York

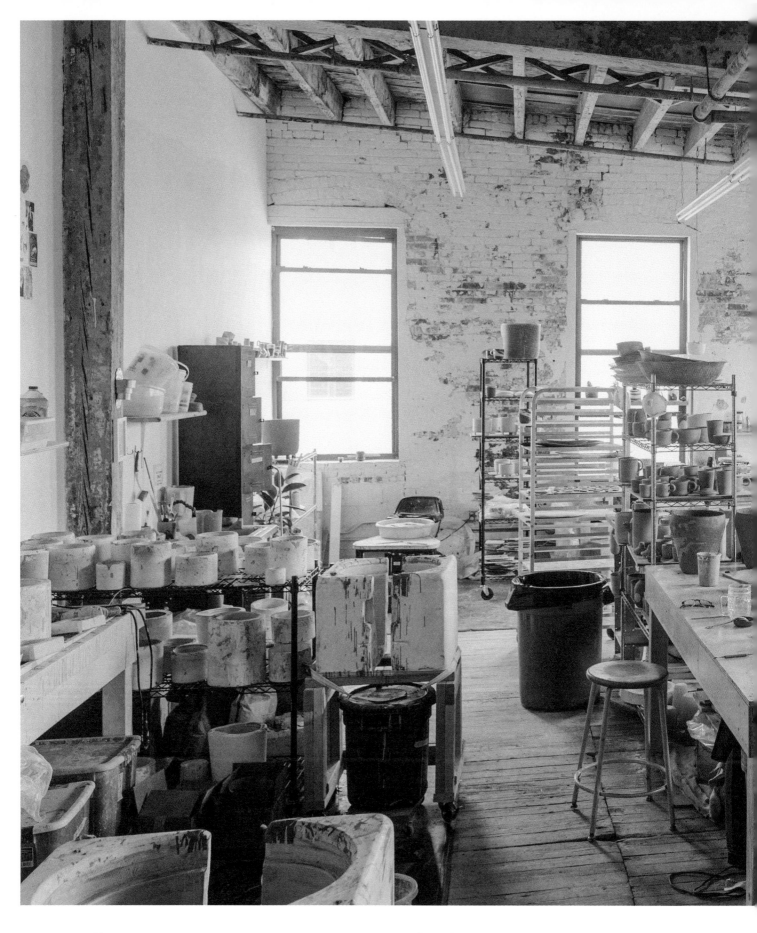

Helen Levi

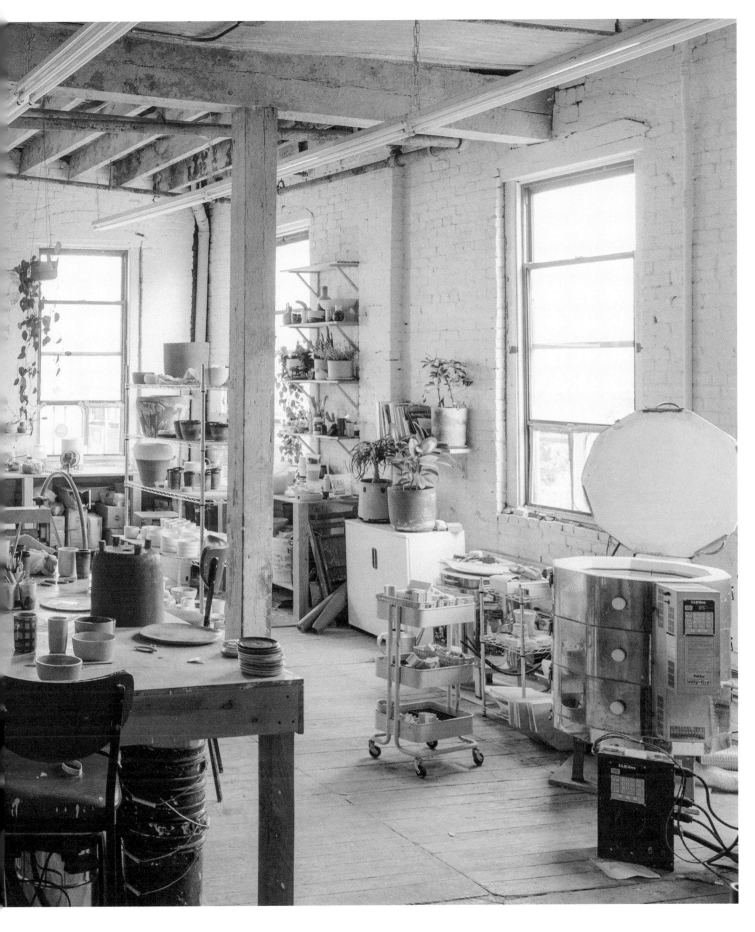

New York

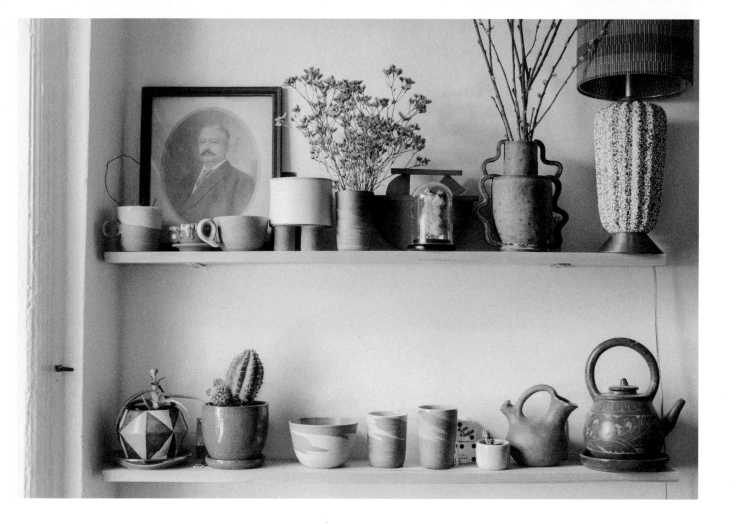

I consider myself to be both an artist and a crafts-
woman. I love the humbleness of the craft side of
my work, though certainly I feel like an artist when
I bring to life an idea by translating it into a physical
object. Ceramics is the perfect blend of art and craft.

Helen Levi

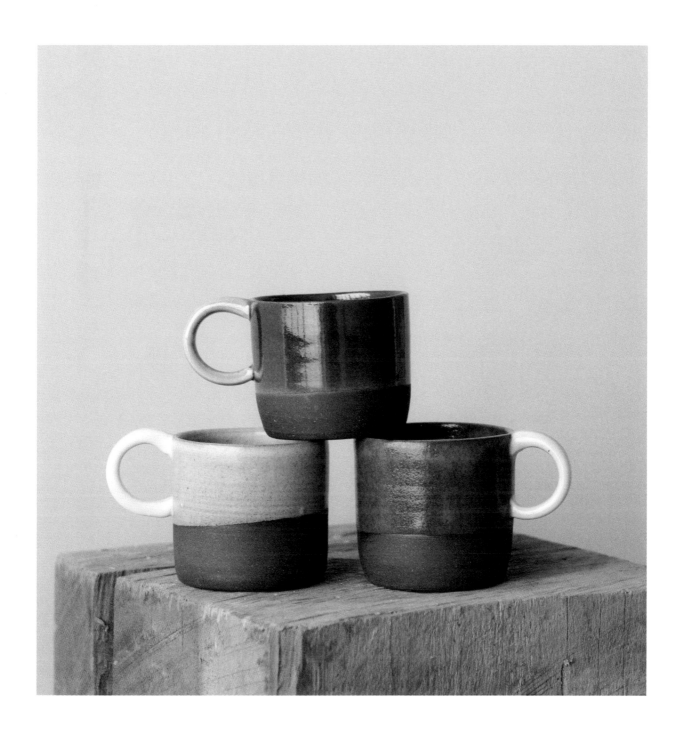

New York

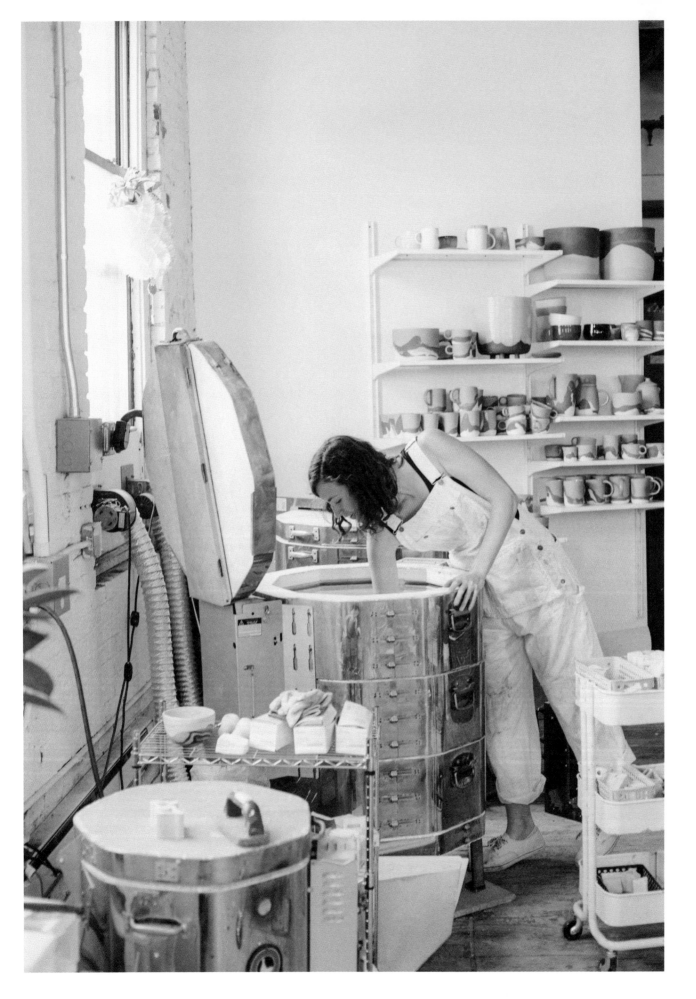

I studied photography in college – and one similarity I've noticed between photography and ceramics is the forced waiting period, while you develop your film or wait to unload the kiln. There is a certain delayed gratification in both practices.

Josephine Heilpern

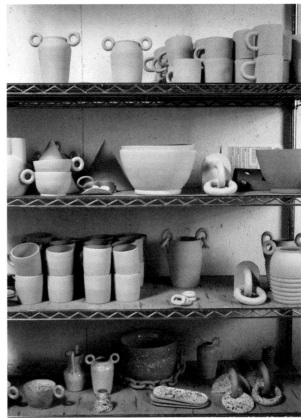

Josephine Heilpern (b. 1986) had lived in Woodstock, Buenos Aires, and New York City by the time she was 14. After graduating in print and sculpture from the Cooper Union, she started to create functional art objects, taking visual references from design history, such as her Memphis-inspired shapes and patterns. But the Memphis colours in her work are restricted to backgrounds and styling: 'I love the natural colour of the clay – it can vary so much that I don't like covering it up,' she says. 'People tend to think my work is very colourful, but I don't actually use any colour except for yellow and occasionally blue. Where I do use colour is when I photograph the work.'

The process of repetition fascinates Heilpern, especially when thinking about man as machine. 'Our body goes through the same movements in order to create a set of objects that look the same – and it's similar for me in the studio, my movements become machine-like. But, even having come from a print background, I do embrace the differences between each piece. I have made thousands of rubber-dipped dot mugs, and knowing that each one is a little different from the next is nice to me.'

Heilpern markets her work under the name Recreation Center on her website and on Instagram, with all the visual prowess of a 31-year-old digital native. 'I know the internet has influenced me more than anything else,' she admits. 'The abundance of images and visual stimuli available online has absolutely inspired my aesthetic. I see too much everyday, but because of that I do learn a lot.' It's not only the online world that inspires her. 'I look at a little bit of everything,' she concedes. 'I love hardware stores and dollar stores and have found some hugely inspiring objects at both of those places.' The city she lives and works in also provides constant motivation: 'I feel like I have a flame under my butt pushing me to work hard and fast in order to survive,' she says. 'And that really works for me, it keeps me motivated and busy. I don't think I would be who I am if I didn't live in New York.'

New York

The history between humans and clay is remarkable. Ceramics use all four elements in their production: clay is earth, you use water to keep it moist and malleable, air dries it and fire makes it functional. It's incredible. The further we move from the original process, the further we move from its relationship with the elements.

Josephine Heilpern

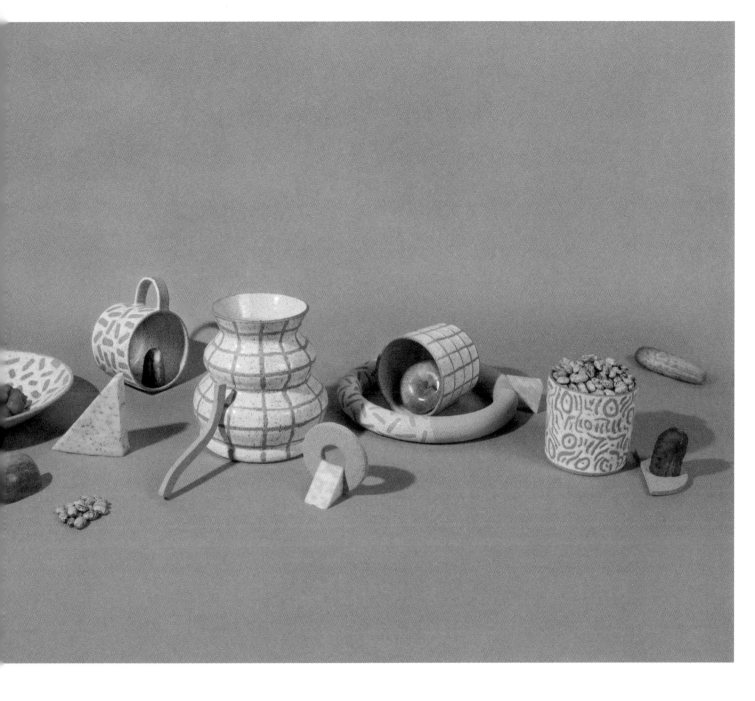

I like ancient pottery – objects made by people
with no name now; objects that were made because
they were needed for eating, cooking and storage.
I admire their functionality and their existence,
borne out of necessity. I admire their connection
to the earth.

New York

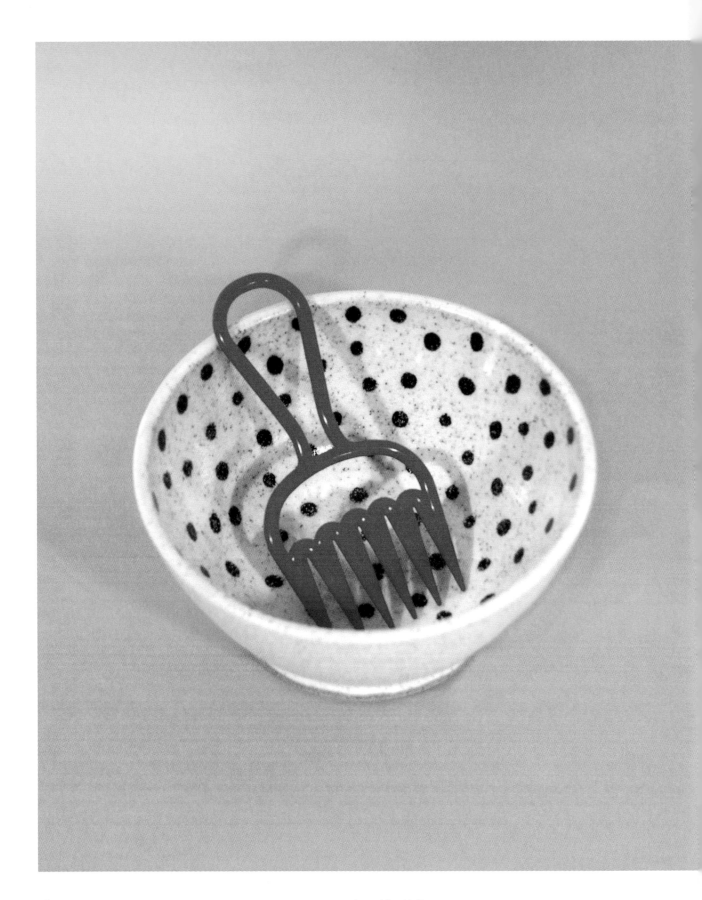

Josephine Heilpern

New York

If you make everything by hand, there is room
for difference between each piece. Each mark
I make on a mug is unique; each mug is a slightly
different shape or size, or sometimes the colour
varies a little. When you own a handmade mug,
you have something that is different from the mug
someone else may own. I hope that that makes
every one special.

Josephine Heilpern

Nina Lalli &
Jennifer Fiore

Ceramics studio Mondays was established by Nina Lalli (b. 1980) and Jennifer Fiore (b. 1972), both long-time New Yorkers who met at a ceramics evening class hosted every Monday. The pair shared an obsession with clay and almost immediately decided to launch a business together. 'There was nothing rational about the decision,' says Fiore. 'We just decided to see if we could make enough money to pay for studio time, and everything moved very quickly from there. We are both incredibly lucky to have a supportive community of family and friends who encouraged us.' Lalli adds, 'It felt great – largely because doing it together and believing in each other so much outweighed my usual self-doubt.'

The pair now hand-make ceramics from a 450-square-foot studio in the Clinton Hill neighbourhood of Brooklyn, using two techniques: pinching the clay by hand, or working from a slab of clay flattened with a roller. Fiore's work is often fluid, whereas Lalli sticks to a more structured approach – and their three part-time assistants handle some of the more

straightforward aspects of production and keep them organised.

They are both minimalists when it comes to colour and mostly work with the hues of the clay itself. 'I'm interested in texture – adding glaze makes me feel a little suffocated. When I do it's usually white or clear. I love bright colours in every other area of life, but I haven't found a way to apply it to my work that I feel enhances it', explains Lalli.

Although they are professional ceramicists, they still have day jobs: 'We don't consider those things to be mutually exclusive. New York is a very expensive place to live. We are both lucky enough to have jobs we enjoy that give us the flexibility to work around studio deadlines.'

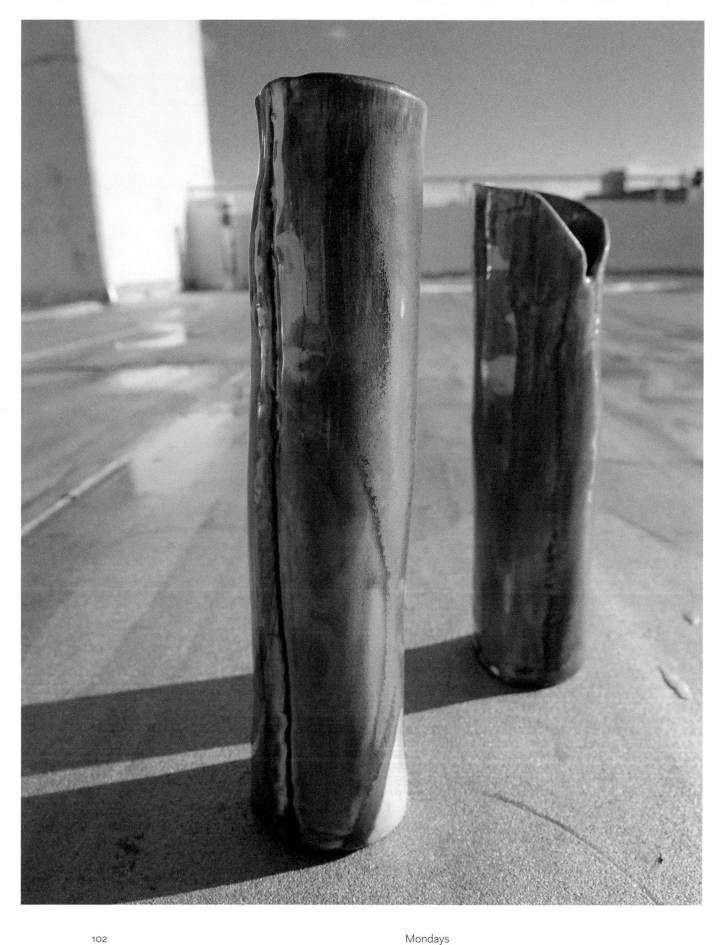

Mondays

Although I work intuitively, I rely on "rules" in my practice selfimposed or otherwise, and find it liberating to make utilitarian objects with their own built in rules (a mug needs to hold liquid, a plate needs to hold food). (JF)

I like my functional pieces a lot – especially knowing that they get used and become an intimate part of other people's lives. (NL)

Getting large production orders early on forced us to grow very quickly. Our technical skills and ability to solve problems grew exponentially. Moving into our own space, we've learned to mix our own glazes and are starting to develop our own recipes, and we finally have the time and space to spread out and slow down and refine the work we've been doing. (JF)

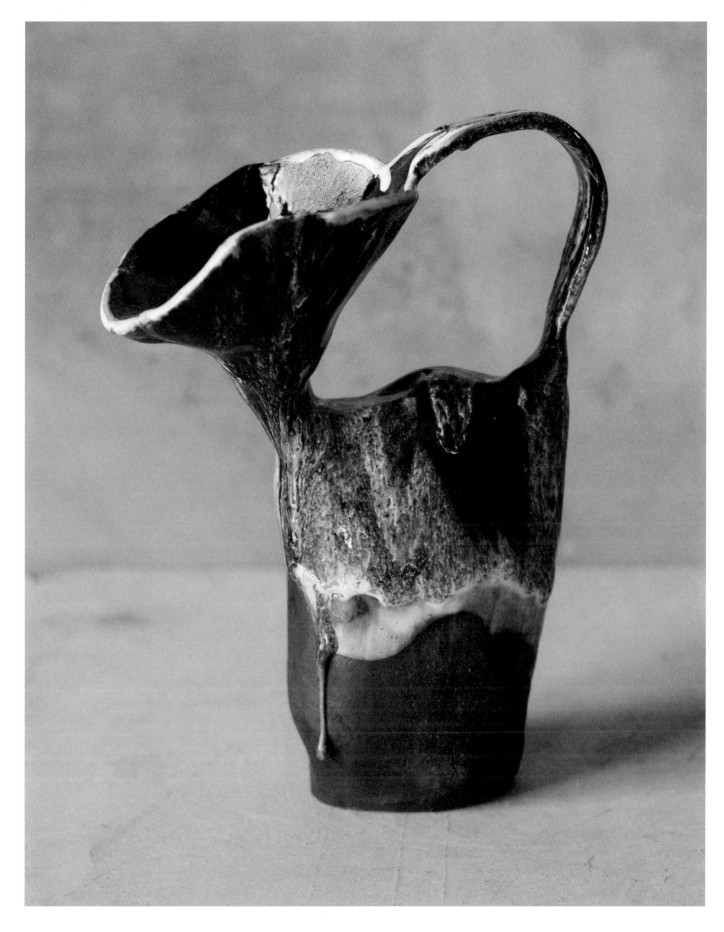

New York

Natalie Weinberger

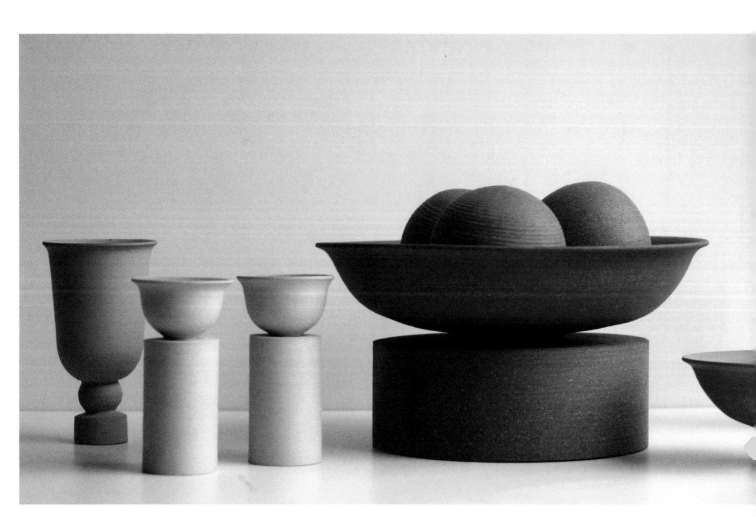

Natalie Weinberger (b. 1985) studied art history and historic preservation – a combination that has enabled her to live all over the world, from Brooklyn to Brazil and from Philadelphia to Phnom Penh. 'My masters in historic preservation was really interesting and had a big impact on my worldview, as well as my general sense of design and craft in historical context,' she says.

Weinberger has always been a maker. She took glass-blowing lessons as a teenager and experimented further at college. She discovered clay in 2010, started throwing on the wheel and decided to devote herself to ceramics full-time just four years later, moving into her first private studio not long after. Its location on the fourth floor of a massive industrial building means it has high ceilings and huge windows. 'I like swift changes in the weather and light – a sunny day interrupted by a storm, or working in my studio at dusk until it's so dark I finally turn the lights on,' says Weinberger of the space. 'I like the contrasting moods that are brought on by the weather, the cycle of the day, and other natural forces. When I'm making pots I have a definite mood in mind, sometimes sunny and sometimes gloomy.'

Her work is a compromise between aesthetics and functionality – contemporary pieces that reference the past, and often seem to defy gravity. 'Achieving the finished form isn't always possible at the throwing stage, so the trimming process is when the idea that was sketched on the wheel finally gets articulated into a clear statement,' she says.

New York

Ceramics for me is about integrity, to create
something that's special and has value in the world,
but is also humble, quiet, and gets the job done. It's
these same principles that I try to uphold in the other
aspects of my life.

Natalie Weinberger

New York

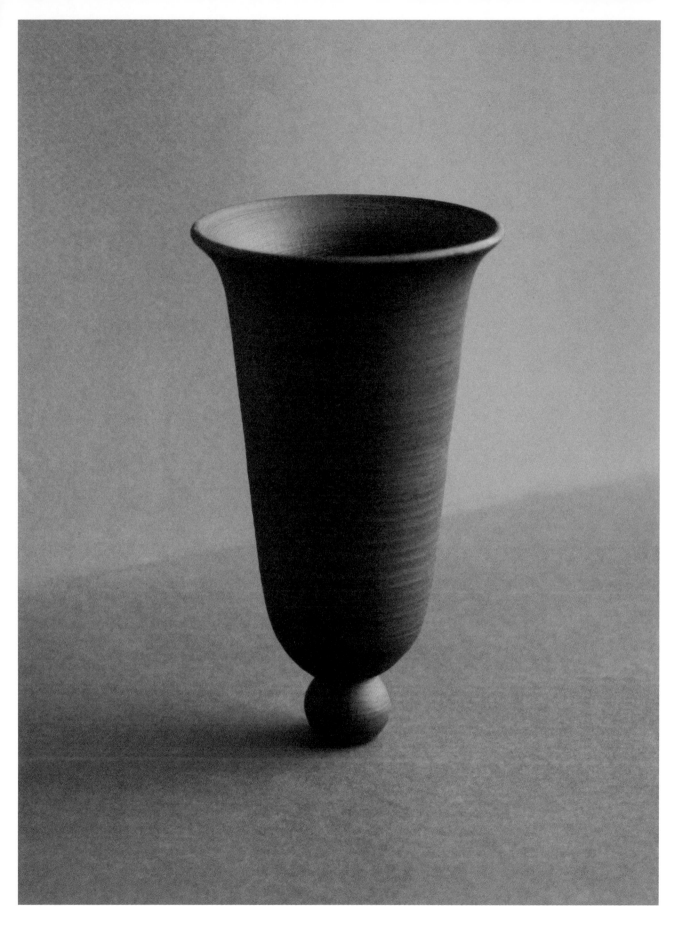

Natalie Weinberger

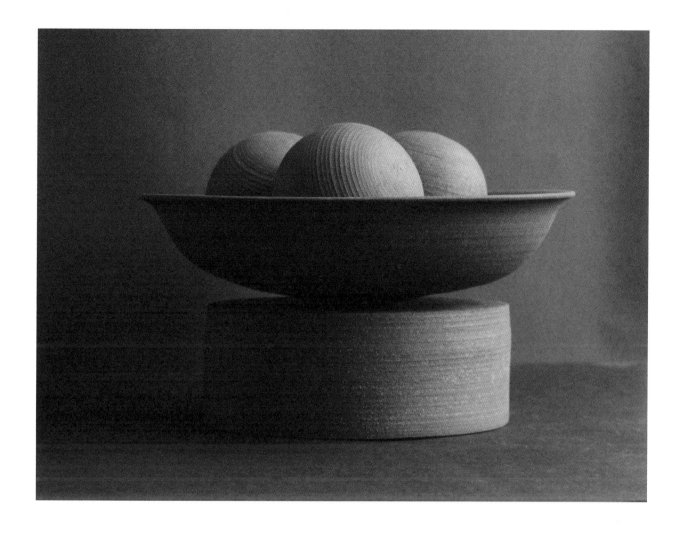

For me, the best part of the process is trimming
a new piece – I like shapes that tend to defy gravity,
so achieving the finished form isn't always possible
at the throwing stage. The trimming process is when
an idea sketched on the wheel gets articulated into
a clear statement.

I like swift changes in the weather and light – a sunny day interrupted by a storm, or working in my studio at dusk until it's so dark I finally turn the lights on. I like the contrasting moods that are brought on by the weather, the cycle of the day, and other natural forces. When I'm making pots I have a definite mood in mind, sometimes sunny and sometimes gloomy.

Natalie Weinberger

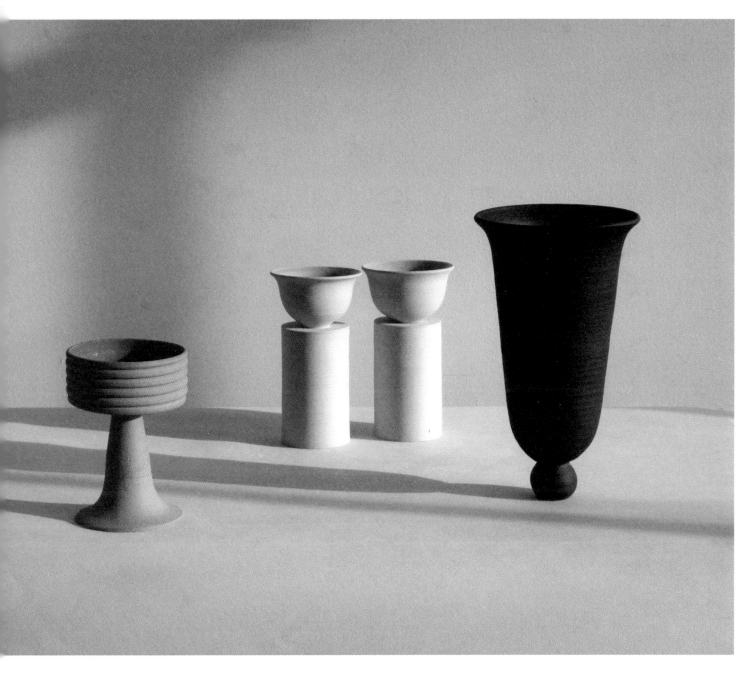

New York

Romy Northover

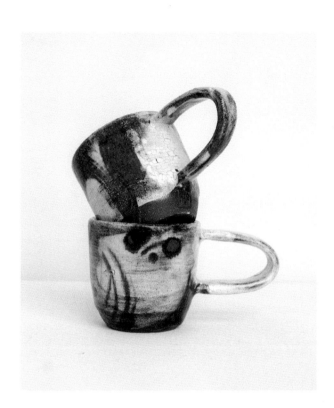
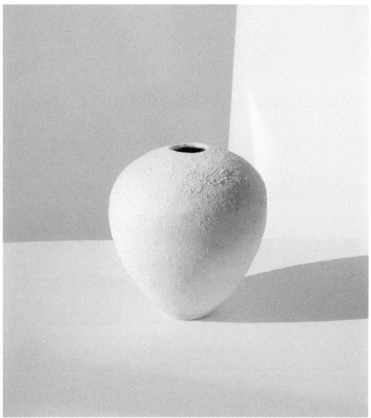

Growing up in the countryside in a family of designers, filmmakers and artists, Romy Northover (b. 1981) was encouraged to pursue creative avenues, and first fell in love with ceramics at secondary school, where she trained in the European tradition with British ceramist Celia Allen. 'I come from a creative background so without a shadow of a doubt my education started at home with my family,' Northover says. 'It was a very natural part of our family life. I was always supported in going my own way – the hardest part for me was figuring out what that was.'

She studied in London, and lived in Hong Kong, Venice and Berlin before opening her studio, No., in 2012 at Togei Kyoshitsu, a ceramics studio in New York that focuses on Japanese traditional techniques. 'Moving and experiencing new cultures is always something that felt very natural to me,' she says. 'I was fortunate that this was possible in my youth – it was essential to my education.' Despite her global experience, moving to New York was a challenge. 'It

forced me to make very important decisions about what I was doing with my life,' she explains. 'It was in New York that I started taking care of my health seriously and made the decision to go back to ceramics.'

Northover now works in a shared studio in Long Island City, Queens. The impressive, open space with high ceilings and white walls, is run by Magda de Jose and Andrew Kennedy. 'I knew the second I saw pictures of it online that that was where I wanted to work – my surroundings and environment are hugely important to me,' she says. The work she makes there is about communicating a concept or idea, but not always one that can be put into words. 'Excessive pressure on the conceptual can become paralysing,' she says. 'I have to allow for intuition, muscle memory, touch, style, aesthetic and mood – not just in a visual sense. It goes very deep into the visceral. There is a vast realm of intelligence beyond thought. In addition to that, working through the material is part of my methodology, my discovery process. There are answers in the clay.'

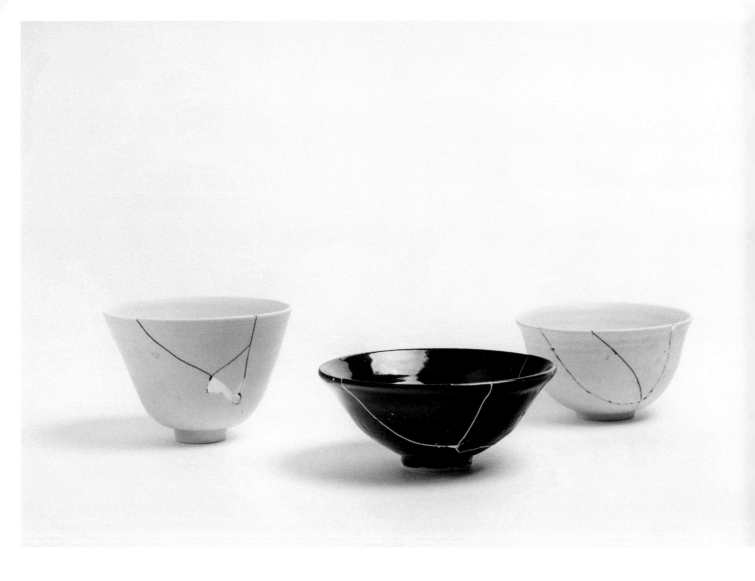

Romy Northover

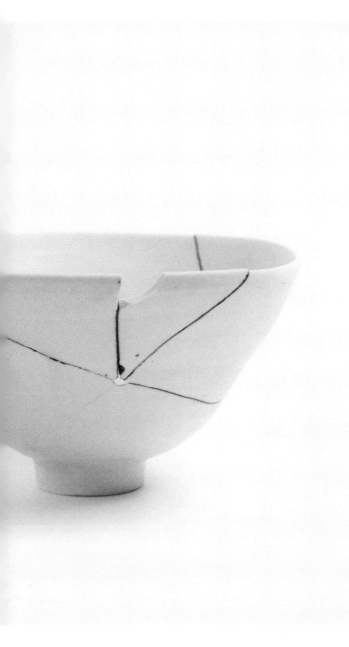

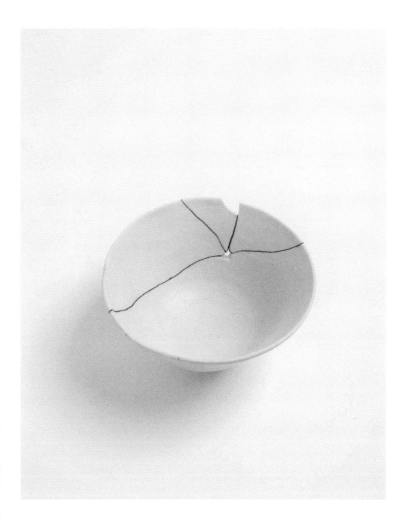

The more I discover about ceramics the more I realise
how little I know; the potential is endless. I am looking
for a kind of truth and purity – in concept, in medium,
and in process.

New York

Romy Northover

I need to give myself time, physically and mentally. I cannot, and do not want to, churn out work. We have become over-saturated with 'stuff' and are suffering as a result. We buy cheap and disposable things but someone, somewhere is paying the price, whether it be poor quality, underpaid workers or environmental consequences. I believe I make important and powerful work, and I stand behind it.

Shino Takeda

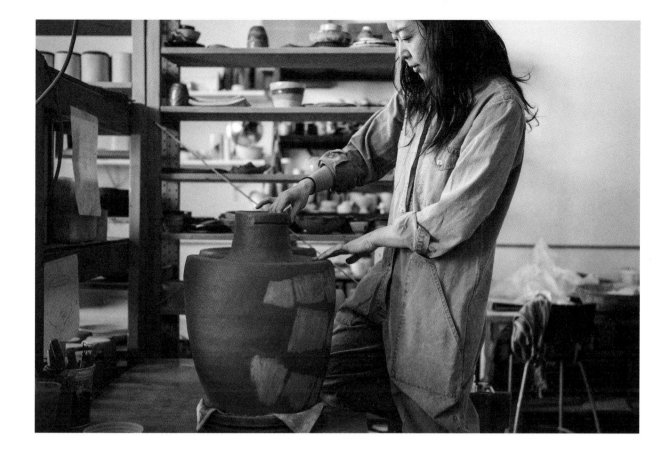

Shino Takeda (b. 1975, Japan) arrived in New York to pursue a career in ballet, but her upbringing, in the Japanese region of Kyushu with its strong ceramics heritage, eventually caught up with her. 'My mother was an avid collector of traditional Japanese ceramics,' she says. 'My parents loved nature and art too. We would climb a mountain at 3am to see the sunrise, or drive for two hours to see fireflies. Their attitude had a profound influence on me.' The naïve surface pattern design and bold colours in her work clearly demonstrate these early experiences. 'Colours are extremely important to me,' she says. 'I experience the world though colour – days of the week, times of day, heat, birdsong, the smell of the ocean – even missing someone has a colour. I immerse my senses in these colours and try to capture them in my ceramics.'

What started as a hobby grew organically when a friend of a friend started stocking her work. Word got around both directly and through social media – Pinterest and Instagram were just taking off. Today, more than 20,000 people follow her Instagram feed and you can find her cups, spoons and bowls in boutiques all over the world. 'I think I was in the right time and in the right place with the right people,' she says. 'I've had a lot of luck.'

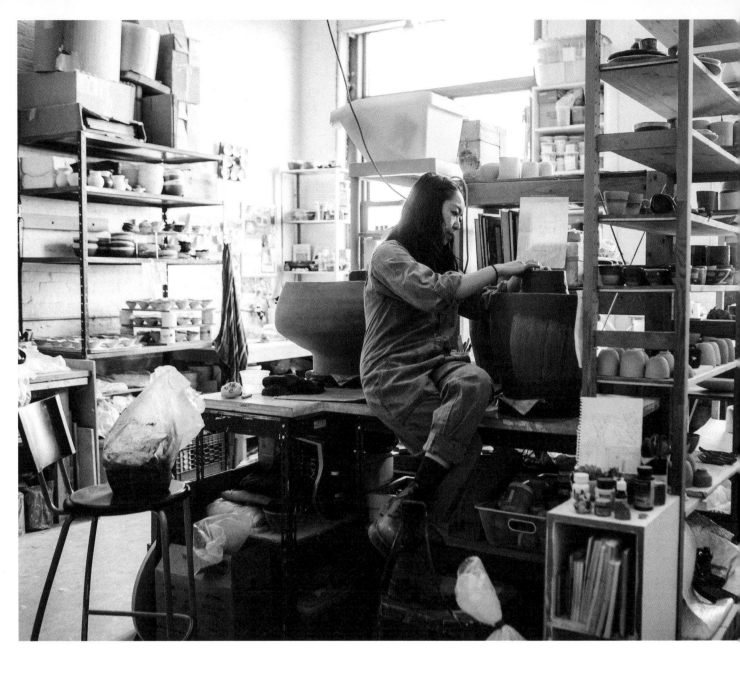

Shino Takeda

I get to the studio around 10am and work for 10 to 12 hours a day. I have a two-week cycle. I make shapes all week, then bisque fire. They come out two days later, and then I glaze for two days, then glaze fire, unload the kiln, pack and ship out. Then I start all over again.

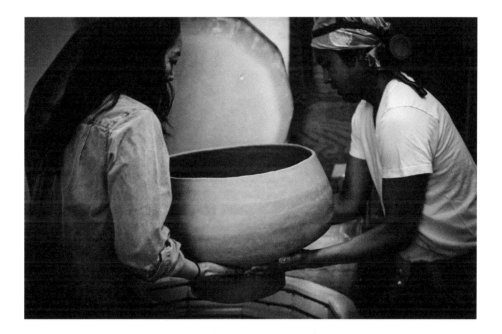

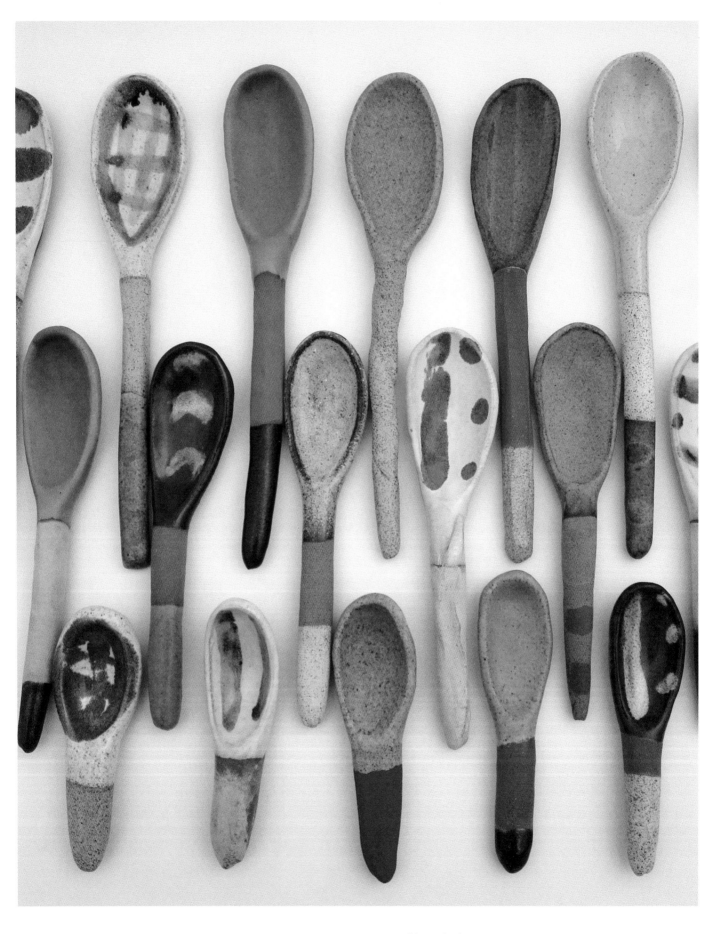

Shino Takeda

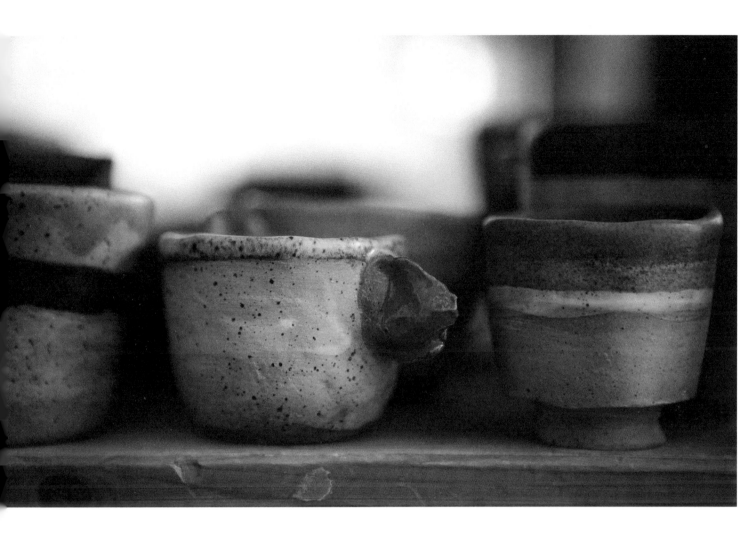

Without colours, my works would just be practical
pieces – they wouldn't have any feeling or personality.

New York

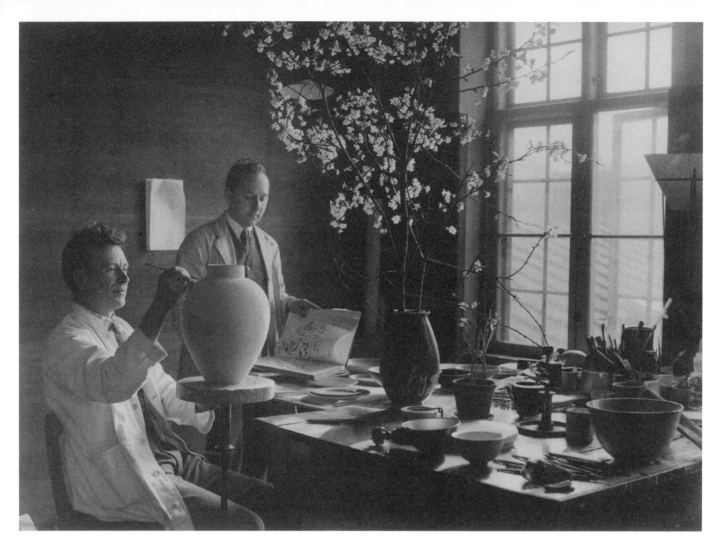

Vase painting at **Royal Copenhagen**, *c.* 1930

Copenhagen

ONWARDS & OUTWARDS

For such a small country, Denmark holds a remarkably significant place in world ceramics. The Victoria and Albert Museum's senior curator for glass and ceramics, Alun Graves, says he has acquired more from Denmark for the V&A collection than from any other country outside Britain. A heritage that includes porcelain production dating back over 200 years and one of the world's most influential 20th-century Modernist movements is a double-edged sword for contemporary Danish designers, but a new generation of ceramic artists is breaking free from tradition and has its sights firmly set on the future.

Denmark's ceramics reputation was built by Royal Copenhagen, the 'manufactory' that chemist Frantz Heinrich Müller established in a converted post office in 1775 to exploit his 50-year monopoly on the production of porcelain – at a time when all of Europe and Scandinavia were obsessed with so-called 'white gold,' due to exports from China and the secrecy surrounding its manufacture. King Christian VII added the 'Royal' to its name in 1780

when he assumed financial responsibility for operations. The imperially approved wares qualified for London's 1851 Great Exhibition and the World Expo in Paris in 1889, winning the Grand Prix at the latter – a sign of Royal Copenhagen's growing international influence. It was privatised in 1868 and is now owned by Finnish company Fiskars, but retains a regal title to this day. Almost every household in Denmark owns its porcelain, and although Copenhagen's contemporary studio potters are hesitant to make comparisons between their own handmade work and the granddaddy of Danish ceramics (whose production has since moved to Asia), Royal Copenhagen's influence is inescapable. Generations of Royal Danish Academy of Fine Arts ceramics graduates were given unparalleled access to tools, techniques and glazes and in return infused Royal Copenhagen with innovation. That ended over 20 years ago (the brand continues to set live briefs for students) but the porcelain manufacturer's standing is still keenly felt by the next generation. 'When I make things in white with a dash of cobalt blue, I think about that fact that they will go

well with Royal Copenhagen,' admits Tasja Pulawska, one of the potters in this chapter.

In common with many cities around the world, Copenhagen's next ceramics boom was ushered in by the Modern movement in the mid-20th century. The Kunsthåndværkerskolen (The School of Arts and Crafts) was instrumental in the development of Danish Modernism, counting Hans J Wegner among its alumni, but in terms of ceramics, the Saxbo Workshop, lead by Nathalie Krebs (1895–1978), had the biggest influence. If Royal Copenhagen established Denmark's vessel tradition, Saxbo defined its form. 'If there's one thing that symbolises Danish pottery... it's the cylinder,' says Tom Morris, writing for *Monocle* magazine. 'Described as a "national fetish" [...] the cylinder is a form that is reduced down to the bare essentials of function – no bells and no whistles. It's essentially the most minimalist thing you can make and that's why it was so ubiquitous in the 1950s and 1960s.' Morris rightly links this simplicity of form with Modernism, pointing out that ceramics workshops 'Saxbo, Bing & Grøndal and Palshus excelled at using clay very simply, but slightly playfully, just like the design masters such as Hans J Wegner and Arne Jacobsen did with wood.'

But perhaps there's more to the subtle, restrained 'quietness' that came to define contemporary Danish ceramics. In common with other Scandinavian countries, there is a cultural mindset in Denmark that prevents Danes from standing out: something called 'janteloven.'

The laws of Jante were first documented in Aksel Sandemose's 1933 novel *A Fugitive Crosses His Tracks*, although the Danish-Norwegian author insisted he was simply describing social norms that had been part of the cultural psyche for centuries. They include diktats such as 'you are not to think you are anything special,' and 'you're not to think you can teach us anything', resulting in something akin to the 'tall poppy syndrome' more commonly understood in English-speaking countries, where people who strive to achieve too much are brought back down to earth. Danish ceramicist Mette Marie Lyng explains

its contemporary meaning as simply 'envy on one side and humbleness on the other.'

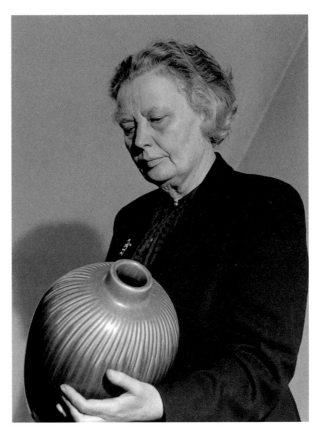

Nathalie Krebs, 1954

To readers from cultures where personal achievement is highly prized, this notion sounds alien, and perhaps even cruel, but it has its benefits, encouraging people to value the collective over the individual and collaboration over competition. 'Janteloven encourages me to seek social or collective relevance for whatever I create,' says Tortus Copenhagen's Eric Landon, an American who lives and works in Denmark. 'True Danish design is not based on the material needs of the individual that differentiate us, but on the functional needs that bond us together. Janteloven reminds us that the motivation for achievement should be the common good.'

However for those born into the culture, janteloven can be more complex, and opinion is fiercely divided about its contemporary relevance. Responses to

questions about its influence on ceramics vary from 'It's the reason I left Denmark,' to 'It's an old-fashioned cliché that doesn't make sense today.' London-based Danish ceramicist Ditte Blohm says that even discussing it is 'like talking about the devil.' She argues that while Danish creatives of her generation don't like to admit that it affects their craft practice, it's difficult to argue that the designers they admire, such as Hans J Wegner and Arne Jacobsen, created the simple, humble and clean aesthetic that they did uninfluenced by janteloven. Describing her own work she says, 'I love art that is colourful and yells to be looked at, but I could never make things like that myself. My work is more humble and tells its story quietly. I'm not sure if that's janteloven or just the Danish style, but I suspect that the two things are inextricably linked.'

However, as one of the most digitally connected cities in the world, Copenhagen is changing and Danish ceramicists are increasingly looking outwards to the world for inspiration instead of backwards to Denmark's heritage. 'My students aren't interested in tradition,' says Martin Bodilsen Kaldahl, associate professor at the Royal Danish Academy of Fine Arts, co-founder of contemporary gallery Copenhagen Ceramics and ceramic artist in his own right. 'When I studied, we were taught to feel part of Denmark's strong ceramics tradition. Today's students are looking to the future.' Kaldahl argues that janteloven was a product of isolated rural populations that, in our connected world, just don't exist anymore. 'Everyone now has access to urban culture,' he says, suggesting that even the Danish obsession with the cylinder has had its time and citing the bold work of abstract artists such as Kristine Tillge Lund and Steen Ipsen. 'We don't think too much about being Danish anymore. Today's ceramic artists are truly international.' Anders Arhoj, the potter in this chapter who most closely represents this new international breed of artists, agrees. 'The danger in a country of 5.5million people is that everybody starts to think alike,' he says. 'So we have to do what Danes have always done; travel out into the big wide world, find new ideas and bring them back to refine them. Maybe that's what we're good at: distilling and refining.'

While there is certainly a colour palette and an attention to form that is distinctly Danish common to the work of most of the studio potters in this chapter, Kaldahl and Arhoj are right in describing the contemporary ceramics movement as internationally connected and that's as true of Copenhagen as of all the cities in this book. While their histories are distinct, their futures are increasingly intertwined.

Ditte Fischer

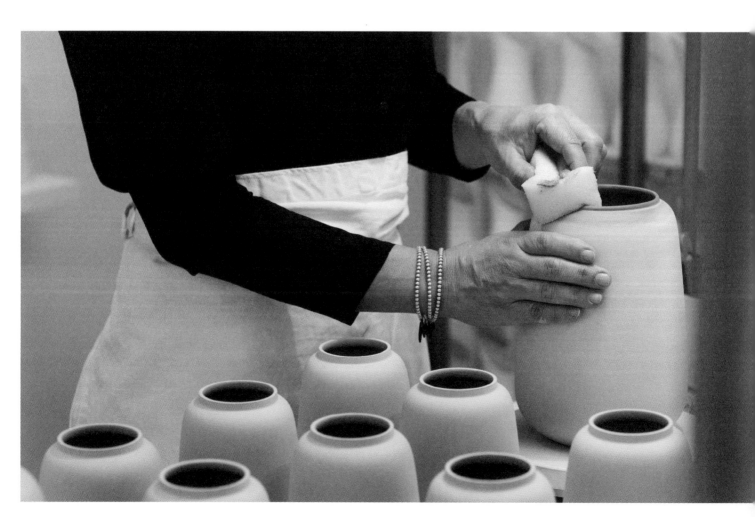

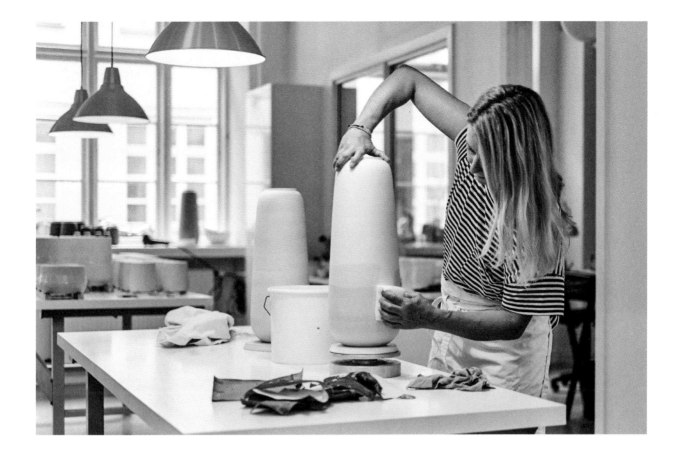

Ditte Fischer (b. 1966) produces porcelain tableware such as jugs, cups, teapots, vases and plates using a selection of moulds. Everything is made by hand in her workshop. 'I care about good craftsmanship and the experience and history behind it,' she says. 'It is very important that we maintain skills and knowledge and pass them on to the next generation. You need professional knowledge in order to develop new knowledge. I like products where you can see that the maker has done his absolute best.'

Most of her tableware is formed into low and open forms in order to present food in the best possible way. She leaves surfaces undecorated and glazes them only on the inside so that attention is focused on the colour and texture of the food, rather than the pieces themselves. 'It is important to me that my ceramics have a classic and simple expression that supports the functionality of the product and fits in almost everywhere,' she says. It's a straightforward approach that results in the clean lines and curves that have become the signature of her work.

'Nature and architecture have always inspired me,' Fischer says. 'I use Copenhagen to get in the right mood to design. A bike ride through the streets of the old city or a walk by the harbour are two of my favourite trips. I also use the nature around my cottage in North Sealand to clear my head and get new ideas. The silence in nature is a perfect contrast to daily life in the city.'

Ditte Fischer

Copenhagen

Though I do not make on-off products I prefer my ceramics to come out in small numbers. I have my hands on every single product and everything is made in my own studio here in Copenhagen. I care for good craftmanship and the experience and history behind it. It is very important that we maintain skills and knowledge and pass them on to the next generation.

Ditte Fischer

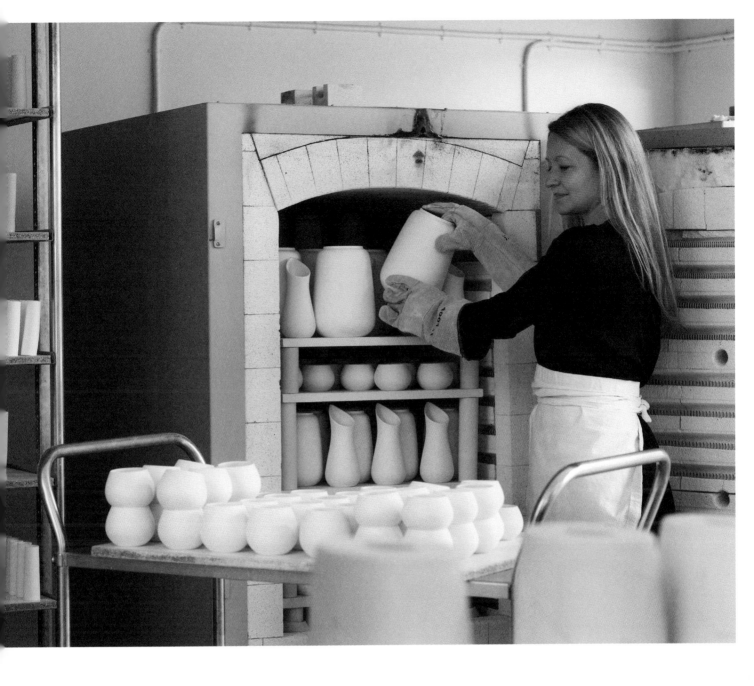

Copenhagen

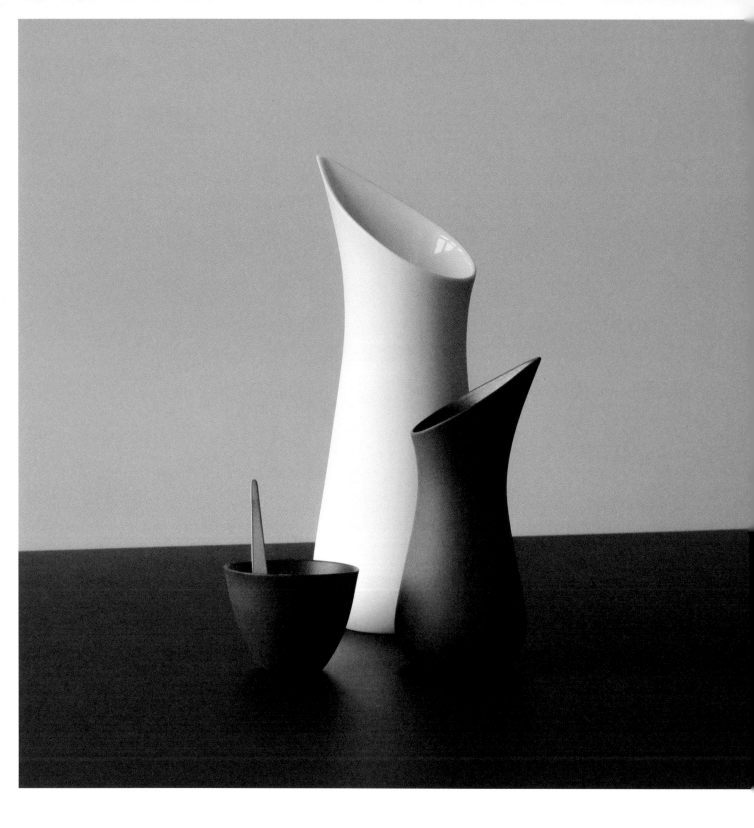

Ditte Fischer

My designs are very graphic and without any
decoration. I work with lines and curves and am
always looking for a simple and strong expression
that supports the function of the product.

Anders Arhoj

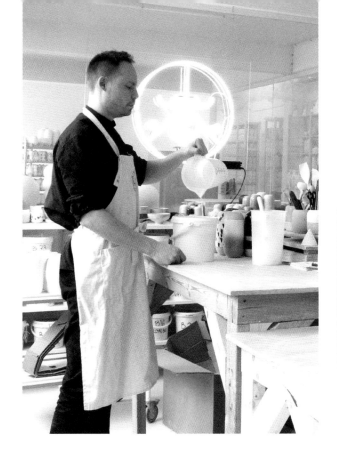

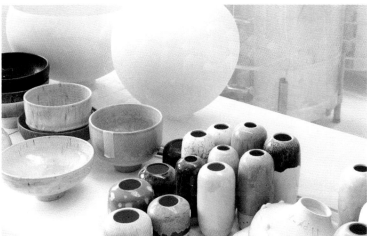

Anders Arhoj (b. 1979) originally established Studio Arhoj in Japan – a country with a similar ceramic aesthetic to Denmark's – where Arhoj studied language and worked in design. Japan's natural materials, such as wood, stone and clay, remain a significant influence on Arhoj's work, but he also draws inspiration from modern pop culture, music videos, computer games, electronic music, Japanese anime, 1980s comics and experimental fashion. 'Going back and forth in history and picking what's appropriate is what a designer should do: know your tools and use them,' he says. 'It's extremely important to feed your eyes and not let them go blind by staring at the same things year after year.'

This varied palette of references results in colourful objects that are both decorative and functional – often with anthropomorphic qualities. The saturated colours and humour in his work sets him apart from most of the potters in this chapter, whose work, like many Danish potters, is characterised by simplicity and functionality. 'Perhaps that's because I am

just a designer and not a potter or a ceramicist,' he explains. 'I have no clay-related education. It might also be because I'm not just interested in the material itself but also in everything around it: the larger scope of branding, styling, product design and running a company – making all these different wheels turn the right way is an exciting challenge.'

Stoneware clay is among his favourite materials and he imports it from France, England and the Netherlands because the stoneware deposits in Denmark are now largely exhausted. 'Working in stoneware is both a gift and a curse; you can obtain a rustic, dramatic, close-to-nature look with a good clay body and a nice glaze – which is aesthetically very close to my heart,' he says. 'But I've found that this can limit the scope of colours and textures if you want to go in another direction visually.' In response to these limitations, Arhoj also works with porcelain, as the white canvas provided by the material allows even the brightest colours to be achieved with glazing.

Copenhagen

Anders Arhoj

People everywhere are taking classes in pottery and buying ceramics by local artists. This means that larger design companies are eagerly trying to manufacture product lines that emphasise or imitate the handmade look. Sadly, this means that at some point the human eye will become tired of clay and pottery – it's inevitably going to fall out of vogue. Only the ceramicists, potters and clay nerds will hold on to their beloved mud until the trend returns.

I love the texture and tactility of ceramics – and I think it's exciting to be allowed to play around with Mother Earth's own materials. There are strict laws of chemistry and physics that you must understand in order to control the process: the drying processes, the behaviour of the atom structure, the chemical elements of the periodic table, etc – and yet you can also bend all these laws and explore by yourself. You can work with clay your whole life and never learn everything there is to know. There is always something hidden around the next corner.

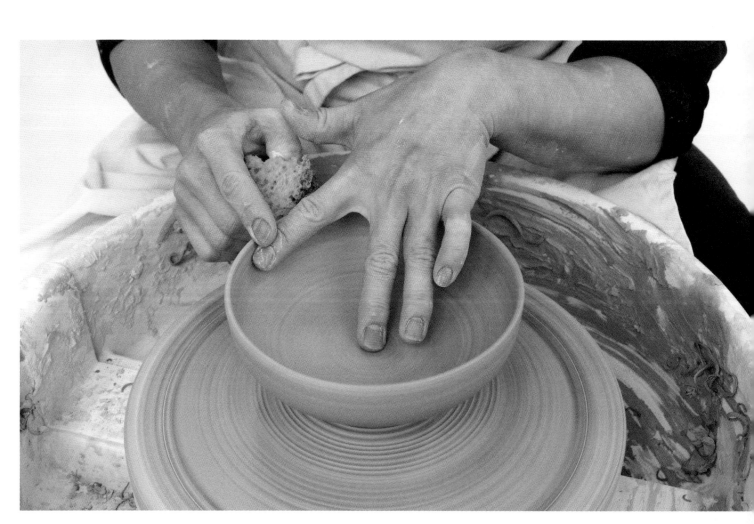

When you turn on the kiln you walk around for
two days looking forward to that moment when
the contents have finally cooled down enough for
you to peek under the lid without anything exploding.
Seeing the results of your idea: mixing two chemicals
in a new way, firing to a higher temperature, trying
out a new shape: it's all very giving. Much more
than pushing around pixels on a screen.

Inge Vincents

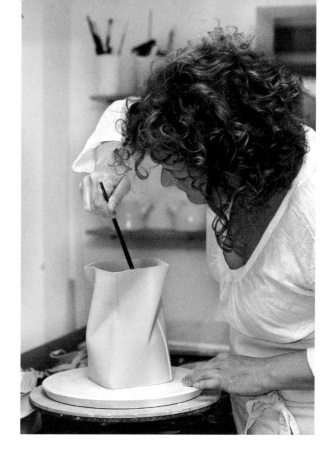

Inge Vincents (b. 1967) has been playing with clay since she was four years old. Both her mother and grandfather were sculptors, but Vincents was prevented from studying art at university because her portfolio didn't include any drawing – to this day, she rarely uses a pen. So she decided on business studies instead. 'I have always been a very independent person, and I thought that one day I would probably run my own business, so business studies seemed a sensible choice,' she explains.

She continued taking courses with skilled ceramicists and artists, and in her mid thirties took a radical turn: after a year of pottery classes at technical college followed by an internship with Danish potter Christian Bruun, she launched a full-time career as a ceramicist. 'I had played with clay for 33 years before ever thinking in commercial terms,' she says. 'This meant that when I made the change I had a lot of hours with clay behind me, and this was crucial in being able to make a living almost from the start.'

Vincents' studio and store are in the middle of a street of independent shops. The door is always open and she sells all of her work straight from the kiln: 'I get a lot of direct feedback from my customers,' she says. 'And, with no middleman taking half of the profits, my work is affordable to a larger public. Meeting the recipients of your work and knowing that someone appreciates it is a huge motivation. There are quite a few artisans in the Copenhagen area, so the competition is tough, but that just keeps you on your feet in terms of always giving your best.'

A handmade object talks to people in a different way from a mass-produced object. I have seen the reaction in hundreds of people, and I guess it is biological. It brings you back to the root of who you are, because no matter how technological we become, we still have hands and eyes, brains and senses. And it is universally gratifying to make these work together.

Inge Vincents

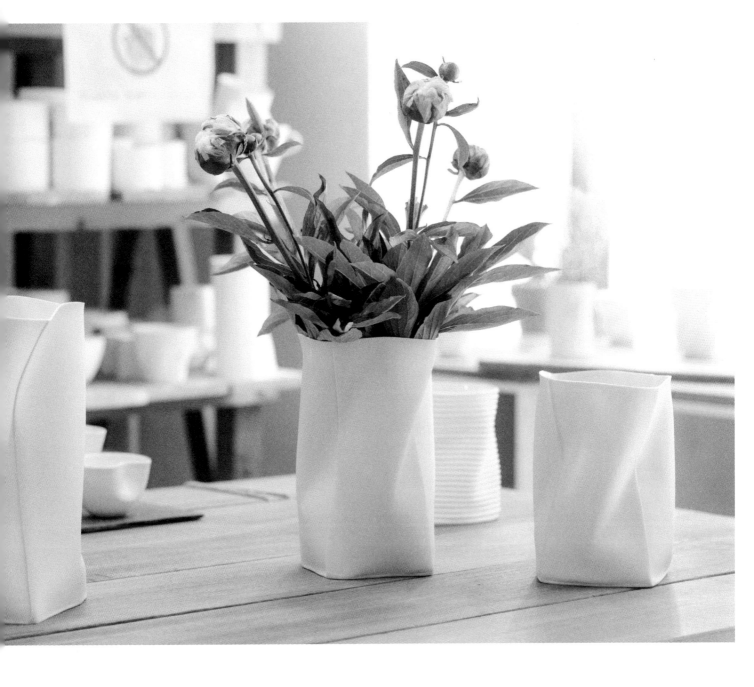

Copenhagen

Inge Vincents

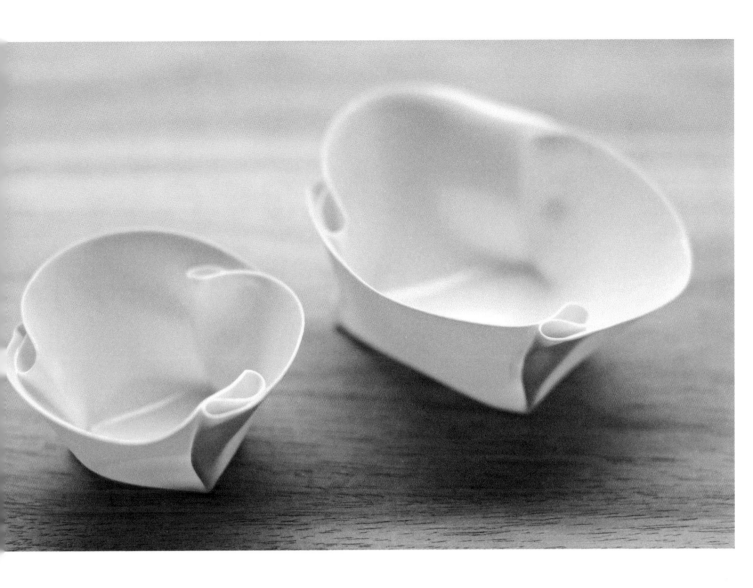

I aim for an organic yet tight shape; I really like to see the organic properties of the clay in the end result. Clay is soft and pliable, and when you get the timing right you can freeze these qualities in the work. This is often where ceramics become very tactile – where you just have to pick it up. This irresistibility is essential.

Tina Marie Bentsen

Tina Marie Bentsen (b. 1981) started her career as a pottery apprentice with almost no knowledge of ceramics. After three years of absorbing the skills of the craftsmen she was assisting, she continued her education at the Kolding Design School, where she was trained as a ceramic designer. She now has her own studio in the old city centre of Copenhagen, in a space shared with another four makers.

She is also the co-founder of Den Danske Keramik-fabrik, a small ceramics factory just outside of the city, on the tiny island of Bornholm. The factory was established to enable Danish studio potters to keep their production local when demand gets too big for them to manage themselves. 'That is where the dilemma begins – should you hire an assistant, which is sometimes not possible due to limited space or economy, or should you send your production off to China, Vietnam or Portugal, since there have been no production factories in Denmark for years?' she says. Many Danish ceramicists have experienced the problems of working with overseas factories:

minimum orders are huge, global transportation is far from sustainable and communication is difficult. Not to mention the resulting loss of skills from Denmark. 'Nobody seemed to solve this dilemma for us, so a handful of colleagues and I decided to do something about it ourselves,' Bentsen explains. 'We spent our hard-earned savings, put in a lot of work and opened our own factory in April 2016. We are now able to send our orders to our "shared assistants", to a place we know has high environmental standards, takes good care of the employees, maintains material knowledge and know-how and creates local jobs.'

Mass consumption and throwaway culture
are things I try to resist. In my work, I produce
handmade, limited and thereby more expensive
ceramics, which will hopefully stay with somebody
for a much longer time than cheap, mass-produced
ceramics. In my private life, I try to be conscious
about my shopping habits and the values
I'm teaching my eight-year-old daughter.

Tina Marie Bentsen

Copenhagen

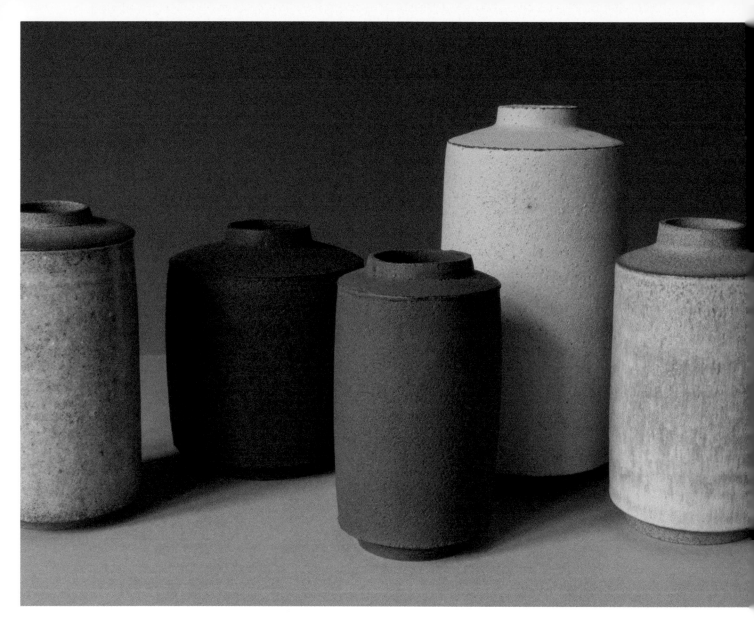

It is as if I have a conversation with the clay or with
the never-ending glaze development, which often
– if not always – ends in a compromise between
what I thought I wanted and what the materials,
the technique and the kiln are willing to give.

Tina Marie Bentsen

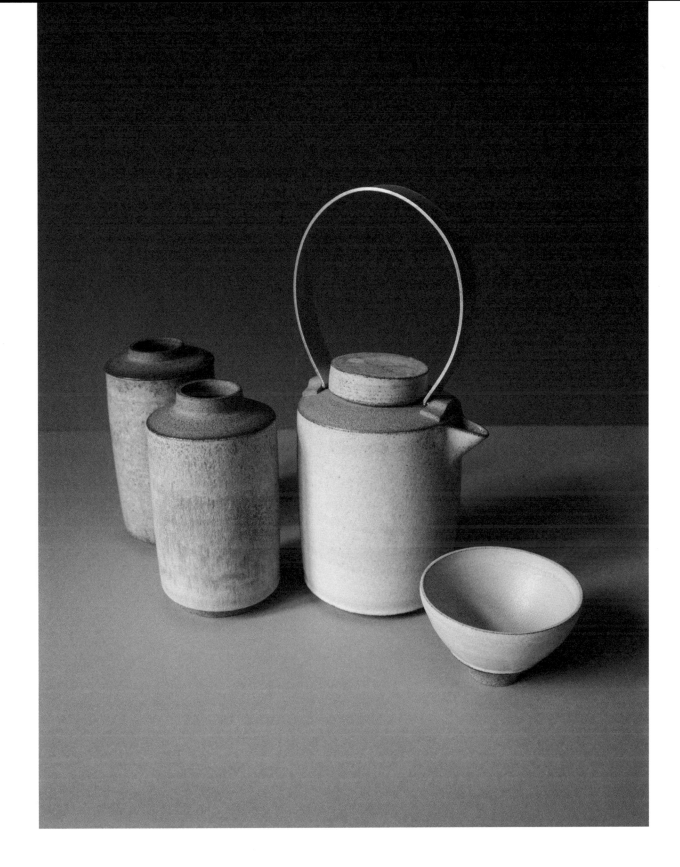

Copenhagen

Tasja Pulawska

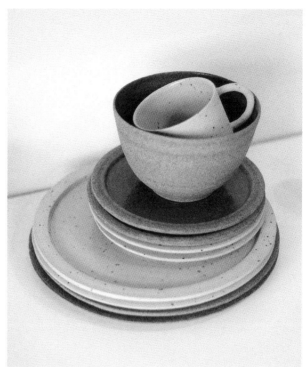

Tasja Pulawska (b. 1983, Poland) grew up in Berlin and Warsaw, where she worked as a graphic designer for five years while exploring ceramics as a hobby. It was only when she moved to Oslo in 2012 that she started dedicating more time to the craft. Working in a shared workshop meant she could see how others were handling the clay and gain a better understanding of her own practice. Having made the decision to work as a ceramicist, she moved to Copenhagen and, shortly afterwards, started working as an apprentice to Eric Landon at Tortus Copenhagen. She's now his assistant and helps him teach pottery to his workshop students, alongside running her own studio. 'Moving to Copenhagen allowed me to change my career, and gave me the freedom to be a maker,' she says. 'Design and handwork have a long and great tradition here. People appreciate it and are very knowledgeable about it.'

Now a professional ceramicist with her own practice, Pulawska's main concern is sustainability. She's highly conscious of the fact that producing things only adds to an already escalating number of objects in the world, so she tries to make her work as ecological as possible. 'I think that handmade pieces are treated with more care, so they are used longer and in a way become timeless – especially if they are made of a natural material like clay that can survive throughout centuries,' she says. 'This attribute of pottery has always appealed to me. I like natural materials and vintage things. A piece of wooden furniture or a plate that comes from the previous century and is still beautiful and practical simply makes me happy – even more so when it gains a patina over time. It would be such an honour if any of my pieces get that far and someone could look at them the same way in the future.'

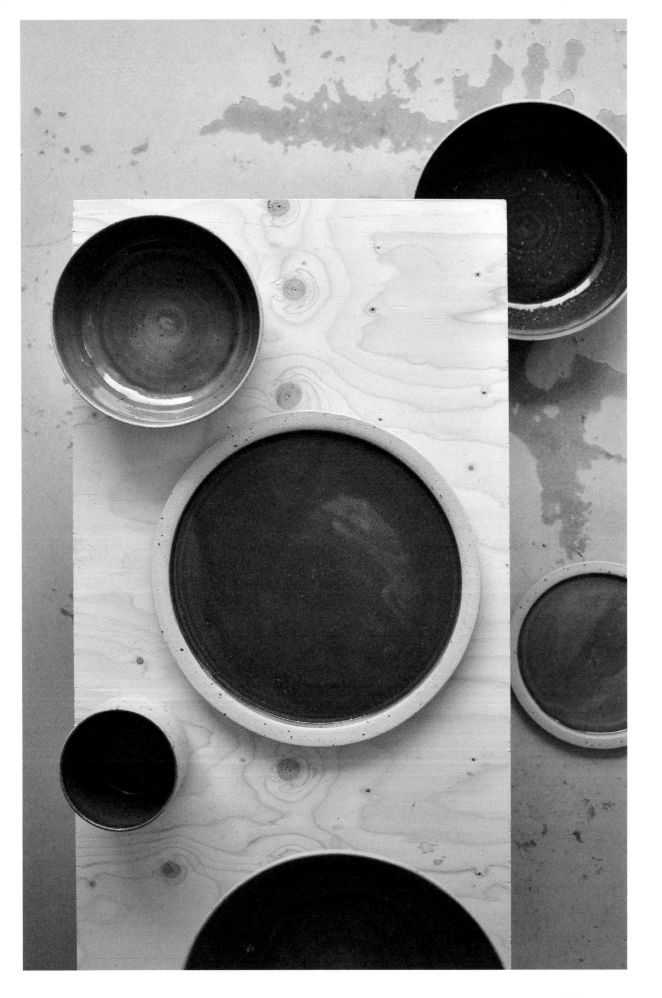

I like to know where the things I buy come from and I think people in Copenhagen share that view. More and more people like to support local businesses and the notion of "shopping small". There have been so many people from the neighbourhood coming in to congratulate me on my new place and it's mostly locals who buy my work. They are drawn by the authenticity of it but also by the fact that they can follow every step of the making process of the things they are buying.

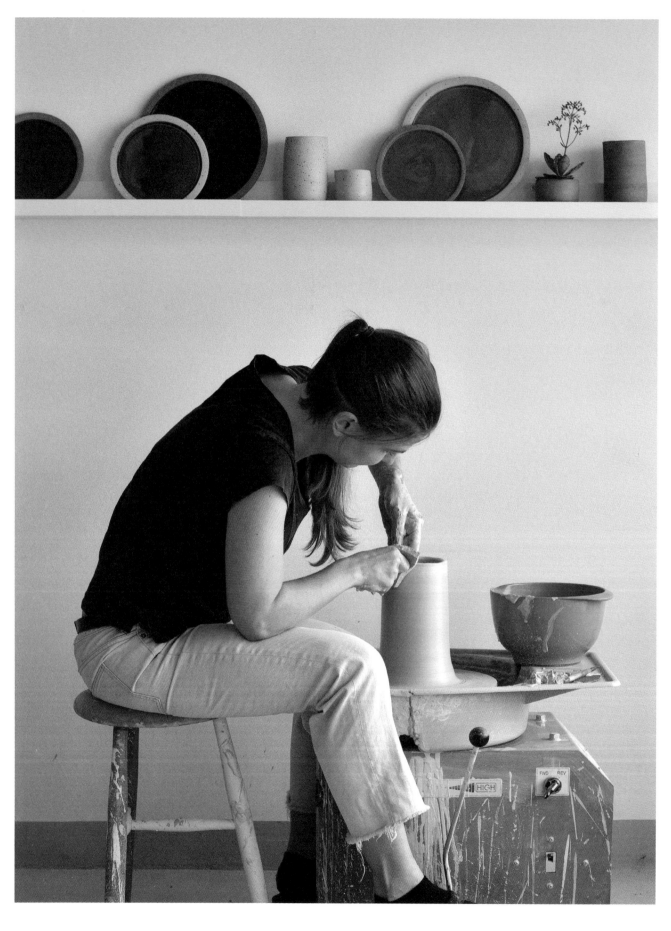

Tasja Pulawska

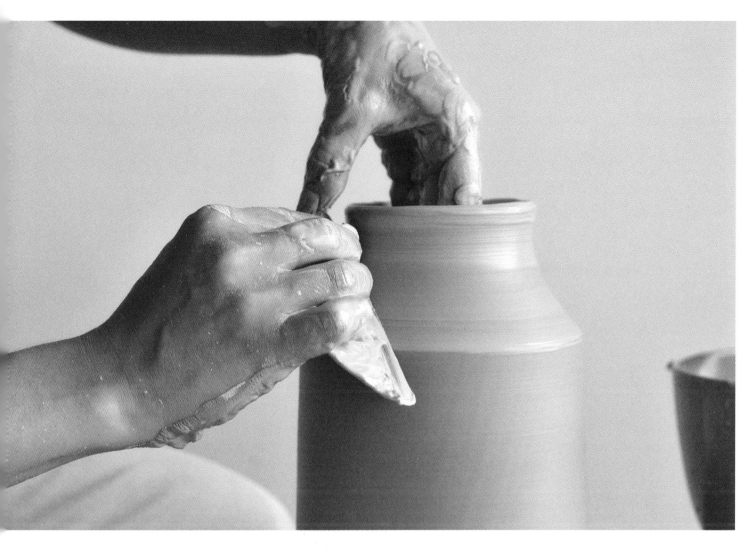

I always felt that as a maker, first of all, you have to have a good technique. It's not easy today to find people who can teach you, but I was lucky enough to learn from the best, so I know I have strong underpinnings. Nevertheless, learning is a never-ending process – as long as I feel I'm learning, that keeps me inspired, open and striving for something new or better.

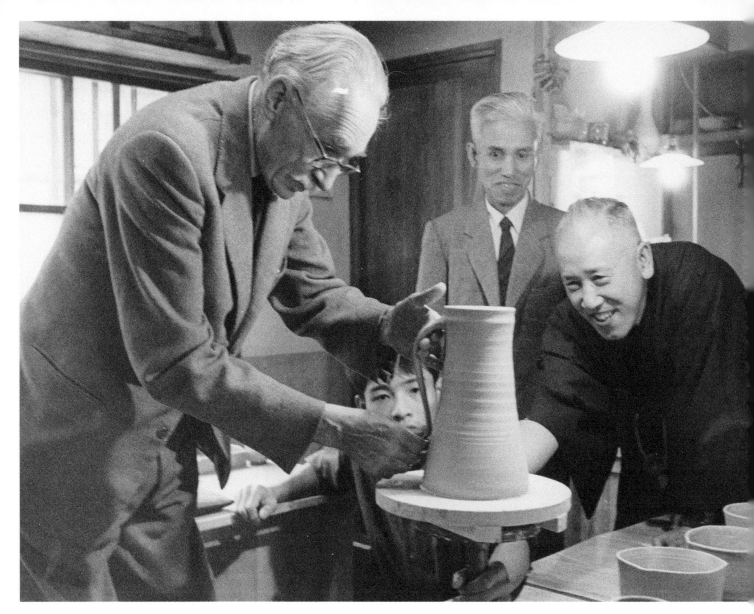

Bernard Leach, Yanagi Sōetsu, Hamada Shōji and **Teamaster Sato** at Toyama, Japan, 1960s

Tokyo

Jōmon ware is not only the earliest type of ceramic object found in the Japanese archipelago, but also the earliest example of functional pottery anywhere in the world, so it's no wonder that ceramics are so tightly bound up in Japanese identity. It may seem curious then that anonymity played such a crucial role in Japan's 20th-century Mingei folk craft movement, but its co-founder, Yanagi Sōetsu, believed that setting 'the individual artist free from his individuality,' was crucial in preserving Japan's collective identity.

National identity became a new concern for Japan during the Meiji period (1868–1912) after the Kanagawa Treaty with America forced the archipelago to open its borders for the first time after 220 years. In the same way that Glenn Adamson talks about modern craft being invented in opposition to industrialisation, so Japanese identity was created through interaction with the 'other' that its people were encountering for the first time. Alongside building its military and empire, the country sought to assert its *nihonjinron* (essential Japaneseness) in contrast with the West, and pottery was something in which Japan had far more skill and history than America or Europe. Ceramics formed a substantial part of the three international exhibitions the country took part in between 1862 and 1910 – and the Imperial House of Japan created new laws protecting often extinct crafts techniques, encouraging Japanese artists to resurrect them.

However, the Meiji period also saw Japan industrialise at an unprecedented pace and so, by the 1920s, a way of life that had remained unchanged for generations was under threat. In the same way that the Arts and Crafts movement can be seen as a reaction against Britain's Industrial Revolution, Mingei sought to reassert cultural identity through preserving particularly Japanese crafts and the lifestyle that went with them – looking to the past for alternative models for the future.

Unglazed earthenware jar with incised decoration, **Jōmon ware**, 3500–900 BC, Japan

Japanese philopher Yanagi Sōetsu (1889–1961) together with potters Hamada Shōji (1894–1978) and Kawai Kanjirō (1890–1966) coined the term *Mingei* (literally 'art of the people') and Yanagi formalised the Folk Art Movement in 1926. The Folkcrafts Pavilion at the Tokyo Exhibition in 1928 was largely designed and made by craftsmen associated with the movement and in 1936 the Japanese Folk Crafts Museum (Nihon Mingeikan) was established. Mingei had become a powerful tool in maintaining Japanese tradition in the face of an increasingly industrialised and globally entangled society.

Despite being so concerned with ideas about identity, one of the movement's crucial components – one that markedly differentiates it from Britain's Art and Crafts Movement – is that of anonymity. Yanagi had been inspired by trips to Korea, then under Japanese occupation. Edmund de Waal explains in *20th Century Ceramics:*

Mingei was best seen in the work of peasant Korean potters, or the craft workers of Okinawa, who made things unknowingly and self-effacingly, unconcerned by an imperative to innovate. As a movement, its aim was to preserve some of the threatened narrative local traditions of handwork through inspirational contact with artist-craftsman leaders.

Juxtaposed with capitalism, industrialisation, mass production and urbanisation, the anonymous beauty in these objects was put on a pedestal. 'Not a single piece of Sung ware bears the signature of its maker,' says Yanagi in *The Unknown Craftsman*, explaining that this was because craftsmen of the Sung Dynasty were not 'self conscious artists.' Hamada and Kawai followed his ethos and didn't sign their work, but obscurity was not a new idea. Even before the Meiji period, feudal Japan was structured on ritual, repetition, and the notion that the individual was secondary to the overarching national narrative – everything, from sumo to samurai, was predicated on the role played, not what was achieved.

However, many contemporary commentators, Tanya Harrod in particular, are critical of Yanagi's quest for anonymity, bristled by references to young boys bored to tears by the repetition of the craft, an image that is far from the joy in self-directed making championed by the Arts and Crafts movement: 'The Mingei movement was profoundly elitist, led by a small self-appointed group of artists, including the British potter Bernard Leach,' she says in *The Real Thing.*

The movement's theorist [Yanagi] saw himself as a sensei (master), guiding "unspoilt" artisanal craftsmen whose work, he believed, should remain essentially anonymous. His way of thinking contrasts with the ideals of the Arts and Crafts Exhibition Society that from the start made a point of giving credit to both the designer and the maker of the object in their catalogues.

Rightly or wrongly, by combining anonymous folk craft with Buddhist precepts and the wabi-style tea

ceremony, Yanagi was able to articulate a uniquely Eastern identity. In *The Unknown Craftsmen*, he talks of a Buddhist liberation from the duality of beauty and ugliness, in which craftsmen rise above the distinction between the two and simply make work with 'heart,' 'warmth' and 'friendliness' that transcends authorship. The ritualistic practice of tea ceremonies had been imported to Japan from Song China as part of the Zen sect of Buddhism.

> Wabi is a literary term related to the concept of material deprivation, which in the context of the tea ceremony has come to mean the rejection of luxury and a taste for the simple, the understated and the incomplete. At first conceived as an aid to meditation, the tea ceremony developed as a major aspect of Buddhism, with tea masters increasingly acting as arbiters of taste.

explains Emmanuel Cooper in *10,000 Years of Pottery*. The understated aesthetic of this teaware created by ordinary craftspeople has resulted in a uniquely Japanese aesthetic that has endured in ceramics to this day.

The Allied occupation of Japan after the Second World War was yet another threat to the country's identity and after its sovereignty was restored in 1952, Japan sought to reaffirm its uniqueness again. Initiatives such as the title of Ningen Kokuhō (Living National Treasure), which is awarded to craftsmen (to date no women have received the honour) with important traditional knowledge and skills, highlighted the value of tradition in Japanese culture, and played an important role in promoting Japanese identity overseas. Ofra Goldstein-Gidoni argues that the concept of Japanese culture promoted abroad

> is strongly influenced by the way Japanese culture is presented by Japanese both in Japan and in the framework of organized international contacts. What is put on exhibit as "Japanese culture" is mostly an officially endorsed "traditional" culture.

Nihonjinron is less an observed phenomenon and more an ideal to live up to. This official version of 'Japaneseness' has had a profound impact on the way Japanese potters are perceived both at home and abroad, and even how they perceive themselves, but much in the same way as Copenhagen's potters are throwing off the shackles of janteloven, Tokyo's potters are finding their own way forward. While deeply respectful of the long history of ceramics in Japan, they are part of a global community and just as likely to credit the influence of Lucie Rie as Yanagi Sōetsu. Tokyo's contemporary potters are part of an edgy and internationally connected scene that has its sights firmly set on the future.

Erica Suzuki

Erica Suzuki (b. 1985) was initially a student of architecture, but soon realised that drawing plans for others to work from denied her the opportunity to work with her hands and create something entirely her own. She became interested in pottery after seeing an exhibition of the work of German-born British studio potter Hans Coper and went on to study at the ceramics school in Gifu. Suzuki moved to Tokyo in 2014 and launched ceramics studio Sōk. 'The name of the studio comes from the verb "to soak". It's a pottery term and means keeping the temperature in the kiln uniform for a while, at its highest.' Confronted with the lack of space in the city, she started to make smaller pieces to exploit the full potential of her studio's tiny kiln.

Suzuki now produces ceramic vessels, small objects and fashion accessories such as earrings and necklaces. 'Pottery in Tokyo is never the best choice – it is difficult to have a large studio because the rent is so high – and there are plenty of things to worry about when your space is so small,' she says. 'However, I

have rarely felt inconvenienced in my production. Since both clay and glaze ingredients can be sent by delivery service, it is possible to produce without stress in Tokyo.' Hans Coper's mentor, Lucie Rie is another inspiration, especially when it comes to working in confined spaces. 'Lucie Rie is the leading expert on urban pottery,' says Suzuki. 'In order to do ceramics in London, she devised a way to paint with a brush, without having to make large quantities of glaze. Her ingenuity of technique is an inspiration for the spirit of ceramics in Tokyo.'

Mass production and mass consumption is starting to break down in Japan today. People are beginning to resist ever-increasing things, because objects are overflowing. It is my mission as a maker to make something good over time, rather than making a lot. My productivity would improve if I used moulds, but I still make pieces one by one, because every little difference that appears when making by hand is important for my style.

Erica Suzuki

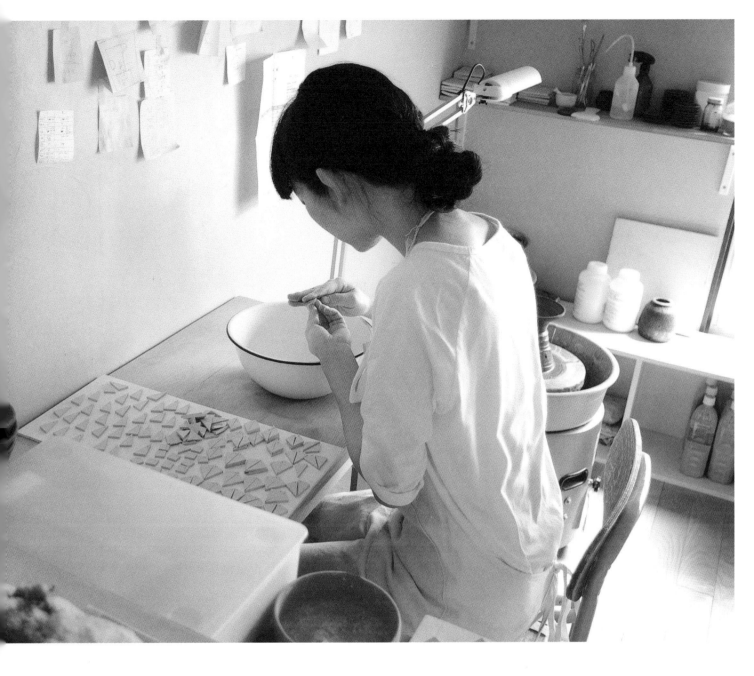

Tokyo

The most frustrating element in the process is also the most interesting – and that is the fact that the exact results are not known until the moment you unload the kiln. I often overlay several kinds of glaze, but even a slight difference in how I've done that can produce big differences in results, so I make new discoveries every day.

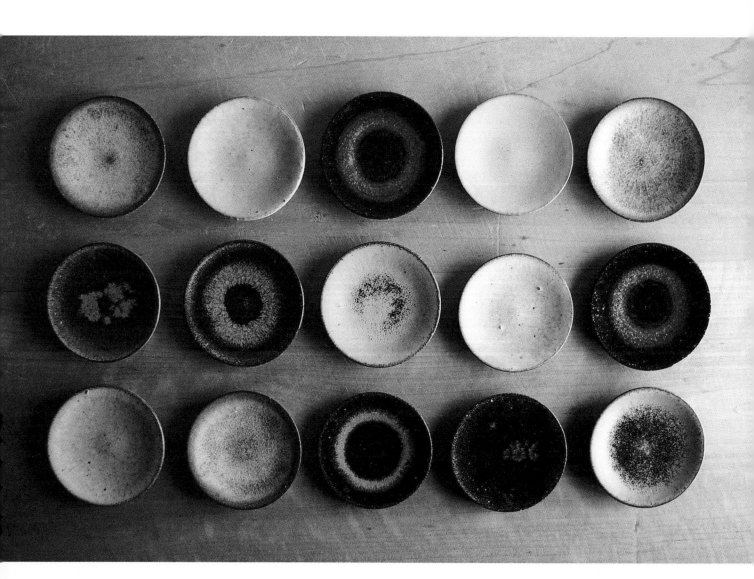

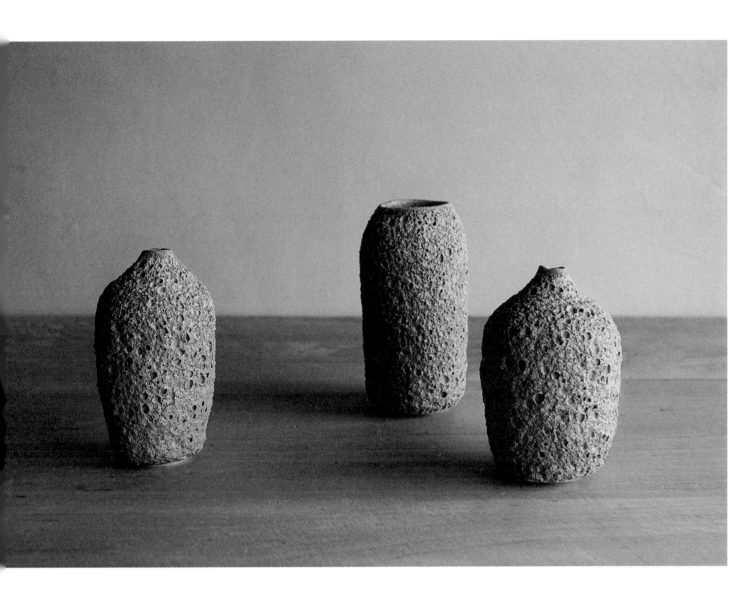

Tokyo

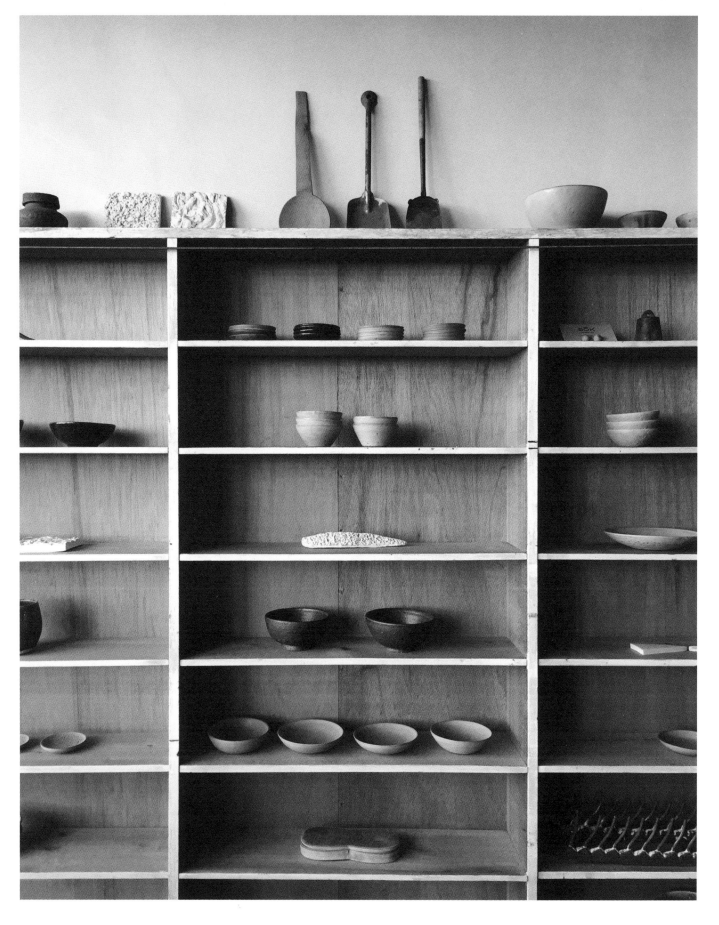

Erica Suzuki

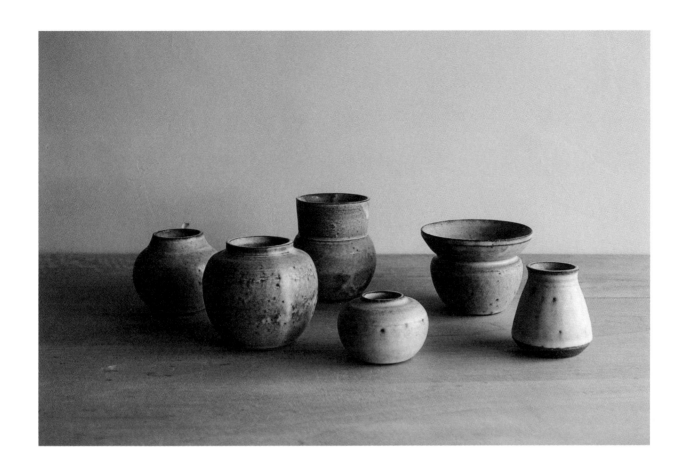

My basic philosophy has not changed, but as I get older, my favourite colours and forms are evolving. It is important to have both an unchanged axis and yet the margin to change flexibly. Whatever you make, the goal is to be able to create as many works as you think are good.

Haruna Morita

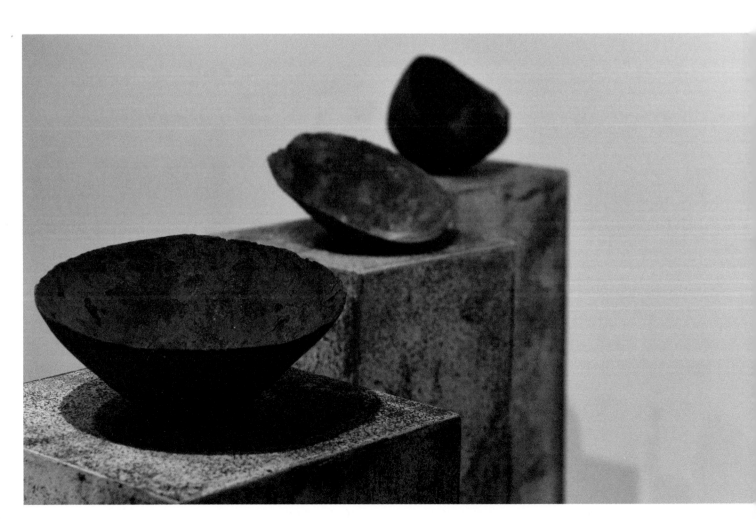

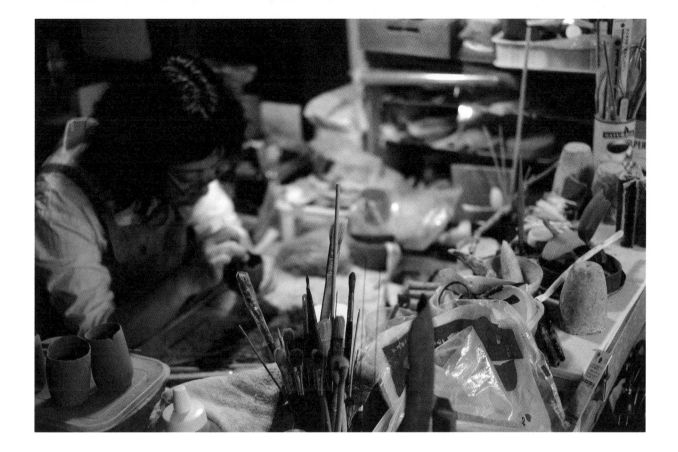

The abstract pieces that Haruna Morita (b. 1981) makes from a specific type of terracotta clay found in the Shigaraki region are formed intuitively – the only thing dictated in advance is the size. She starts with a lump of the grainy-textured clay and either starts to throw or to roll out slabs, without any premeditated ideas about what she's making. A form will emerge – usually a cylinder or a bowl – and then she cuts and slices the piece or attaches it to another. 'I continue to explore the final form by manipulating the random shape into a more concrete one, but at the same time I try to understand the limits of the clay's versatility,' she explains. 'During this process, a new shape can emerge from the sliced or cut parts of the original piece. To encounter an unplanned and unpredicted form is one of the most fascinating aspects of ceramic art.'

She applies the raw ingredients of glazes, such as minerals and metal oxides, directly on the bisque-fired clay, using a paintbrush, as if she were applying layers of paint. She might add paper, fabric, cloth or string – whatever she needs to achieve the desired textures. 'I apply layers of raw materials and repeat the firing process at between 1,210 and 1,230°C until the piece almost reaches a place where human touch seems to be long lost, and its presence becomes independent and organic,' she says. 'For me it is very important to be able to explore the nature of ceramics and to allow the pieces to form themselves freely.'

Tokyo

I apply layers of raw materials and repeat the firing process at between 1,210 and 1,230°C until the piece almost reaches a place where human touch seems to be long lost, and its presence becomes independent and organic.

Haruna Morita

Tokyo

Haruna Morita

I have used the same clay for over 13 years, as it
has the right viscosity and a fine grainy texture.
My hands have adjusted to this terracotta over the
years, which allows me to manipulate it naturally
and almost intuitively, without any particular
awareness of creating a shape.

My primary motive is to make sense of what I see,
feel and understand in the natural world and
express that in the form of ceramic objects. There is
no intention of delivering a particular message
to society through my work.

Yukiharu Kumagai

Yukiharu Kumagai (b. 1978) creates most of his ceramics without a studio or a kiln. He digs up his own clay and fires it in open bonfires – clearly something not possible in central Tokyo where he teaches ceramics at the Musashino Art University. Instead he travels in order to create – to the coast, to local islands, to friends' studios and to the mountains. 'It's an easy way of firing,' he says. 'I'm attracted to the aesthetic of the resulting surface of the object, stained by carbon.'

Kumagai studied art and design in Tokyo, specialising in ceramics and quickly beginning a career as an independent potter. He is inspired by the earthenware of the Jōmon period and, apart from utilitarian objects, he also makes figurines, masks and sculptures, often using unfired or sun-dried clay – he even draws with clay onto Japanese washi paper.

'What I find fascinating about the earthenware pieces I create is that they can be made with a pair of bare hands, with natural clay that you can find anywhere,

and without special tools or equipment,' he explains. 'Cost-free firing methods using merely a bonfire can transform a piece of soft clay into a water-resistant pot.'

Kumagai is constantly learning and driven by a desire to share what he discovers, meaning that teaching is an important part of his practice. 'Every time I make something, I find it interesting and enjoyable, and I keep making over and over again,' he says. 'I want to keep exploring and learning from the clay, and I want to show people how great this material is.'

Yukiharu Kumagai

What I find fascinating about the earthenware pieces I create is that they can be made with a pair of bare hands, with natural clay that you can find anywhere, and without special tools or equipment. Cost-free firing methods using merely a bonfire can transform a piece of soft clay into a water-resistant pot.

Tokyo

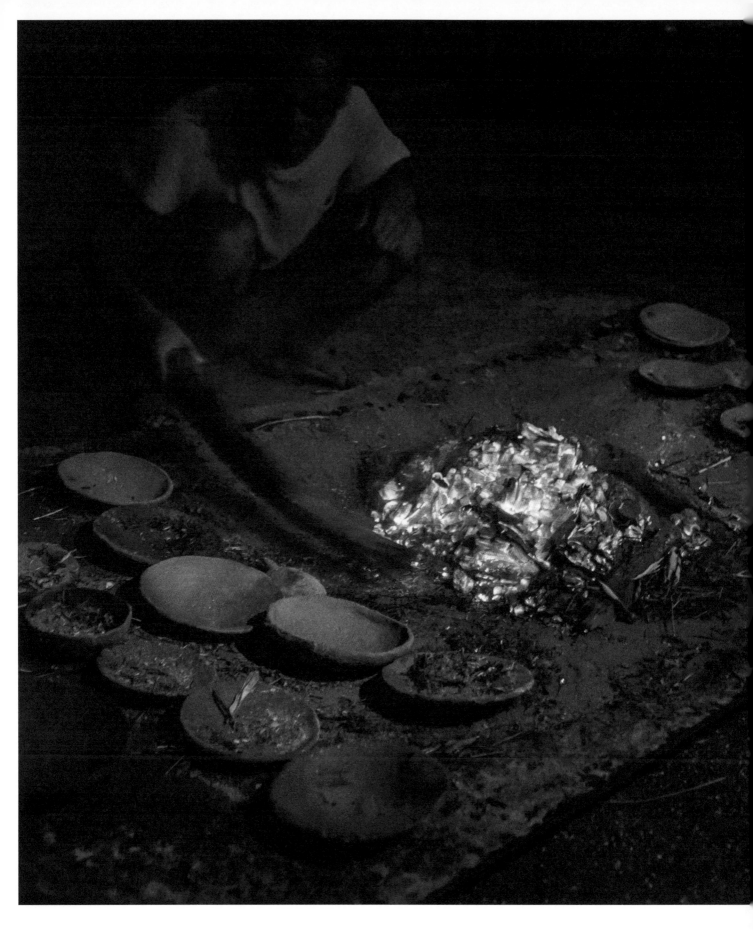

Yukiharu Kumagai

I usually start by digging up natural clay. I play with it and manipulate it until something interesting emerges. Then I fire the piece, often without a kiln; just in an open-fire in a field.

Miki Furusho

Miki Furusho (b. 1967) digs her own clay on the Izu Peninsula, about 100 km southwest of Tokyo. Rugged coastlines, pristine forests and clear views of Mount Fuji make for breathtaking surroundings as she works. Once back in the studio, she doesn't wedge the clay – the usual practice of kneading the clay to remove air bubbles – because this would cause the natural pink, brown and white tones to merge into a uniform red. Instead, she pats it into a paper-thin slice, which she applies onto forms made of another plain clay from Shigaraki, leaving the Izu clay parts unglazed. 'Natural patterns of blacks, browns and whites appear after they have been fired,' she says. 'As I don't wedge, these are the original patterns of the clay, just as it has been dug out – they look like marble or tree bark.'

Furusho also collects iron ore and grinds it into tiny pieces with a potmill to turn into a glaze. 'This black glaze is beautiful when reduction fired in a kerosene kiln, rather than in an electric kiln,' she says. 'Tiny crystallisations appear on the surface of the glaze,

which has a matte expression.' The smoke and noise of her fuel-burning kiln makes it impossible to use in her tiny 11-square-metre studio in the centre of Tokyo, so instead she has installed it in Hiratsuka, about 70 kilometres from her home. 'For every firing, I have to put my work in boxes and take it there by car. If my kiln was electric, I could fire at home, but I prefer a fuel-burning kiln.'

Despite the lack of space in the city, Furusho – who read law in Tokyo and later studied at Arita College of Ceramics – sees Tokyo as an environment that frees her from tradition and rules: 'Most potters in Japan are based in Mashiko, Seto, Arita or Shigaraki – not in Tokyo. Being based in Tokyo means I am free from the usual practice of ceramics. And Tokyo is also the centre of Japanese culture and art – it has many shops, galleries and museums. It's an inspiring environment, and I can sell directly to the shops.'

My work is all about texture. I want to express
the beauty of the unwedged clay, which is
an original memory of the earth.

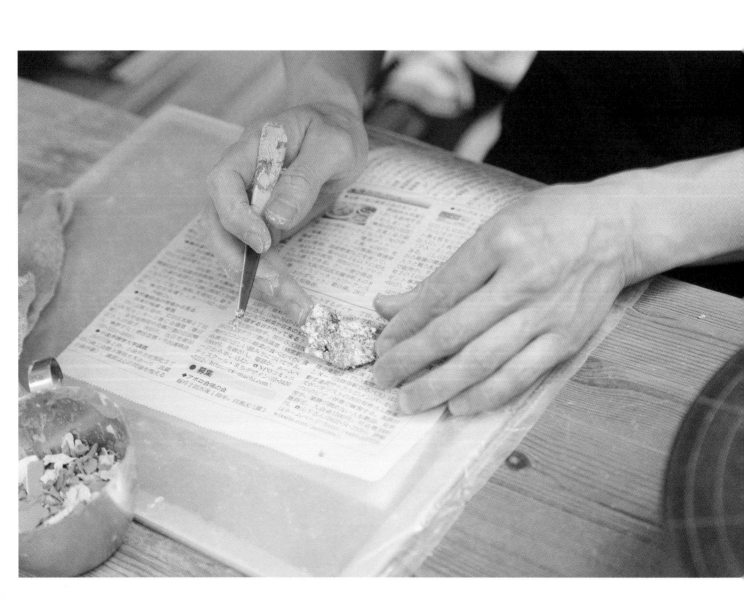

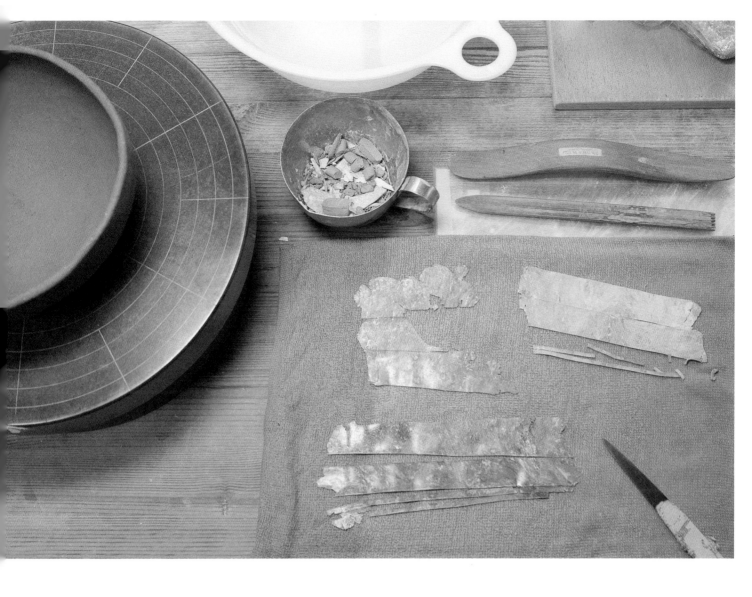

Tokyo

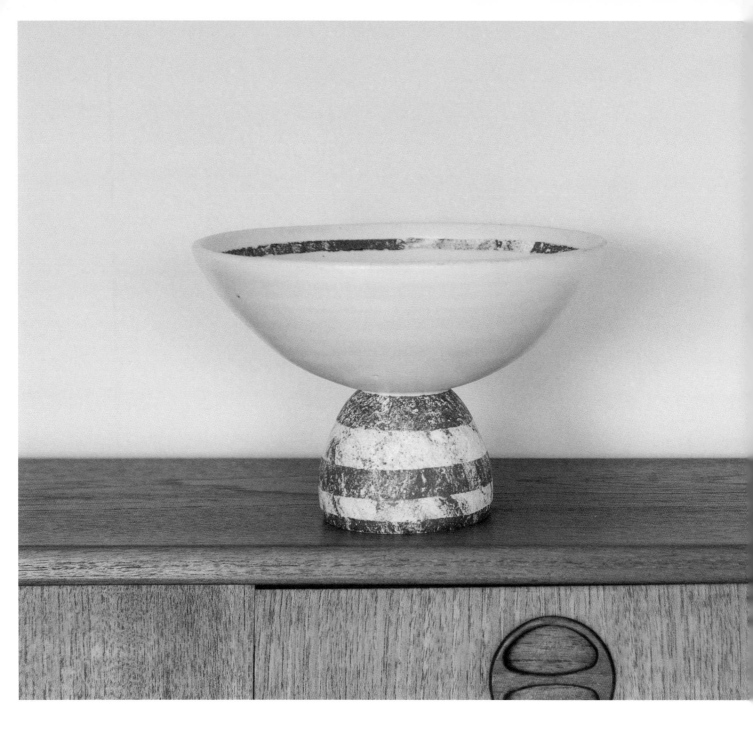

Miki Furusho

In Japan, we have a word that comes from
the Japanese tea ceremony: "ichigo ichie".
It means a "once-in-a-lifetime opportunity".
Making by hand is like ichigo ichie – everything
you make is the only one of its kind in the world.
No two of my Izu-clay-patterns are the same.

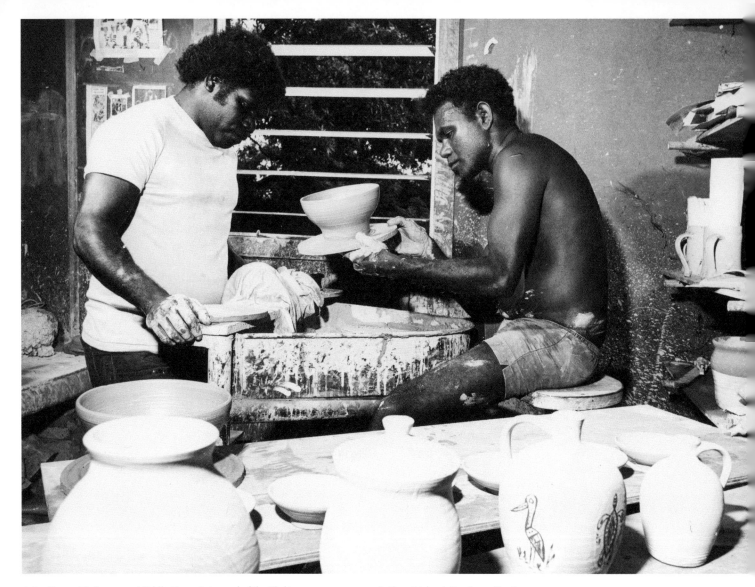

John Bosco Tipiloura and **Eddie Puruntatameri** of the Tiwi Language group on Bathurst Island, Northern Territory, 1977

Sydney

ANCIENT & MODERN

Sydney has a thriving contemporary ceramics scene characterised by handmade tableware developed in tandem with a food revolution that started with chefs such as Donna Hay and Tetsuya Wakuda. Hay, Wakuda and others started to commission handcrafted ceramic tableware and wood fired stoneware from local potters for their restaurants and studio pottery has flourished hand-in-hand with the epicurean movement ever since. The result is a distinctly Australian style that can be seen in the work of the studio potters featured in this chapter. While their work is largely informed by European and Asian influences that are covered elsewhere in this book, the full story of Australian ceramics cannot be told without reference to the Aboriginal and Torres Strait Islander communities.

'Clay at Weipa was sacred. We only used it for ceremonial purposes and each colour had a meaning.' So said Dr Thancoupie Gloria Fletcher James AO (1937–2011), elder of the Thaynakwith people of Western Cape York in far North Queensland and one of Australia's best-known Aboriginal ceramicists. The sacred role that clay played in Weipa is typical of Indigenous communities across Australia. While ceramics history dates back millennia in many parts of the world, no pottery has been found in Australia that pre-dates the late 18th century. Clay was used for ceremonial decoration, for cooking and as an antiseptic, so sources of quality clay were known – and it's likely that pottery was understood through the Indonesian fishermen who visited Australian waters – but as semi-nomadic hunters and gatherers, Aboriginal people had little use for pottery.

In Australia, clay is a contemporary medium introduced by potters following European and Asian traditions, largely from the 1950s onwards. However, it would be wrong to conclude that Aboriginal and Torres Strait Islander ceramics simply follow European and Asian teachings – it is in the synthesis of those teachings with ancient cultural symbolism and story-telling that the Indigenous ceramic art movement was established and two ceramicists

Dr Thancoupie Gloria Fletcher James AO

in particular, Thancoupie and Eddie Puruntatameri, played a crucial role in this process.

Thancoupie was an elder of the Thaynakwith people in the Western Cape York area of Queensland and the last fluent speaker of the Thaynakwith language. She studied ceramics in the Anglo-Asian tradition at East Sydney Technical College from 1969, taught by non-Indigenous Australian ceramicists such as Peter Rushforth, Bernard Sahm and Peter Travis, as well as Shigeo Shiga who was Japanese, American Joan Grounds, and Derek Smith who is English. She absorbed all of those influences, but went on to create an oeuvre entirely of her own. She described the inspirations behind the spherical pots that came to typify her work as 'mother, love, unity, tribe, and everything to do with woman,' and they were decorated with drawings of the legends she was told as a child. Her roles as a story-teller and an advocate

for her community were vital and in many ways clay was just a medium through which she could do that work. Her ceramics are now in the collections of the National Gallery of Australia, as well as in museums and art galleries in Victoria, South Australia and Queensland. She was awarded the AO – Order of Australia – in 2003.

Puruntatameri studied under the non-Indigenous Australian ceramicist Ivan McMeekin and English potter Michael Cardew, who in turn had trained under Bernard Leach. McMeekin and Cardew established a pottery at the Bagot Aboriginal Reserve near Darwin, after the publication of McMeekin's *Notes for Potters in Australia: Raw Materials and Clay Bodies*. The pottery's ambition was to train artisans to make functional ware for the local community, but as McMeekin explained, it was also about helping Indigenous communities to 'find a satisfactory relationship with this wider community of some few million people of varied extraction that now inhabit Australia'. It was a time of great change, and in the same way that clay helped people navigate the change brought about by the industrial revolution in nineteenth century Britain, the creative expression found in clay was one way that Aboriginal and Torres Strait Islander people communicated and preserved their culture in a fast-changing environment. In 1970, Puruntatameri and McMeekin established the Tiwi Pottery on Melville Island (one of the Tiwi Islands and part of the Northern Territory) with similar aspirations, and soon achieved artistic and commercial success. Here, the emphasis was on surface decoration and so, although the forms were Asian-inspired, Japanese brushwork was quickly replaced with decoration unique to Tiwi, derived from images and patterns traditionally painted onto bark or rocks or drawn into the sand. In 1999, the Pottery won the 16th Aboriginal and Torres Strait Islander Art Award in Darwin, and today works by Tiwi potters are held in major public and private collections all over the world.

The legacy of Thancoupie and Puruntatameri is that Indigenous ceramic art is now seen as a movement in its own right that goes above and beyond

the influence of Europe and Asia. Testament to this is the pottery at Ernabella in the South Australian desert and the Aboriginal and Torres Strait Islander Arts and Crafts School, established at Cairns TAFE College Queensland in 1985. Alumnus of the latter Jenaurrie Walker is building on the work started by Thancoupie and Puruntatameri and has explained:

> My contribution towards supporting our people is to become recognised as an artist and to promote and develop the art of the Indigenous population of Australia. This opens up discussion about our heritage and culture and it can change the ignorance and lack of resource material that has been a problem and has created many of the conditions we face today.

Whereas in Europe and Asia ceramics is an ancient practice, for these communities, it has proved to be a new medium through which to tell their stories, enabling them to breath new life into an ancient culture.

Alana Wilson

Alana Wilson (b. 1989) works in a large garage over-looking Tamarama Beach, Sydney. Born in Canberra, she spent the majority of her childhood in New Zealand surrounded by water. Her parents ran a swimming school and she swam most mornings, evenings and weekends. Today, when she's not in her studio, she teaches swimming at a local aquatics centre. 'These environments have been immensely influential on my work and lifestyle,' she says. 'My studio overlooks the water to the south end of the beach with the waves crashing on the rocks – it's a great spot to keep an eye out for dolphins or whales. I find having this amount of water close by extremely balancing. My studio is a blank space where I can work through ideas.'

Wilson moved to Sydney to study ceramics at the National Art School, graduating in 2012. 'We were encouraged to try things, rather than to question them or hypothesise too soon,' she says. 'Because of this, I am still very experimental in my practice. Working through forms and experimenting with

glazing and firing in the studio is immensely reward-ing.' She explores both primitive and contemporary aesthetics and techniques in order to embrace tex-ture and tonality. 'I am constantly refining the ves-sels' silhouettes and language of form, which will often depend on the associations I aim to embed within the works and whether they reference cer-tain ancient or historic cultures,' she says. Because all Wilson's works are vessels, regardless of what meanings and references she embeds in them, they can always be used as functional objects. 'They fit into daily life and can be easily understood by a wide audience, because we are so familiar with a vessel – it's something that would normally be in tactile con-tact with the human body.'

Colour – and the lack of colour – has a profound significance in my work. I have done a lot of research relating to the psychology of colour and light, and how they affect the environment and the viewer. When someone describes something with the phrase "less is more", what they think of as "less" often in fact allows the texture, physicality and presence of the works to be more dominant.

202

Alana Wilson

The most compelling feeling I try to communicate in my work is that moment when suddenly every-thing becomes clear – when you have a precise understanding and immense appreciation of the time and place you are in, the people that you are connected to and the importance of humanity.

I love the honeymoon phase of an idea, when you are profoundly inspired and feel such a strong need to be making in the studio and setting up opportunities to allow this idea to grow and succeed in reality.

Sydney

Hayden Youlley

Hayden Youlley (b. 1983) designs and makes porcelain tableware, motivated by the desire to inject joy into mundane objects. 'There is a simple feeling of enjoyment I get from using a piece of my own work to eat breakfast from, and from knowing that there are more and more people doing the same thing every morning.'

Although he has always been passionate about design and craftsmanship, Youlley didn't discover ceramics until he enrolled in a Bachelor of Design degree at the University of New South Wales' College of Fine Arts (now UNSW Art & Design). 'Things really clicked for me as a designer when I found ceramics during my second year,' he says. 'Clay gave me the freedom to create in the moment and the ability to explore whole ideas from start to finish. The endless possibilities of surface, scale and volume offered by its malleability really sparked my interest. Once I started working with clay, I realised that it appealed not only to my fascination with materials and processes but also to my sense of independence

as a designer. It's the only medium I have worked with where I can carry out every step in the process myself – from designing and prototyping to realising and manufacturing.'

While out looking for inspiration, Youlley tries to veer off the beaten track. 'Redfern, the inner-city suburb of Sydney where I live, is a dynamic place with a mix of ethnicities and classes and a number of cutting-edge galleries, a buzzing food and bar scene and a string of vintage stores,' he says. 'It's an important place in terms of Australian Aboriginal history, culture and community, and there are beautiful murals around Redfern that reflect this.' He practises slowing down and bringing his awareness to the things most people would disregard or fail to see. 'I love to discover new areas, details, sights, sounds, emotions, thoughts, paths and experiences by engaging with the life that is just out of reach of our everyday attention.

Sydney

I find that using lots of different colours together creates a feeling of playful chaos. When I'm trying to be more light-hearted I will design using all the colours of the rainbow, which always makes me smile. I introduced a coloured edge range in the Paper Series for this effect. The playful, chaotic nature of the many colours that you can stack and arrange in different ways allows you to explore and experiment and be surprised by new and interesting colour combinations.

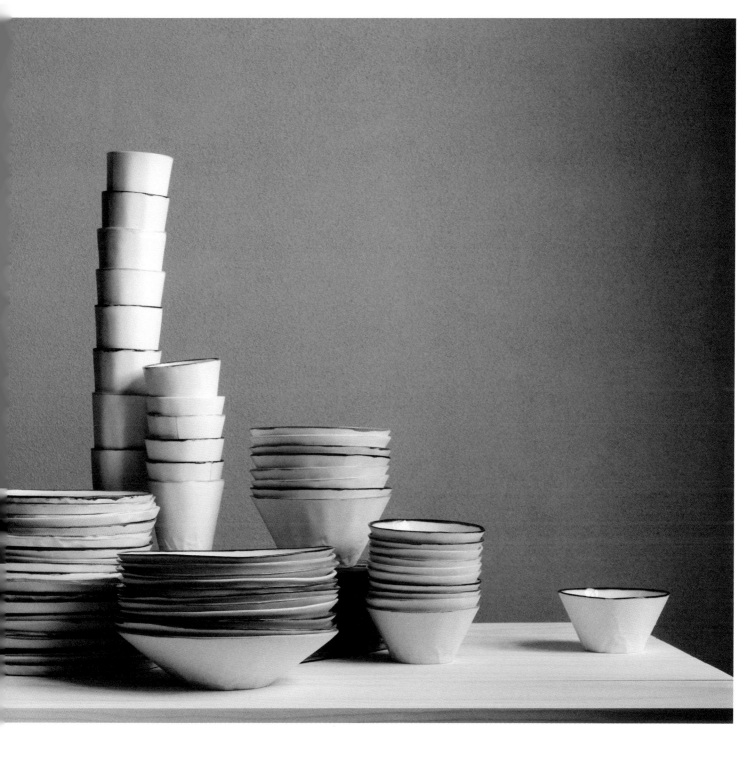

Sydney

The best part of the process is crafting by hand every day, which gives me a satisfaction that I have never experienced in any other job. It gives me a feeling that I am somehow fulfilling my intended purpose, and that who I am as an individual and what I am doing with my life are aligned. Knowing that objects I designed and created have in a small way made someone else's life a bit more fun is very satisfying.

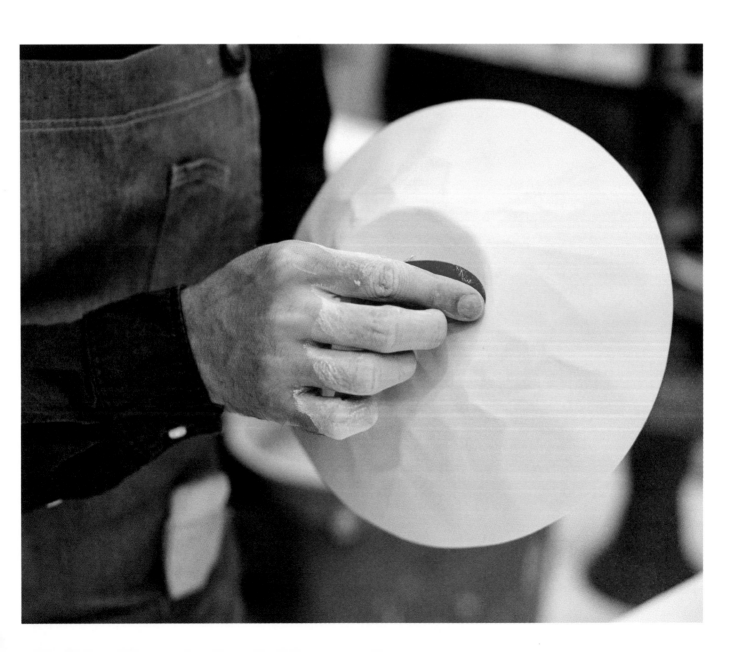

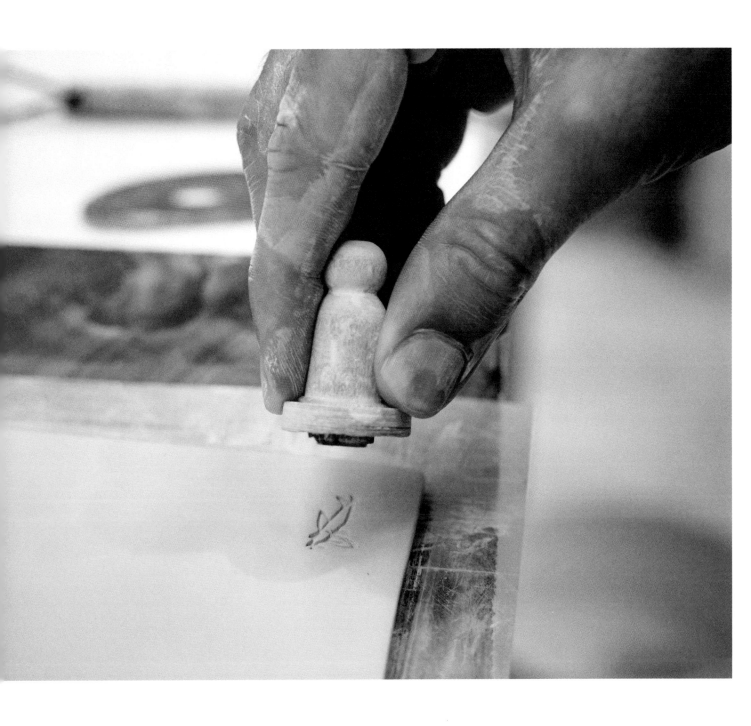

Sydney

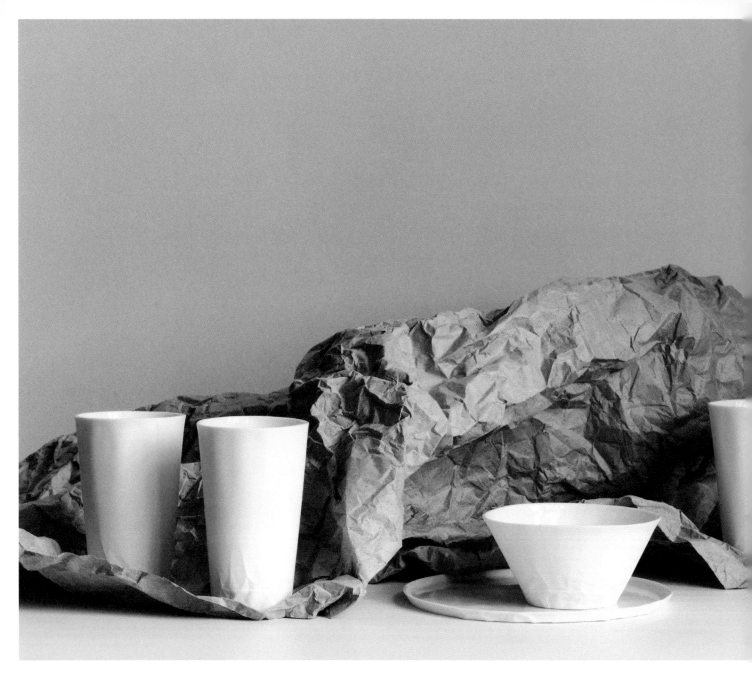

Hayden Youlley

The Paper Series is the result of countless hours of trial and error in order to give the ceramics the look and texture of crumpled paper. Through this process, I discovered three things: how much texture and how many undercuts can be added to moulds while still being able to remove the piece once it has been cast; how to make textures survive the rigours of the mould-making process, which include saturation and extreme heat, and still be accurately embedded in the mould; and how to make a particularly strong mould that will hold small and sharp details through many casts to limit the amount of times I need to replace and remake my moulds.

Keiko Matsui

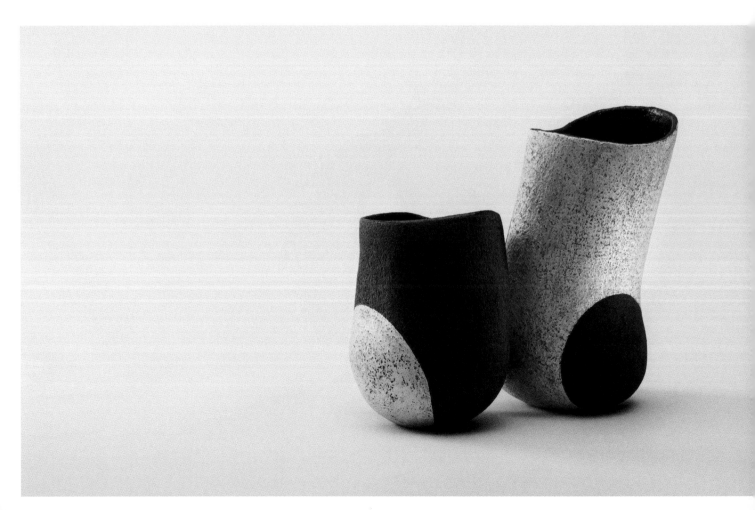

Keiko Matsui (b. 1969, Japan) had travelled to more than 30 countries before she settled in Sydney in 1999. Experiencing other cultures and seeing the art they produce provided a lot of inspiration for her work. 'Since I left Japan, I have been exploring "between-ness" – instead of searching for belonging, I wanted to incorporate the mixture of Western and Eastern cultures, adding functionality to sculptural objects, or combining the art of traditional Japanese flower arrangement with contemporary ceramics.'

Inspired by a Japanese restoration technique known as Kintsugi, through which an object is perceived to be more valuable after it has been repaired, her work explores the altering and reforming of fine porcelain forms through the cutting and rejoining of sections. 'Instead of hiding the join line, I choose to show the joins as they are,' she says. 'It is my intention to express our fragile being and accept imperfection.' Her work begins on the wheel and is then manipulated, cut and reassembled. She pays particular attention to the form and proportion, the profile or outline of a vessel and the interconnectedness of interior and exterior.

Although her work has evolved in response to Australian influences such as Les Blakebrough and Prue Venables, it retains a strong connection to her cultural roots. The result is a unique style that is delicate yet tactile.

Sydney

White is one of the most absolute colours and
it has been used in rituals and ceremonies in
many cultures. In Japan, white is used to suggest
purification and beginning, which is why I am so
drawn to this sacred colour.

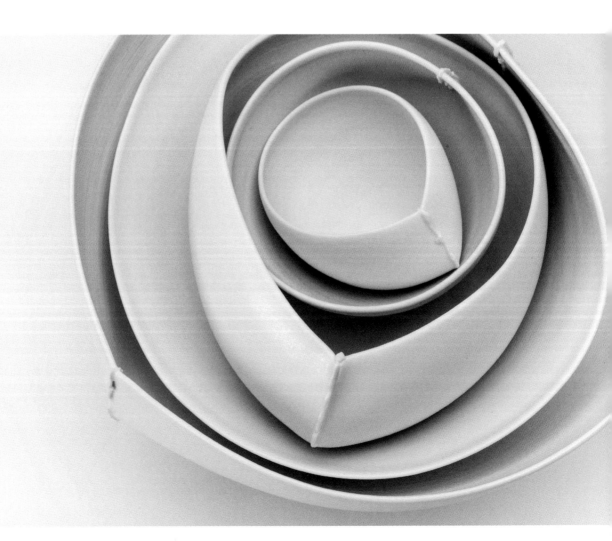

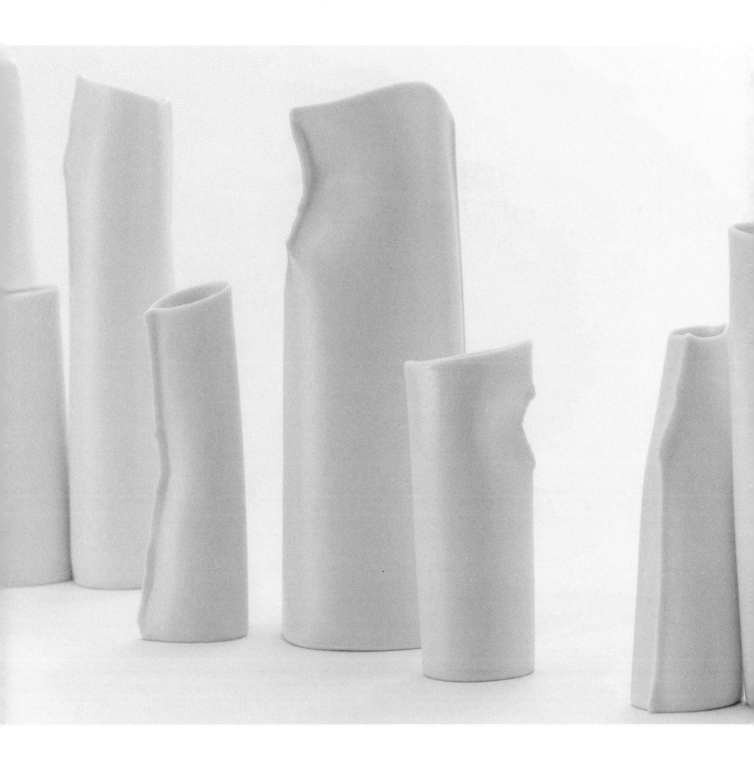

Sydney

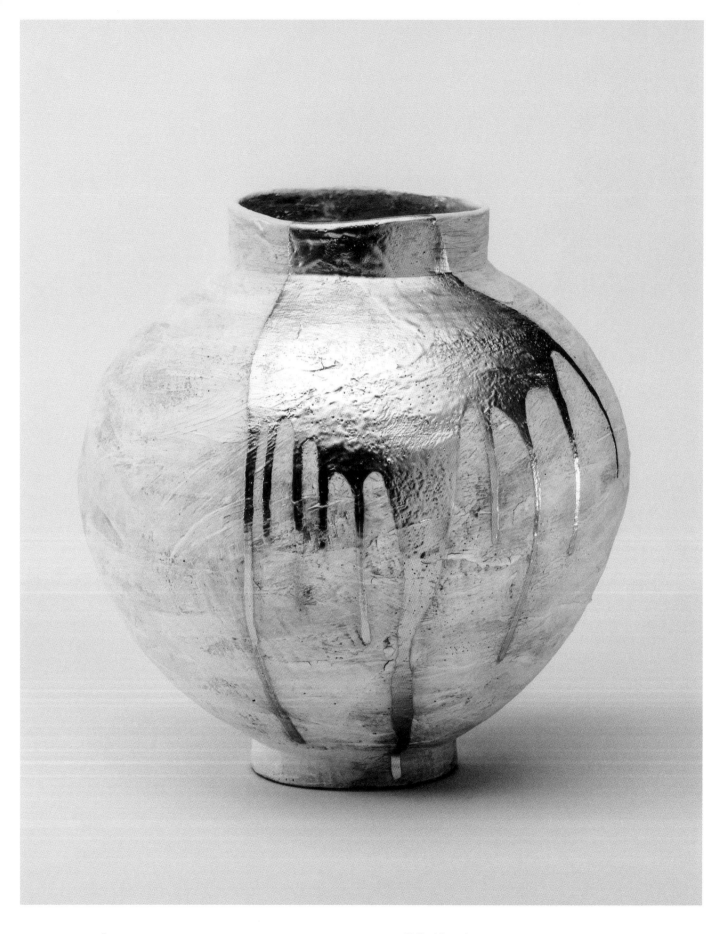

Keiko Matsui

It is my choice to create objects by hand. Sometimes, people don't have many choices. Therefore I feel privileged to have this occupation in which I'm able to use my hands. I'm grateful to express myself freely in clay and get great joy from it.

Tara Burke

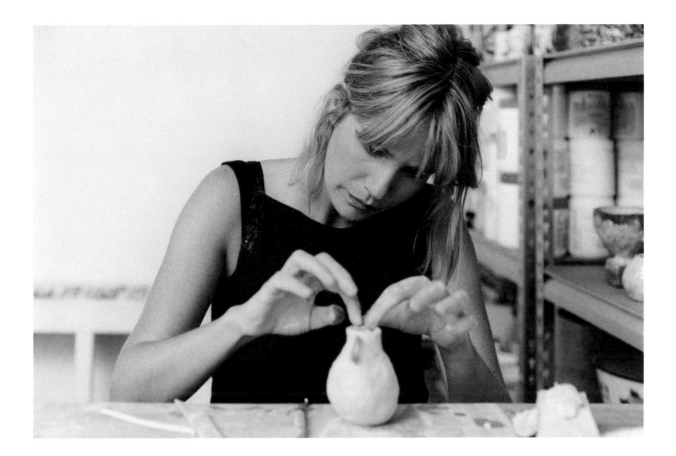

Tara Burke (b. 1989) hand-builds ceramic pots, bowls and tiny vases for single-stemmed flowers in a shared studio at the Nest Creative Space in Alexandria. 'I mostly work with my hands and I like that you can see my finger marks in the end product,' she says. 'I like to exploit the tactility of the material, contrasting raw and rough stoneware surfaces with impossibly smooth, white porcelains. These surfaces are reflective of the Australian environment – from rough and rocky bushland, to white sandy beaches, to the Red Centre. There is no shortage of inspiration in this environment.'

After studying anthropology in Melbourne, Burke moved to Sydney for a change of environment and ended up studying ceramics. 'It sort of happened by accident', she explains. 'I'd spent a few years floating between different degrees when I decided to switch to Sydney College of the Arts to study ceramics formally. I'd taken throwing lessons in Melbourne and loved them, but felt that there was more to ceramics than the wheel.' Studying ceramics in a formal setting gave her time and space to experiment with the material. 'There is a temptation to stick to what you know in ceramics, especially given the intrinsic volatility of the materials you are working with, but it's much easier to experiment in a university kiln than your own.'

Her first exhibition came about after she uploaded pictures of her work to Instagram and after that, the process of dedicating herself to ceramics was an organic one. She soon had enough interest in her work from galleries and retail spaces that she didn't need to find a job when she graduated. 'Of course, it hasn't all been blue skies, and I'm figuring it out as I go along, but I am thankful for the opportunities that have come my way so far, and for the fact that I have been able to make it work with support from the people around me.'

Sydney

The initial creation of an object is the best part of the process. I make almost all of my work by hand-building, and it's the initial shape-making that I find most rewarding.

Tara Burke

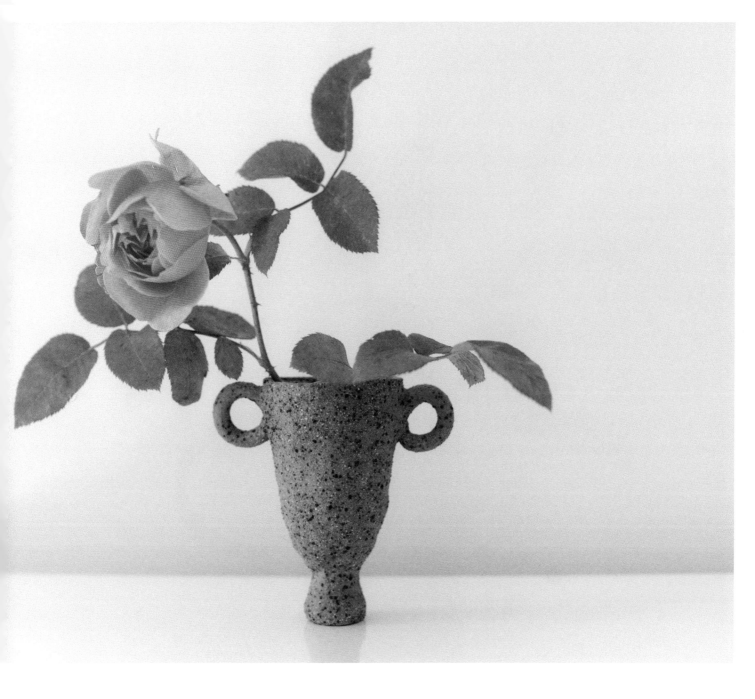

My focus is on textural components and form.
To achieve texture, I use a broad mix of clays,
including recycled and foraged clays.

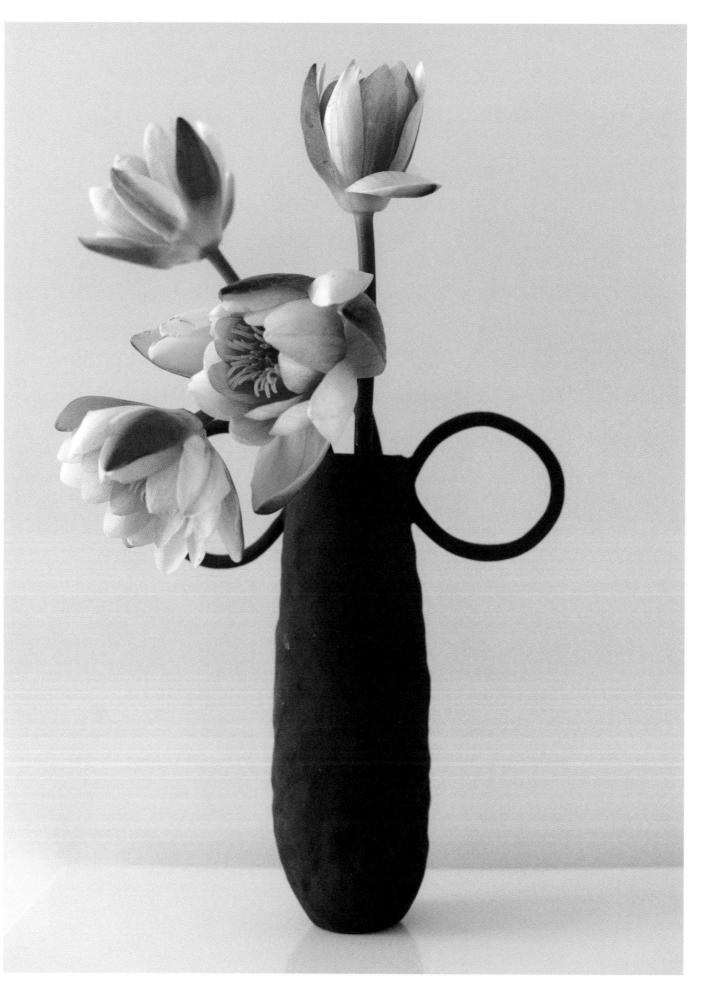

I work with very muted, neutral tones – nothing too loud or colourful. I enjoy more natural and organic colours and textures over bold colours.

Places to visit

This list includes a selection of museums, shops, galleries and other places that might interest and inspire lovers of ceramics and the handmade.

London

British Museum
The Percival David collection of porcelain includes some 1,700 examples of the finest Chinese ceramics in the world, all of which are on display at the Sir Joseph Hotung Centre for Ceramic Studies.
Great Russell St, Bloomsbury WC1B 3DG
www.britishmuseum.org

Clay Collective
As well as being a shared ceramics studio, Clay Collective runs a programme of workshops and events, including walks along the Thames to find the relics of historic potteries that once lined its banks.
Studio 1.1, Hackney Downs Studios,
17 Amhurst Terrace, Hackney E8 2BT
www.clay-collective.com

Contemporary Applied Arts
Contemporary Applied Arts was founded in 1948 to promote British craft. The multi-disciplinary gallery showcases the work of more than 350 members, from recent graduates to established talent.
89 Southwark Street, SE1 0HX
www.caa.org.uk

Contemporary Ceramics Centre
The Contemporary Ceramics Centre is the gallery of the Craft Potters Association and showcases changing exhibitions of contemporary work.
63 Great Russell St, Bloomsbury WC1B 3BF
www.cpaceramics.com

The Kiln Rooms
The Kilns Rooms is a social enterprise that offers a communal studio, equipment and technical support, and evening and weekend classes. Again, there are options for beginners through to trained practitioners.
Railway Arch 198, Bellenden Road, SE15 4QJ
www.thekilnrooms.com

Museum of London
The Museum of London documents the history of London from prehistoric to modern times, and includes an extensive collection of English slipware.
150 London Wall, EC2Y 5HN
www.museumoflondon.org.uk

Native & Co
Run by British-Japanese Chris Yoshiro Green and Taiwan-born Sharon Jo-Yun Hung, Native & Co specialises in homeware made by craftspeople in Japan and Taiwan.
116 Kensington Park Road, W11 2PW
www.nativeandco.com

The New Craftsmen
Mayfair-based luxury concept store The New Craftsman sells pieces by British makers, including Nicola Tassie (see p. 38), alongside a rotating exhibition bringing to life key themes in contemporary craft.
34 North Row, Mayfair W1K 6DG
www.thenewcraftsmen.com

Putney School of Art
Founded by Sir William Lancaster, Baron Pollock and Sir Arthur Jeff in 1883, Putney School of Art is a purpose-built art school offering half-day, evening and weekend classes, as well as summer schools, in a range of subjects including pottery and ceramics.
Oxford Road, Putney SW15 2LQ
www.putney-art-design.co.uk

Raw Ceramic Workshops
Matthew Raw offers weekday evening classes at Raw Ceramic Workshops, enabling you to bring your own ideas as well as responding to demonstrated techniques.
Ermine Mews, 33 Laburnum Street, E2 8BF
rawceramicworkshops.com

Turning Earth
With two locations in London's E2 and E10, Turning Earth is an open-access members' ceramics studio that is accessible to anyone – from complete beginners right through to professional artists.
Railway Arches 361-362, Whiston Road, E2 8BW
www.turningearth.uk

Victoria and Albert Museum
The V&A is the world's largest museum of decorative arts and houses a stunning collection of ceramics, both historical and contemporary. The new V&A shop stocks a good range of ceramics and books on the subject.
Cromwell Road, Knightsbridge SW7 2RL
www.vam.ac.uk

São Paulo

A Casa – Museu do Objeto Brasileiro
The Museum of the Brazilian Object hosts exhibitions and cultural activities such as courses, lectures, seminars and workshops.
Avenida Pedroso de Morais 1216, Pinheiros
www.acasa.org.br

Casa Diária
Casa Diária sells a wide range of carefully curated products by independent brands and makers.
Rua Arthur de Azevedo 1315, Pinheiros
www.casa.diaria.co

Espaço Norma Grinberg
The studio of renowned ceramic sculptor Norma Grinberg can be visited by appointment – and there are also lectures, workshops and exhibitions.
Rua Fidalga 960, Vila Madalena
www.normagrinberg.com.br

Galeria Nacional
Galeria Nacional stocks a wide range of Brazilian design from furniture to stationery, including a good selection of ceramics.
Rua Mateus Grou 540, Pinheiros
www.galerianacional.com.br

Kimi Nii Showroom
Part of the Japanese-Brazilian community that has been so important to ceramics in São Paulo, Kimi Nii is one of Brazil's most internationally recognised contemporary ceramicists.
Rua Girassol 314, Vila Madalena
www.kiminii.com.br

MAE
The Museum of Archeology and Ethnology at the University of São Paulo is a fascinating place to visit for those interested in pre-Columbian and indigenous ceramics.
Avenida Prof. Almeida Prado 1466, Butantã
www.mae.usp.br

MuBE
The Brazilian Sculpture Museum houses sculptures, paintings, photography, drawings and graffiti art works.
Rua Alemanha 221, Jardim Europa
www.mube.art.br

Museu Afro Brasil
Museu Afro Brasil in Ibirapuera Park houses a collection of more than 6,000 objects, including ceramics, relating to African and Afro-Brazilian culture.
Avenida Pedro Álvares Cabral, Portão 10, s/n, Parque Ibirapuera
www.museuafrobrasil.org.br

Museu da Casa Brasileira
Brazil's Architecture Museum organises temporary exhibitions and holds a collection of Brazilian furniture ranging from the 17th century to the present day.
Avenida Brg. Faria Lima 2705, Jardim Paulistano
www.mcb.org.br

SESC Pompéia
SESC Pompéia is a cultural and sports centre in a former barrel factory transformed by architect Lina Bo Bardi in 1977. It comprises a swimming pool, a library and a restaurant and houses concerts, exhibitions, cultural activities as well as ceramics classes and open workshops.
Rua Clélia 93, Pompéia
www.sescsp.org.br

Terra W Estúdio
Founded in 1998, Terra W Estúdio is an art space offering ceramic and weaving courses, as well as producing utilitarian and decorative ceramics, sculptures, and scarves, shawls, blankets, rugs and tableware.
Avenida Pedroso de Morais 2301, Pinheiros
terrawestudio.com.br

New York

Homecoming
Brooklyn-based coffee, plant, flower and homeware shop Homecoming also sells pastries and single-origin coffee drinks.
107 Franklin Street, Brooklyn NY 11222
www.home-coming.com

La Mano Pottery
La Mano Pottery is a ceramics studio in the Chelsea neighbourhood of New York City, welcoming beginners and experienced potters alike. Many of the objects made on site are available for sale.
La Mano Pottery, 110 West 26th Street NY 10001
www.lamanopottery.com

Leif Shop
Leif is a curated lifestyle shop in Williamsburg selling homeware, textiles, table linens and artwork.
99 Grand Street, Brooklyn NY 11249
www.leifshop.com

Les Ateliers Courbet
Les Ateliers Courbet sells furniture, lighting, flooring, decorative objects and home accessories, with a focus on material quality, craftsmanship, heritage and provenance.
175-177 Mott Street, NY 10012
www.ateliercourbet.com

Metropolitan Museum of Art
The Met presents over 5,000 years of art from around the world and has an extensive collection of ceramics, together with a well-stocked shop selling contemporary pieces.
1000 Fifth Avenue, NY 10028
www.metmuseum.org

Mociun
Mociun is a minimalist store selling textiles, ceramics, jewellery, and homewares.
224 Wythe Avenue, Brooklyn NY 11249
www.mociun.com

Noguchi Museum
The Noguchi Museum was designed and created by the Japanese-American sculptor Isamu Noguchi, and now holds the world's largest collection of his sculptures, drawings, models and designs.
9-01 33rd Road, Queens NY 11106
www.noguchi.org

Onishi Gallery
Established in 2005, Onishi Gallery features contemporary Japanese artists working in a range of media, including ceramics, glass, metalwork and calligraphy.
521 West 26th Street, NY 10001
www.onishigallery.com

Sara Japanese Pottery
Sara Japanese Pottery sells handcrafted ceramics, glassware and Asian-inspired homeware, created by both Japanese and American artisans.
950 Lexington Avenue, NY 10021
www.saranyc.com

Shibui Japanese Antiques
Shibui offers unique Japanese antique pieces, including ceramics, textiles, traditional Japanese art implements, and the shop's specialty – authentic antique tansu chests.
20 Jay Street, Suite 510, Brooklyn NY 11201
www.dumbo.is/hometo/shibui-japanese-antiques

Still House
Still House is a gallery-style space with thoughtfully designed contemporary glass, ceramics and jewellery from local and international artists.
117 East 7th Street, NY 10009
www.stillhousenyc.com

The Primary Essentials
With an emphasis on the rituals of daily life, the Primary Essentials is a boutiqueshowcasing products for the home by local designers and artisans.
372 Atlantic Avenue, Brooklyn, NY 11217
www.theprimaryessentials.com

Totokaelo
Primarily a fashion outlet, Totokaelo also sells a collection that it terms 'art-object,' including tableware, lighting, textiles and prints.
54 Crosby Street, NY 10012
www.totokaelo.com

Copenhagen

Ann Linnemann Galerie
Ann Linnemann Galerie is a small gallery in Østerbro that shows contemporary Danish and international work in thoughtfully curated exhibitions, alongside original pieces for sale.
Kronprinsessegade 51, 1306 Copenhagen
www.annlinnemann.blogspot.dk

Butik for Borddækning
A shop selling the work of seven makers, Butik for Borddækning has a focus on tableware. An exhibition space showcases work by the members of the collective and invited guests.
Møntergade 6, 1116 Copenhagen
www.butikforborddaekning.dk

Clay Keramikmuseum
Clay: The Museum of Ceramic Art, Denmark, is in Fyn, a short day trip from Copenhagen, and includes ceramics ranging from a 235-year-old Royal Copenhagen plate to experimental contemporary artworks. A new building has added 1,500 square metres to its floor space.
Grimmerhus, Kongebrovej 42, 5500 Middelfart
www.claymuseum.dk

Designer Zoo
Designer Zoo is a collective of seven makers with a shop selling their work alongside Danish ceramics and other objects made by craftsmen from all over the country.
Vesterbrogade 137, 1620 Copenhagen
www.dzoo.dk

Ditte Fischer Copenhagen
Ditte Fischer (see p. 130) has been making and selling ceramics in Copenhagen since she graduated in 1995 and has always dreamed of having her own shop. 20 years into her career, that dream came true.
Læderstræde 14, 1201 Copenhagen
www.dittefischer.dk

Inge Vincents
Working solely in white, Inge Vincents (see p. 146) produces paper-thin ceramics on the edge of functionality – this is her shop and studio.
Jægersborggade 27, 2200 Copenhagen
www.vincents.dk

Keramik og Glasværkstedet
Keramik og Glasværkstedet is a small, airy shop selling handmade work by Danish glass and ceramics artists.

Kronprinsessegade 43, 1306 Copenhagen
www.cargocollective.com/list

Studio Arhoj
Located by the harbour, Studio Arhoj (see p. 138) is a Danish interior and design studio run by Anders Arhoj Kigkurren. The studio and associated shop are both open to the public.

Kigkurren 8M, st, 2300 Copenhagen
www.arhoj.com

Tasja Pulawska
Polish potter Tasja Pulawska (see p. 158) works as an assistant to Eric Landon at Tortus Copenhagen. Having served her apprenticeship there, she now runs her own studio and shop.

Mimersgade 21, 2200 Copenhagen
www.tasjapceramics.com

Tina Marie Cph
Tina Marie Bentsen (see p. 152) shares Viktoria Ceramic Studio with four other ceramicists. Visitors can shop as well as walking through the studio to meet the potters at work.

Viktoria Studio, Vesterbrogade 24b, basement across the yard, 1620 Copenhagen
www.tinamariecph.dk

Tortus Copenhagen
The poster boy of the ceramics scene in Copenhagen, US-born Eric Landon runs Tortus Copenhagen from a studio where he welcomes visitors to buy his work or take part in workshops.

Kompagnistræde 23, 1208 Copenhagen
www.tortus-copenhagen.com

Tokyo

Bingoya
Bingoya comprises five floors of handmade traditional crafts from all over Japan. Wares include handmade dolls, bamboo tea canisters, ceramic sake sets, hand-dyed batik fabrics and zabuton (floor cushions).

10-6 Wakamatsucho, Shinjuku-ku, Tokyo
www.bingoya.tokyo

Gotoh Museum
This private museum in the Kaminoge district of Setagaya on Tokyo's southwestern fringe opened in 1960 to display the private collection of railway entrepreneur Keita Gotō.

The collection centres on classical Japanese and Chinese art, including paintings, writings, crafts and archaeological objects, and includes a small selection of Korean arts.

3-9-25 Kaminoge, Setagaya-ku, Tokyo
www.gotoh-museum.or.jp

Hakusan Shop
An eighth-generation family business, Hakusan is a classic pottery shop first founded in 1779 in Hasami, Nagasaki Prefecture. It became world-renowned in 1958 when one of its designers, Masahiro Mori, created the now iconic G-type soy sauce dispenser, which can be found in many design museums' permanent collections. It also sells a wide range of beautiful and affordable everyday items.

5-3-10 Minami-Aoyama, Minato-ku, Tokyo
www.hakusan-shop.com

Idée Shop
With the slogan 'life is the everyday,' Idée challenges its customers to find beauty in the ordinary, selling a modern mix of furniture, homeware, books and clothing. There is also a café and interior-design and gift-selection services.

2-16-29 Jiyugaoka, Meguro-ku, Tokyo
www.idee.co.jp

Japan Traditional Crafts Centre
Founded to champion Japan's heritage crafts practices, the centre holds exhibitions showcasing the making process behind Japanese traditional handicrafts. On the first floor regional ceramics, lacquerware, wood carvings, washi (handmade paper) and fibre arts are sold on the first floor.

Metropolitan Plaza Building 1 – 2F, 1-11-1 Nishi Ikebukuro, Toshima-ku, Tokyo

Kagure Omotesando
Kagure was founded in 2008 in the Omote Sando area as the first shop specialising in ethical fashion. The shop organises exhibitions for high-quality craftwork and exclusive workshops for pottery, yoga and cooking, and present vintage handmade pottery and home workshop tools ('Mingu') from all over Japan.

Mico Jingumae 4-25-12 Jingu-mae, Shibuya-ku, Tokyo
www.kagure.jp

Kappabashi Dougu Street
Also known as Kitchen Town, this street in the Taito district is home to dozens of kitchenware shops. Although mostly mass-produced, the ceramics are attractive and affordable. The two-storey Dengama on the corner of Asakusa-dori is one of the best shops in

the neighbourhood, offering an inspiring selection of artisanal pottery, lacquerware, metal utensils and wooden crafts.

Kappabashi Dogugai, Taito-ku, Tokyo
www.kappabashi.or.jp

Kokugakuin University Museum
Located in the Shibuya district, the Kokugakuin University Museum has a long history of patronage from the imperial family, and houses an impressive archaeological collection, including more than 80,000 objects (20,000 of which are from the Jōmon period), with 3,000 on display at any time.

4-10-28 Higashi, Shibuya-ku, Tokyo
museum.kokugakuin.ac.jp

Musée Tomo
Musée Tomo is a museum for contemporary Japanese ceramic art, featuring the impressive collection of the founder of Satori Museum of Art, Tomo Kikuchi, who died aged 93 in the summer of 2016.

4-1-35 Toranomon, Minato-ku, Tokyo
www.musee-tomo.or.jp

Oedo Antique Market
The largest outdoor antique market in Japan is one of the best places to find unique objects, including ceramics, in Tokyo. It is held twice a month, on the first and third Sundays of the month and offers pieces in all price ranges.

Tokyo International Forum, 3-5-1 Marunouchi, Chiyoda-ku, Tokyo
www.antique-market.jp

Rakuan
Rakuan is a tearoom-gallery in downtown Tokyo with monthly exhibitions that enable you to explore the craft on show alongside your Chinese tea. The row house next to Kiyosumi Park dates from 1928 – interior that combines a modern aesthetic with elements from the Shōwa-period.

3-3-23 Kiyosumi, Koto-ku, Tokyo
www.kiyosumi-01.com/rakuan1

Sengawa Utsuwa
In Tokyo's lively downtown, Sengawa Utsuwa plays host to frequent exhibitions of Japanese potters and also sells ceramics for daily use.

Kondo Building 1F, 1-12-10 Sengawa-cho, Chofu-city, Tokyo
sengawa-utsuwa.com

Sundries
Sundries is a small old-fashioned antiques shop in Tokyo and Aoyama, that sells antique ceramics and sometimes hosts exhibitions of contemporary work.

4-10-15 Minamiaoyama, Minato-ku, Tokyo

Toukyo

A ceramics shop and gallery, founded in 1987 by Ichiro Hirose, Toukyo exhibits and sells high-quality ceramics by contemporary Japanese potters, as well as a small selection of glass, wood and metal artefacts.

2-25-13 Nishi-azabu, Minato-ku, Tokyo
www.toukyo.com

Tokyo National Museum

One of the largest art museums in the world, the Tokyo National Museum houses an extensive collection of pottery from the Jomon period.

13-9 Ueno Park, Taito-ku, Tokyo
www.tnm.jp

Tsuneko Tanaka's Ceramics

This shop houses the work of the artist, Tsuneko Tanaka, and is owned and run by her husband Hiroyuki Tanaka, who claims that his wife was the first to mix Japanese tradition with modern techniques, thus kick-starting the 'crossover style'.

3-27-4 Sendagaya Shibuya-ku, Tokyo

Sydney

Artifex

Artifex is a furniture store that has recently expanded to include ceramic homewares and lighting in its range.

33 Roseberry Street, Balgowlah NSW 2093
www.artifex.com.au

China Clay

A florist and ceramics shop by the sea, China Clay sells work by some of Australia's best emerging and established potters.

27 Burnie Street, Clovelly NSW 2031
www.chinaclay.com.au

Claypool

Established in 2013, the Claypool pottery studio has quickly grown into a buzzing centre that reaches professional and non-professional potters alike.

10 Rancom Street, Botany NSW 2019
claypool.com.au

Elph ceramics

Elph ceramics sells a range of functional, handmade ceramics made by Sydney-based artist and ceramicist Eloise Rankine.

12 William Street, Paddington NSW 2021
www.elphceramics.com

Hayden Youlley Design Studio

Hayden Youlley (see p. 207) shares his studio space with two other designer makers. It's open to the public during the week and by appointment at the weekend so you can meet and buy work directly from the artists.

Studio P1A, 20-28 Carrington Road, Marrickville NSW 2204
www.haydenyoulley.com

kil.n.it

kil.n.it is a not-for-profit creative space, providing five private studios, shared workshop space, a classroom and a glaze kitchen for anyone who wants to develop their ceramics practice.

184 Glebe Point Road, Glebe NSW 2037
www.kil-n-it.com

Koskela

Koskela sells a wide range of Australian design, craft and art, including ceramics, textiles, furniture and lighting. There is also studio space for creative workshops and a café.

1/85 Dunning Avenue, Rosebery NSW 2018
www.koskela.com.au

Planet

Promoting natural materials, sustainability and the handmade, Planet sells hardwood furniture designed by Ross Longmuir, alongside handpicked Australian lighting, homewares, ceramics, textiles and artwork.

114 Commonwealth Street, Surry Hills NSW 2010
www.planetfurniture.com.au

Sabbia Gallery

Run by Directors Anna Grigson and Maria Grimaldi, Sabbia Gallery represents studio glass and ceramic artists from all over Australia and New Zealand.

120 Glenmore Road, Paddington NSW 2021
www.sabbiagallery.com

Sydney Clay Studio

Sydney Clay Studio is a collective of professional potters, and offers individual studio spaces as well as shared pottery wheels, hand-building facilities and tuition.

3A 7-1 Unwins Bridge Road, St Peters NSW 2044
www.sydneyclaystudio.com

Sweets Workshop

An art gallery, retail shop and graphic design and illustration studio, Sweets Workshop exhibits and sells art, decorative objects and independent publications, with focus on local and handmade items.

4/58-60 Carlton Crescent, Summer Hill NSW 2130
www.sweetsworkshop.com

The Plant Room

Primarily a botanical studio, the Plant Room also stocks all the accoutrements of a green-fingered life, such as ceramics, furniture, wall hangings and art.

57 Pittwater Road, Manly NSW 2095
www.theplantroom.com.au

Wood Paper Silk

Wood Paper Silk is a suburban gallery selling art, eco-fashion, homewares and jewellery sourced from local designers and makers.

4 Victoria Street, Lewisham NSW 2049
www.woodpapersilk.com

23 Albert

23 Albert is a high-end fashion boutique, stocking international labels alongside accessories, gifts and homewares.

23 Albert Street, Freshwater NSW 2096
www.23albert.com.au

Kerrie Lowe Gallery

Specialising in contemporary Australian ceramic sculpture and pottery, Kerrie Lowe Gallery also sells pottery supplies such as clay, tools and glaze for professional artists and students.

49-51 King Street, Newtown NSW 2042
www.kerrielowe.com

Olsen Gallery

Olsen, formerly known as the Olsen Irwin and Tim Olsen Gallery, represents some of Australian's leading contemporary painters, sculptors, photographers and ceramic artists, having supported many of them since art school.

63 Jersey Road, Woollahra NSW 2025
www.olsengallery.com

Reading List

Adamson, G. (2013). *The Invention of Craft*. 1st ed. London: Bloomsbury.

Adlin, J. (1998). *Contemporary Ceramics*. 1st ed. New York: Metropolitan Museum of Art.

Cooper, E. (2010). *10,000 Years of Pottery*. 1st ed. London: British Museum.

Crawford, M. (2011). *The case for working with your hands, or, Why office work is bad for us and fixing things feels good*. 1st ed. London: Penguin.

De Waal, E. (2003). *20th Century Ceramics*. 1st ed. London [u.a.]: Thames & Hudson.

De Waal, E. and Clare, c. (2011). *The Pot Book*. 1st ed. London: Phaidon.

De Waal, E. (2011). *The Hare with Amber Eyes*. 1st ed. London: Vintage.

De Waal, E. (2016). *The White Road*. 1st ed. London: Vintage.

Fraser, B. (2012). *Danish Contemporary Classic Ceramics*. 2nd ed. Great Missenden: Cultural Connections.

Gibson, G. (2016). *Another Desktop Series*. Crafts, (263).

Gibson, G. (2016). *Reiko Kaneko: Glazed Expressions*. Crafts, (258).

Granja Pereira de Morais, L. (2015). *Two Japanese Women Ceramists in Brazil: Identity, Culture and Representation*. Journal of International and Advanced Japanese Studies, 7, pp. 201–212.

Grandjean, B., Helsted, D. and Bodelsen, M. (1975). *The Royal Copenhagen Porcelain Manufactory 1775–1975*. 1st ed. Copenhagen: The Manufactory [eksp., Amagertorv 6].

Harrod, T. (2015). *The Real Thing*. 1st ed. Hyphen Press.

Hayden, A. (1912). *Royal Copenhagen Porcelain*. 1st ed. New York: McBride.

Hecht, R. (2000). *Scandinavian Art Pottery*. 1st ed. Atglen: Schiffer.

Jewitt, L. (1878). *The Ceramic Art of Great Britain from Pre-Historic Times Down to the Present Day*. 1st ed. London: Virtue and Co., 26, Ivy Lane Paternoster Row.

Kesseler, R. (2017). *Craftsmanship Alone is Never Enough*. Ceramic Review, (283), pp. 20–23.

Laursen, B. and Nottelmann, S. (2000). *Royal Copenhagen Porcelain, 1775–2000*. 1st ed. København: NYT Nordisk Forlag Arnold Busck.

Leach, B. (1985). *A Potter's Book*. 2nd ed. London: Faber & Faber

Lone, S. (2001). *The Japanese Community in Brazil, 1908–1940*. 1st ed. Houndmills, Basingstoke, Hampshire: Palgrave. McMeekin, I. (1967). *Notes for potters in Australia. Volume 1. Raw materials and clay bodies*. 1st ed. Sydney: New South Wales U.P.

Morris, T. (2017). *Potted History – Copenhagen*. Monocle, (92).

Pascoe, J. (1995). *Delinquent Angel: Australian Historical, Aboriginal and Contemporary Ceramics*. 1st ed. Florence: Centro Di.

Sennett, R. (2009). *The Craftsman*. 1st ed. London: Penguin Books.

Tokyo potters I. (1992). 1st ed. Kyoto: Kyoto Shoin.

Walker, D. (2016). *Craft's Identity Crisis*. Crafts, (258)

Watt, A., Bamford, R., Black, S., Daly, G., Dionyse, C., Horrell, C., Matsui, T., Mincham, J., Pearson, C., Roguszczak, E., Shoji, M., Stoner, M., Teschendorff, J., Viková, J. Viotti, U. and Wideman, M. (1988). The First International Ceramic Symposium in Australia. 1st ed. Canberra, Australia.

Wildenhain, M. (1986). *Pottery: Form and Expression*. 1st ed. Palo Alto, Ca: Pacific Books Publ.

Wildenhain, M. (1973). *The Invisible Core*. 1st ed. Palo Alto, Calif.: Pacific Books.

Yanagi, M., Leach, B. and Hamada, S. (1972). *The Unknown Craftsman*. 1st ed. Tokyo, Kodansha International.

Photographic Credits

Every effort has been made to contact copyright-holders of photographs. Any copyright-holders we have been unable to reach or to whom inaccurate acknowledgement has been made are invited to contact the publisher.

Alana Wilson: back cover, textures on endpapers, pp. 198, 199 (right), 202–203, 204, 205

Amanda Prior: pp. 206, 208–209, 212–213

Amy Piddington: p. 221

Angelo Dal Bó: pp. 58–65

Barry Stedman: pp. 24, 25, 28–29

Ben Boswell: pp. 40, 41

Bill Payne: p. 194

Camilla Winther: p. 147

Christian Geisnæs: p. 150

Crafts Study Centre: pp. 10, 13, 164; Mrs. Jane Coper/Crafts Study Centre (2004): p. 11

Daichi Saito: pp. 182–187

Denis Giacobelis aka Ringo: pp. 72–77

Ditte Fischer: pp. 130–136

Erica Suzuki: pp. 168–175

Eva Zeisel Archive: p. 81

Florian Gadsby: pp. 14–20

Frankie & Marilia from frankieemarilia.com: pp. 51, 54, 55, 56, 57

Gabriel Bianchini: pp. 52, 53

Greg Piper / Courtesy Keiko Matsui: pp. 214–218

Helena Yoshioka: p. 66

Helen Levi: pp. 84, 85, 89

Inge Vincents: p. 151

James Chororos: front cover, pp. 82, 83, 86–87, 88, 90

James Rawlings: pp. 22, 23, 26

Johnny Mazzilli: p. 49

Joseph Edward: pp. 148–149

Josephine Heilpern: pp. 92–99

Josh Nefsky for The Garnered: pp. 116, 117

Joshua Morris: pp. 207, 210, 211

Luisa Brimble: p. 199 (left)

Mana Miki: p. 179

Matthew Warner: pp. 30–37

Miho Aikawa: pp. 121, 122, 123, 125

Mitsuhiro Kamada: p. 177

MONDAYS: pp. 100–105

M. Stylianou: pp. 42–43

Naira Mattia: p. 67

Natalie Weinberger: pp. 106, 107 (left), 108, 109, 110, 111, 112

No. | Romy Northover: pp. 114, 115, 118

Otto Hagel (Marguerite Wildenhain papers, 1930–1982. Archives of American Art, Smithsonian Institution): pp. 4, 80

Pedro Nobrega: pp. 68–71

Pippa Drummond: p. 107 (right)

Rodrigo Fonseca: p. 50

Ryoko Sekiya: pp. 176, 180

Shino Takeda: pp. 120, 124

SOLK: p. 146

Studio Anders Arhoj: pp. 138–144

Tara Burke: pp. 220, 222–223, 224

Tasja Pulawska: pp. 158–163

Tatsuhiko Shimada: pp. 188–193

Thea Burger: p. 78

Tina Marie Bentsen: pp. 152–157

Victoria Zschlommer: p. 201

Colophon

Text
Katie Treggiden

Editors
Micha Pycke & Ruth Ruyffelaere

Graphic Design
Dylan Van Elewyck

Production
Emiel Godefroit

Printing
DeckersSnoeck

ISBN 978-1-4197-2763-4

PRINTED AND BOUND IN BELGIUM
10 9 8 7 6 5 4 3 2 1

Abrams books are available at special discounts when
purchased in quantity for premium and promotions
as well as fundraising or educational use.
Special editions can also be created to specification.
For details, contact specialsales@abramsbooks.com
or the address below.

ABRAMS The Art of Books
115 West 18th Street, New York, NY 10011
abramsbooks.com

The author and editors sincerely wish to thank:

Leyton Allen-Scholey, Anders Arhoj, Tina Marie Bentsen,
Hanne Bertelsen, Ditte Blohm, Tara Burke, Stewart Carey,
Malin Cunningham, Nicole Donaldson, Jennifer Fiore,
Ditte Fischer, Yara Fukimoto, Miki Furusho, Florian Gadsby,
Heloisa Galvão, Lars Gregersen, Fernanda Giaccio, David
Gorrod, Alun Graves, Joanna Ham, Josephine Heilpern, Sue
Howdle, Josete Huedo, Jennifer Isaacs, Helen Johannessen,
Martin Bodilsen Kaldahl, Reiko Kaneiko, Yukiharu Kumagai,
Nina Lalli, Helen Levi, Anthony Leyton, Judy Linden, Mette
Marie Lyng-Petersen, Keiko Matsui, Liliana Granja Morais,
Haruna Morita, Romy Northover, Simon Oldin, Sofia Oliveira,
Albane Paret, Taz Pollard, Tasja Pulawska, Malene Hartmann
Rasmussen, Matthew Raw, Treaisa Rowe, Peter Ruyffelaere,
Shelley Simpson, Barry Stedman, Alice Stewardson,
Takuyosho Sunakawa, Erica Suzuki, Shino Takeda, Nicola
Tassie, Robert Treggiden, Kia Utzon-Frank, Inge Vincents,
Matthew Warner, Goppy Parke Weaving, Natalie Weinberger,
Alana Wilson and Hayden Youlley